Praise for the book

A true entrepreneur, Ronnie Screwvala took a startup to a global scale by partnering with The Walt Disney Company. He has the qualities I believe necessary for great leadership—embodying the spirit of curiosity and optimism, taking smart chances, and pursuing excellence always.

BOB IGER,
Chairman and CEO, The Walt Disney Company

The story of Indian media in the last twenty years is the story of how a few brave entrepreneurs like Ronnie built an exciting industry from scratch—with few guideposts and no templates to replicate. I hope Ronnie's story will be a beacon for entrepreneurs who seek to create their own next big leaps.

JAMES MURDOCH,
COO, 21st Century Fox

Entrepreneurship is as much about vision, creativity and courage as it is about the acumen of recognizing what to do and what not to do, and knowing when to enter and when to exit a business. There is no better person to learn these lessons in entrepreneurship from than Ronnie himself.

KISHORE BIYANI,
Group CEO, Future Group

There is no one better than Ronnie Screwvala to write on entrepreneurship! This book, based on intense personal experiences and packed with anecdotes, is a great primer for those wanting to take the plunge, innovate or take their firms to scale. This is just the book we need for inspiring a 'Startup Nation'!

NANDAN NILEKANI,
Co-founder, Infosys, and former Chairman,
Unique Identification Authority of India

Ronnie is a rare breed: innovative, disruptive, compassionate, sincere, honest and smart. I feel honoured to call him my friend.

ANDY BIRD,
Chairman, Walt Disney International

Businesses need to go beyond the interests of their companies to the communities they serve. I hope this book will inspire many to believe and question how they impact others as they grow their companies.

RATAN TATA,
Chairman, Tata Trusts

Ronnie is a first-generation entrepreneur who I have admired for his energy, drive, passion and risk-taking ability. This book will be a guide for the next generation of entrepreneurs to learn from and get inspired by.

MUKESH AMBANI,
Chairman, Reliance Industries Ltd

Good entrepreneurs experience personal success. Great entrepreneurs multiply their success and help others rise along with them. Ronnie is a great entrepreneur.

ANAND MAHINDRA,
Chairman, Mahindra Group

Ronnie symbolizes the true spirit of Indian entrepreneurship. I have witnessed his personal growth as an entrepreneur, his passion, his challenges and his ability to innovate, disrupt and build. His journey and experiences will be a strong learning and read for entrepreneurs and professionals at any stage of their careers.

UDAY KOTAK,
Executive Vice Chairman and Managing Director,
Kotak Mahindra Bank

DREAM WITH YOUR EYES OPEN

From modest beginnings in Mumbai's Grant Road, surrounded by the energy and unbridled potential of a country always on the verge of greatness, **Ronnie Screwvala** is a first-generation entrepreneur.

His early days on television and in theatre inspired him to pioneer cable TV in India and build one of the largest toothbrush manufacturing operations, before founding UTV, a media and entertainment conglomerate spanning television, digital, mobile, broadcasting, games and motion pictures, which he divested to The Walt Disney Company in 2012.

For his innate ability to merge creativity with commerce, *Newsweek* termed him the Jack Warner of India, *Esquire* rated him as one of the 75 most influential people of the 21st century and *Fortune* as among Asia's 25 most powerful.

On to his second innings, Ronnie is driven by his interest in championing entrepreneurship in India, and is focused on building his next set of ground-up businesses in high growth and impact sectors. His more recent commitment to being a first mover in sports has made him lend his support to kabaddi and football.

He is passionate about social welfare, and with his wife Zarina, through their Swades Foundation, has given single-minded focus to empowering one million lives in rural India every 5-6 years through a unique 360-degree model.

He lives in Mumbai with Zarina and daughter Trishya.

DREAM
WITH
YOUR
EYES
OPEN

RONNIE SCREWVALA

AN ENTREPRENEURIAL
JOURNEY

RUPA

Published by
Rupa Publications India Pvt. Ltd 2015, 2016
7/16, Ansari Road, Daryaganj
New Delhi 110002

Sales centres:
Allahabad Bengaluru Chennai
Hyderabad Jaipur Kathmandu
Kolkata Mumbai

ISBN: 978-81-291-3994-8

Seventeenth impression 2022

20 19 18 17

The moral right of the author has been asserted

Printed in India

To Zarina and Trishya,
the wind beneath my every step
even when I did not have wings

And to my mum and dad,
who taught me the true values of life

∾

All proceeds from this book go to our Swades Foundation
and to everyone in our villages in India
who, too, dream with their eyes open

Contents

Thanks to...

I never thought I would write a book, but when I finally got around to it, less than a year ago, the experience turned out to be exhilarating and cathartic. To go back in time and recall all the incredible people I have had the privilege to work with or partner; to go down memory lane to relive the magical as well as the scary moments—the highs and lows—has been sensational and brought to the fore so many learnings, till now tucked away in the past, which stay with me as I embark on my new journey.

Thank you, Wynton Hall, for being such a great partner and collaborator in the writing of this book. You understood me so well from the start and you brought structure to the chapters and a tonality to the narrative that makes this book an easy read.

Thank you, Patrick Smith, for your incredible eye for detail, never missing a sliver of a point and for putting it all together.

Thanks to my wife, Zarina, and my daughter, Trishya, to whom I have dedicated this book, for your patience and support—for bearing with me during all those days and late nights when I was locked in the study, for the many dinner table conversations that veered towards the chapters of the book, and for the many times I would rush in and request you to drop everything (as you so graciously did) to read the few paragraphs I had just written and was excited about.

Thanks to some of my close colleagues and fellow entrepreneurs as

also to all of Trishya's best friends for your valuable feedback, detailed and diverse, on the early drafts, which no doubt helped me improve the book.

Thanks to Amrita Pandey, a colleague, who in the ten years I have known her as she worked at UTV, would enter my office room every two years to nudge me to write a book, only to be shooed away... till one day about a year-and-half ago, when we were in a group, brainstorming on executing the TV show *Sharks Tank* in India, she once again brought up writing a book and, for the first time, I wrote down on a Post-it: 'Book?'

Thanks to my trusted colleague and executive assistant, Zenobia Tamboli, for her guidance, correction of facts and her commitment through the multiple drafts of the book.

Thanks to Rupa Publications, Kapish Mehra and Ritu Vajpeyi-Mohan, for breaking boundaries in publishing this book, and for holding my hand through the whole process, from an idea to a book on the shelf.

It is the growing spirit of entrepreneurship and leadership in India, coupled with the new wave of optimism, passion, aspiration and ambition, that inspired me to contribute in my small way and write this book.

Entrepreneurial Chronology
The Last Twenty-five Years

I am sharing my career arc in headline form, not because this book is about my career per se, but rather to offer a point of reference. In each chapter, I draw on anecdotes that connect my real-life experiences, both the good and the bad, to the book's message. These stories aren't always presented in chronological order.

My entrepreneurial journey spans twenty-five years till date. My first serious business venture was pioneering cable TV in India in the early 1980s before stumbling on to manufacturing toothbrushes later in the decade; that business, Lazer Brushes, grew to be one of the largest of its kind in India.

My early theatre and front-of-television days, which began as a hobby, attracted me to the media and entertainment business. In the early 1990s, I incorporated UTV with a vision that, at the time, was not so ambitious—to create television programmes for various channels. Over the next five years, we grew in imagination and ambition, created various divisions, and started offering a range of services: from making advertising films and documentaries, to providing in-flight entertainment programming for multiple airlines,

dubbing for most Hollywood live action and animation content in India, and setting up a large post-production and special effects studio—even while continuing to create television shows.

Up until then, I had not raised external funding—neither for cable television nor for toothbrushes or UTV—mainly because the ecosystem wasn't mature enough then. And there was another reason guiding this decision. I wanted to bootstrap without being answerable to external investors at a time when I focused on growing businesses where predictability was low.

However, by the mid-1990s, I changed my business model. Seeking scale and needing capital, we took on our very first investor, Rupert Murdoch. Soon after, Warburg Pincus, one of the top three global funds, also took a stake in UTV. Our subsidiary built a state-of-the-art post-production studio and, later, a massive animation facility, for which we managed to bring three investors on board—Hinduja Finance, Infrastructure Leasing & Financial Services (IL&FS) and Mitsui of Japan.

In the early 2000s, we embarked on three major initiatives, amongst many others always in the works. For one, we expanded the UTV footprint across Southeast Asia, specifically to Singapore and Malaysia, to create television programmes and later, even a channel. Second, back from a trip to the US, and inspired by what Sam Walton and Walmart were doing, as also the success of the home shopping channels, Home Shopping Network (HSN) and QVC, I decided to pioneer 'home shopping' and 'as seen on TV' in India. For our home shopping business, separate from UTV, we were able to bring on board marquee Silicon Valley investors, Draper and Walden. Our third initiative was acquiring a South Indian (Tamil) language channel, Vijay TV, from liquor baron Vijay Mallya, which we grew for two years; we then partnered with Star TV for a 50:50 joint venture to broadcast across all four South Indian languages.

By 2006, the scale bug had bitten us. UTV pivoted to a mostly consumer-facing business; we began our expansion towards a broadcast television network, a movie studio and, eventually, games and mobile. Our kids' channel, Hungama, led to a long and fruitful partnership with The Walt Disney Company. Soon after, we launched Bindass, India's first

youth channel, and a bouquet of three movie channels under the UTV brand. I personally started a business news channel—Bloomberg UTV—tying up with Bloomberg, the number one global name in business data.

UTV's foray into movies started with a few duds; we learnt well from these setbacks, evident in the successes of 2003-2004—*Chalte Chalte, Swades* and *Lakshya*. But our real inflection point was the 2006 breakout *Rang De Basanti*. With our fair share of ups and downs, we created, produced, distributed, or co-produced more than sixty movies over the next decade.

Looking for the next big thing, we also diversified into games—console, multi-player and mobile—for the first time acquiring rather than building. With the sole exception of Vijay TV, everything I'd done until then was built from the ground up and organically.

In February 2012, The Walt Disney Company acquired UTV. I transitioned as the managing director of the combined entity, Disney UTV, till December 2013, when I moved out of the media and entertainment business and into my second innings.

Introduction
Made in India

Entrepreneurship is a journey, not an outing.
You cannot make a deal with yourself by saying, 'I'm going to try this out for
two years and see.' Entrepreneurship is about living life on your own terms.
Dream huge. And when you do, dream with your eyes open.

Failure fascinates and intrigues me.

I've never understood why people are so afraid to fail. Or why they hesitate to stretch for that next rung on the ladder of life just because they might topple over.

Failure is a part of life. Everyone fails. I know I have. More times than I can count.

I am routinely asked questions about my various entrepreneurial experiences, and most want to hear about the successes. Why don't they ask about the failures? It would give me more to talk about.

Just one early example: My first Bollywood film, *Dil Ke Jharoke Main*, was such a flop you've probably never seen it. Nobody saw it. Or at least no one will admit to it. But the lessons I learnt producing that film propelled me forward in that part of my business and gave me the learnings I needed to thrive, not just in cinema, but in managing creativity and believing in my own convictions and gut.

After growing UTV for a few years in the late 1990s, we wanted to expand into broadcasting and the movie business. What we ended up with in that first effort was a perfect storm of questionable movie-making, one that traded on every Bollywood stereotype under the sun: a villain, a hero, a love interest, six songs and three long hours of celluloid.

Here's how bad it was: I refused to see the movie in the preview theatre. Instead, I had a system built in my bedroom so I could watch and cringe alone. Back then in the movies, I lacked the wisdom to follow through on my intuition. I was labelled the odd guy out, a South Mumbai Parsi with a perceived tenuous command over Hindi, surrounded by people who kept saying, 'This is the formula that works.' I sat with the director of *Dil Ke Jharoke Main* several times to persuade him to consider a few cuts. By our last trip to the editing room, it dawned on me that no matter what we did, the film was going to bomb.

My 'oh god' moment in the movie was a scene of a cobra drinking milk, a scene that drags on...and on. I couldn't for the life of me figure out why it was in the movie, except that the director insisted that the cobra was a good luck charm.

What the hell, I thought, *if it's going to be a disaster, I may as well go with the popular consensus. Who knows? Maybe it could work.*

So how did the cobra's good luck charm work for us?

The film cost ₹100 million to produce (about ₹450 million in today's terms). We lost it all.

What does a person take away from such, or any, failure?

In business, as in life, failure can be a stronger motivator than success. Get that failure out of people's minds quickly and focus on moving forward, and you won't see that experience as 'the end of the road'.

We countered failure every time with the complete conviction that, no matter what else happened, we would succeed. That attitude got me through many of the lowest moments in my professional and entrepreneurial career.

◆

I wanted to write a book for those who share my passion for entrepreneurship, leadership, winning and dreaming of a better future. I believe in India's entrepreneurial spirit because I have seen and experienced its unbridled power. I believe in the boundless potential of our still nascent ecosystem. I want my country to realize its full strength on the global stage as a world leader in ideas; I want to see a nation of people who think big, innovate, work hard and follow their dreams. And I believe you—and *we*—are the future of entrepreneurship in India.

All through my career, the entrepreneurs, leaders and intrapreneurs from companies in India and around the world—who I've been fortunate enough to know, meet, learn from, or mentor—are inspiring, generous and, above all, cool. They love and savour the rush that comes with flying as high as their wings will carry them.

For me, this book is all about demystifying failure, inspiring success, raising ambitions and dreaming big. As I brainstormed the book's title with a few colleagues, one asked, 'Ronnie, what's your view on the notion: "If you can dream it, you can do it?"'

My immediate reaction was, 'Sure, but you need to be wide awake, then and always. And you need to do it with eyes open, not closed...' Then, I knew we had the title for the book.

My sharing here is about staying real, practical, feet-on-the-ground and focused. So *Dream With Your Eyes Open* is the perfect blend of the 30,000-foot view, when you're flying and thinking big, and the ground view, where you're walking the talk and making it happen.

If you've ever had an impactful, disruptive product or business idea, been curious about owning your own business, or have already taken the first steps on your entrepreneurial path, this book holds insights for you.

If you've been running your own company for the last seven-odd years, and scale, brand and value creation are some of the issues you confront, keep reading.

If you think your parents or family would freak out if you dared to suggest ditching your safe haven—your professional job—to pursue your dreams of owning your own business, relax. Better yet, share this book with them.

If you're an experienced professional ready to take a plunge into your own business or simply dedicated to continuing as an effective leader in the company, read on.

In all these cases, this book shares experiences, failures, successes and anecdotes that can provide you with insights and give you a fighting chance when it comes to team-building, mentoring, growing a business, surviving and succeeding in a David-versus-Goliath world.

Dream With Your Eyes Open is as much for those who are a decade or more into their entrepreneurial journey as for the fence-sitters and the ones just embarking. It doesn't matter if you are twenty, thirty or forty—age is not a deterrent. After all, I'm in my fifties and looking to start all over again, taking on more challenges and opportunities in my second innings. It's never too late, or too easy.

◆

Harnessing India's enormous entrepreneurial energy in an age of opportunity hinges on a simple but axiomatic truth: The future belongs to those who realize that the goal is no longer teaching talented people how to *get* a job but how to *create* thriving businesses as entrepreneurs or intrapreneurs/professionals in a company. If we master this, India will soar. If not, we will languish. Either way, the old way of thinking— that a solid education ensures a life of stability and security—is quickly evaporating.

Creating a successful, growing business is not nearly as daunting as you might think. Sure, it requires grit and hard work. But that's true of any worthwhile endeavour. Why should that stop you?

The good news is, you couldn't have chosen a better time to kickstart or grow your entrepreneurial ambitions. This statement may seem counterintuitive, since every three years we hear of rising youth unemployment or a sluggish GDP, some global slowdown, or clouds of war. But there's a golden glow in the midst of such gloom. I'm optimistic that this next decade will bring opportunities to the determined and the bold. Today is not the age for sitting on the fence and wasting precious time. After all, the size of our population and the energy and momentum of our economic ecosystem mean millions of

low-hanging entrepreneurial fruit, ripe for the picking.

Many people contemplating entrepreneurship assume they have to conjure up grand, complex, original ideas like Twitter, Google or Instagram. But the reality is, many of the most successful entrepreneurial ventures out there today are equally disruptive, innovative and scalable, or involve fairly straightforward products or services.

So many sectors just starting up have incredible headroom—from health and wellness, to agriculture and education (with or without technology), to Indian consumption, to all those unimaginable sectors, markets and demands that will open up from rural India as we integrate those areas into the whole ecosystem. These businesses may not sound as sexy as a Silicon Valley startup, but they stand to create wealth for those confident and driven enough to recognize and seize these opportunities.

◆

As I started writing this book, I couldn't help but wonder why, after six decades and more of independence, we still remain a developing country, lagging behind most of the world's economies. We are quick to lay the blame on the government, our environment, the world order—everything but ourselves.

As leaders, entrepreneurs, innovators, scientists, professionals or sportsmen, we need to *communicate* and evangelize our passion. On the world stage, we consistently undersell ourselves. Instead, we must stand firm in our conviction that the quality of any product, service or idea that comes out of India has to be world-class. What I'm advocating is nothing less than a mindset and a DNA change for each one of us. Achieve this, and nothing can stop us or slow us down.

In the following chapters, I talk about innovation and scale; staying the course after setbacks (what most think of as 'failure'); what it feels like to be the outsider and yet succeed; the importance of spotting trends, building brands and creating value; and planned (or unplanned) exits, among many other topics. I end with a Q&A, listing the most common questions I hear when discussing entrepreneurship on a

daily basis with both aspiring entrepreneurs and those with years of experience under their belts. Throughout, I share my personal experiences, my learnings, a few of my successes and some of my many, many setbacks.

It has been a fabulous journey so far. And it's a journey you can take, too, as long as you have unbridled confidence in yourself and in your ability to succeed, and as long as you find viable solutions to the inevitable roadblocks and move on.

Entrepreneurship is about living life on your own terms. Time is short. Even with the right ideas, a tireless work ethic, the gift of the gab, a solid network, the ability to hire well, family support and funding— even with all those variables working in your favour—things can go sideways in the blink of an eye. There are no guarantees in business or life.

But if I had one bit of advice to give every colleague, leader, CEO, entrepreneur or founder, I know what it would be:

Dream huge.

And when you do, dream with your eyes open.

1

From Grant Road
to Breach Candy

Risk isn't about rushing headlong into uncertain situations. That's just foolish behaviour. Risk means pushing the envelope when others want to take the safe route, and caring more about potential rewards than possible losses.

In the 1970s, Mumbai (then Bombay) was a whirl of motion, noise and colour. A million kirana stores lined the streets (this hasn't changed much), with honking Ambassador cars, trolley buses and autos jockeying with cycles for space on the narrow roads. There was music, art, literature. People with big ideas and hopes for the future. Then, as now, the city was a crucible for a young entrepreneur with a dream.

As a boy, I soaked in every aspect of vibrant Mumbai like my life depended on it. Back then, India was much more a manufacturing and agricultural economy, and I paid special attention to the economics of business—how family businesses were on the rise, how money changed hands, how businesses appeared one day and disappeared the next, how out of five shopkeepers selling exactly the same hardware, one

succeeded where the others failed.

My childhood at Grant Road, next to Novelty Cinema, was lower-middle-class—we weren't wealthy, but we had what we needed. We lived in an apartment situated on the first floor of the five-storey Arsiwalla building, nearly a century old and in constant need of repair. It had one long corridor with three rooms that held my brother, parents, two aunts and grandparents. The apartment's sleeping area was indistinguishable from its other rooms. I recall begging family members to switch with me so their bedroom could become the de facto living room for a while. I lived there until the age of sixteen, privileged enough to go to a school where most of my classmates came in cars while I waited forty-five minutes for the B.E.S.T. bus to arrive.

Instead of undermining my confidence, my childhood instilled in me philosophies and ways of thinking that stuck with me later when opportunities kicked into warp speed. Risk was a word I knew, but couldn't define. I was keen to observe adults who traded goods on the street every day, shouting offers back-and-forth. Ideas washed over me like the July monsoons (though that didn't mean my eyes weren't also open for the neighbourhood's attractive young girls).

That ecosystem spurred my first entrepreneurial experience. All of us local kids from the building got together and hung a drop curtain, and, with handbills, invited audiences for the four play-cum-concerts we put on in the evenings, rotating the performances in our various living areas. I enjoyed bonding with my friends, and their parents were thrilled to have their kids doing something productive. Everybody in the building paid to watch us. Their kids were in it, how could they not? And at the age of ten, I earned my first round of money. It wasn't much, just enough to hire a cycle to earn me a date with a girl who lived just behind us at Balaram Street.

Those first shows led to other projects, each a little more complex than the last. My family's small veranda overlooked the cinema—at that time one of the city's top movie halls. Because no one had television then, red-carpet premieres were a huge spectacle. Bollywood advertised its films by gathering everyone for twice-a-month events and waiting for the stars to come out. Newspapers did the rest, splashing flashy

front-page photos of the industry's most glamourous personalities—Amitabh Bachchan, Jitendra, Rajesh Khanna, Sharmila Tagore, Helen, Nutan, Manoj Kumar, Waheeda Rehman and a host of others.

The roads around our apartment were chock-a-block for every premiere, and our veranda was the ideal vantage point for anyone who wanted to see the glory of Bollywood. Realizing that there was a market for balcony seats, I sold tickets to people who wanted to gawk and point at their favourite stars and snap pictures they'd proudly show their family and friends.

I was tempted to make more money by offering snacks. My grandparents frowned upon food service, the first setback in my entrepreneurial career as a ten-year-old. Still, they and my parents humoured me and were pleased by my ambition—even if they drew the line at fifteen strange people on their veranda.

Small stories, sure, but those are the moments that shaped my entrepreneurial spirit. No magic formula, no groundbreaking idea, no inside family track or connections. But my childhood at Grant Road was a time of infinite possibility; it whetted my appetite to break out, dream big dreams and, sometimes, watch them unfold on a scale larger than I could then imagine.

◆

Without doubt, the greatest moment of my adolescent entrepreneurial life was a rock concert organized in the mid-1970s when I was eighteen. According to our parents, rock-n-roll was a sign the world was ending. Still, young India's interest in Western music was on the rise. Calcutta was considered a centre for the country's music culture at the time, though no shows of any magnitude had been produced. Some friends and I wanted to bring attention to Bombay.

We invited four groups from across India to come to the city. It was an ambitious project, the first multi-city music fusion show the country had ever seen. We sought out the largest venue and booked it—the 3,000-seat Shanmukhananda Hall, huge for its time and, as it turned out, the source of our downfall.

We sold 1,500 tickets at ₹100 each. Half the hall—not a bad crowd—

and sponsors helped defray the costs. None of us had organized an event on such a grand scale before, so we went to town with the special effects. As the event neared, costs escalated. But we were an enthusiastic lot; we wanted to put on the best show anybody had ever seen in India.

Happily, the show went off without a hitch. The word-of-mouth reviews were superb. We had pulled out all the stops, given people what they wanted, rocked and rolled. In all that, we had succeeded.

But when the lights came up, we were ₹50,000 in the hole. Even divided amongst three of us, it was still a massive sum for me at that stage. I was bankrupt. It took me the better part of a year to pay off my share of the losses. I felt the sting of debt and learnt what it meant to ask but not beg. I got a third of my share by going separately to my parents, aunts and grandparents, and a third from two girlfriends. The last third tested my hunger and resilience, the part of me that said, *I'll keep going and the next idea will be even bigger and better.*

Having done some front-of-stage hosting, I felt I could pitch to be a model in an advert. I had heard that models got paid a decent sum for a couple of days' work, so here was my opportunity to pick up a possible ten grand, wiping out my losses in one swipe. I cold-called most of the city's advertising agencies, but had little success after three weeks and ten meets.

Despite the rejections, giving up was not an option. A week later, I walked into the office of Lintas (now Lowe Lintas) to do the same routine with the model coordinator there. This time, there was a short line of talent auditioning for voiceovers, so I wiggled my way into the audio studio for the test—an advert for a chocolate brand. Once there, I had no clue what to do. The test took all of five minutes and the wait outside afterwards seemed like an eternity.

Eventually, a lady I would come to know later as Usha Bhandarkar, the agency's creative head, approached me. I assumed she was coming to me with bad news. Instead, she told me I had got the assignment. The final recording was in a few days. A week later, for delivering one punchline, I was staring at a cheque with my name on it. A great start to my coming-of-age at eighteen—one amongst a few other moments in those early days when I knew and felt *I can do this.*

As enjoyable as the voiceover work was, my learnings from the failed music show were quick and painful and remain an integral part of my entrepreneurial DNA—a DNA that insists: *Just be convinced; be confident and go for it, and I'll figure out where the money will come from.* Financially, the equivalent of skydiving without a parachute.

When I hit the ground, though, I couldn't have felt better about things. The money would take care of itself, of that much I was sure. But for the next few nights, I slept little, wandering the streets of Bombay at all hours, thinking only about what I could do bigger and better, and this time call my own. My desire was to be my own boss— to set a challenge and achieve it; to stretch an idea pole to pole, east to west, and take it to scale.

Risk isn't about going headlong into situations where the outcome can't be predicted. That's just foolish behaviour. Risk means pushing the envelope when others want to take the safe route. Risk means caring more about potential rewards than possible losses. To separate yourself from the crowd, think through the worst-case scenarios as possibilities. If a worst-case scenario does become a reality, be just as willing to move on to bigger and better things.

In my later work in cable television, media, toothbrushes and more, I recognized my adolescent self, the long-haired kid with too much energy and no fear, bursting with the 'leap first, look later' mentality.

One of the questions I'm most often asked by would-be entrepreneurs is, 'When do I take the leap?'

I've never come up with a better answer than, 'Who knows better than you? You're the only one who can decide. Based on your best guess, backed by logic and intuition, your research and the support of people you trust, when is the best time?'

Maybe a better question would be, 'How do *you* visualize your leap?'

For the most part, I'm proactive, not reactive. I'd rather jump than be pushed. It's the *Rocky* or *Dilwale Dulhania Le Jayenge* moment, with the inspirational music and the push-ups. The motivational montage and the run-up-the-steps. The freeze-frame ending, arms raised in victory or the hand held out for an eternity from a train leaving the station. In both scenes, there's a supportive family, the kiss on the cheek, and the

whisper in the ear, 'Go for it...and *win.*'

Then you come back to reality and realize you have one hell of a lot of work in front of you. And you're equal to the task.

◆

I have my parents to thank for supporting me during those early days. Their support was never monetary, but they understood that creating something of value could be a noble enterprise. That's an important point to make, since so much of an Indian family's hesitation to consider entrepreneurship as a viable option seems to hinge on finances. I never worried about *what happens if I fail?* Instead, I focused on *what's the worst-case situation if I did?* When asked why I wouldn't get an MBA or a chartered accountancy degree, I'd reply, 'The process is just too long and it's not what I want to do.'

Let's be clear here. I am all for deep studies and more if you plan to be a specialist. That's a personal choice. I think studying accountancy, for instance, is huge, a long journey that teaches one of the most important lessons we can learn in life: *Stay the course.* My brother did his MBA and a PhD in human resources. I have always respected his complete clarity of thought and his determined pursuit of goals.

Over the years, though, I came to understand and appreciate how my attitude towards entrepreneurship caused my parents massive levels of worry and concern. In most other families, the friction and irritation would have been evident, maybe irreconcilable, but my parents were kind enough not to show it. Rather, they respected the fact that I was reaching for my dream. On my part, I knew that if I ran one of my ideas into the ground, they didn't have the resources to bail me out.

I was fortunate to have their steady, mostly unspoken, support. But one of the greatest challenges still facing Indian entrepreneurs is buy-in from family and friends. Even today, when the rest of the world is waking up to the untapped potential of entrepreneurship, the country's ecosystem is such that parents think their children should get jobs, not risk the family's money and reputation on a pipe dream.

This might surprise you: I can't say, on balance, that I disagree with many of the naysayers. Not everyone is cut out to be an entrepreneur, a

difficult endeavour under the best of circumstances, one not made any easier by India's culture of deference. Many young adults respect their parents too much to go against their wishes.

Still, the millennial generation tends to think their parents don't understand the new culture. Just because the previous generation did things one way doesn't mean those methods are effective, relevant, or even possible in today's lightspeed world. That mould needs to be broken.

Ask anyone for a definition of a first-generation entrepreneur. Chances are, you'll get a blank stare or a wrong answer.

India has its own built-in risk component, and the country's existential economy doesn't guarantee a ready market for entrepreneurs. So, when Indians launch innovative, disruptive ideas that would rise like rockets in many other countries, in India, they need to understand the market inside out and prepare to work hard before seeing a profit. Also, they cannot forget: Success is possible, and not all success is measured in millions and billions.

I started UTV with ₹37,500, good for basic rent and some salaries. The business needed to generate positive cash flow from month three. For the first five years, there was no external funding, no ecosystem in place where I could land without crashing if things didn't go as planned. There was no option in those early days of attracting venture capital or private equity into the media and entertainment business, as no one understood its potential. The business had to pay for itself. Cash flows were always stretched, but we remained positive.

◆

The possibility of failure must never faze you. The sun will rise in the morning whether your idea pans out or not. What I do have a problem with is putting a time limit on going out on your own. It's a journey, not an 'outing'. You can't make a deal with yourself or your family by saying, 'I am going to try this out for two years and see.' That mindset is a complete recipe for failure.

Nor does age have much bearing on the success or failure of most entrepreneurial endeavours. People often ask me, 'What's the right age

to begin thinking about entrepreneurship?' My initial response is, I don't remember a time when I wasn't thinking about building something of value. Don't worry about age so long as you go into any endeavour with your eyes open, a reasonable plan, your bullshit detector fine-tuned and your work ethic operating at peak capacity.

Conventional wisdom suggests that the older you get, the lower your ability to take risks and, in many cases, the more adamantly your family, spouse or kids will question your career choices. Logically, this might make sense. You've got more fixed overheads. You're likely looking after more people than when you were single. But that's not a big deal, because those negatives are offset by the life experience you've picked up along the way and the shortened learning curve for someone who knows a lot more about how the world works.

Bottom line: The right familial situation or age to jump is when you feel confident, driven and ready to jump. Most impediments to entrepreneurship are put in place by people who don't have the imagination to dream. Go into every fight certain you're going to win. As General George Patton once said, 'No bastard ever won a war by dying for his country. He won by making the other dumb bastard die for his.'

The fact is, after a relatively brief period, you'll know whether or not you're cut out to be an entrepreneur. If you're chugging like a freight train in a positive direction, no one will tell you to stop because your family doesn't approve or you've aged out of the market. You'll have no choice but to keep working to reach your goals.

That's why you're an entrepreneur.

◆

Jump or get pushed.

When learning to swim at the Cricket Club of India (CCI) pool at the age of eight, I struggled to learn from the coach. One day, out of the blue, my dad picked me up and heaved me into the deep end. No floats, nothing. I went down and came up...down and up, again. Beat the water. And after a few seconds that felt like forever, I managed to surface and stay there, much to my father's delight.

Problem solved. From then on, I swam.

Three days of pussyfooting around the pool, when all it took was half-a-minute of intense concentration and maybe a little fear, followed by the realization that nothing bad was going to happen! In retrospect, I remember two things about that day: (1) if you're half smart, you'll figure out how to survive; (2) far from being mean or neglectful, my dad, who was fully clothed when he grabbed me and dunked me, exhibited the greatest confidence in my ability. He somehow knew that, while I might swallow some water and sputter, in the end I would be fine.

I recall a similar incident with my own daughter, Trishya, many years later. Two-and-a-half at the time, she walked straight into the pool on her own with no idea that something bad might happen. She disappeared into the water just as I put down the book I was reading on a deck chair. Panicking, I jumped in fully clothed, grabbed Trishya and gently placed her, petrified and shaking, at the edge of the pool.

An hour later, I took her back to the pool to underplay her bad experience. My concern, of course, was that she would fear water for the rest of her life. Instead, she became an ace swimmer, top of her class and school, a certified scuba diver and more comfortable in water than anyone I've ever seen.

Because of her young age, I don't think Trishya completely remembers the trauma. But a lifelong fear of the water—or a powerful fear of anything, like failure—can change your attitude towards a lot of life's experiences.

Trishya and I laugh about the incident now. She thinks I overreacted. I tell her that's what parents do. I'm not quite sure if I meant the saving, the overreacting, or both.

◆

My first big setback, a literal failure, came early in life. While we lived at Grant Road, my schooling was at Dunnes Institute, a place that holds great memories for me. When we moved to Breach Candy, I also moved schools, joining Cathedral School in Class VII.

At Dunnes, I got teased a lot about my unique last name. Since it was mainly a boys' school, I wasn't too affected by the leg-pulling. But

when I moved to Cathedral, I knew I had to convert my last name to my advantage—partly because I just wasn't ready to start all over again with the ragging, but mainly because it was a co-ed school. So from the outset, I broke the ice with jokes about my last name (just how Parsis make the corniest jokes about themselves). It worked. The girls thought it was funny and charming (I think). And I had taken the sting out of the joke for the boys. Since I was already making a joke at my own expense, there was not much they could add.

I was a good student. In those days, the final exam was not in Class X but Class XI; the latter class was called 'Senior Cambridge'. A good grade in that class allowed one to jump a year ahead in college. As it happened, I did well enough in my last year at Cathedral to move straight into the second year of my bachelor of commerce (BCom) degree at Sydenham College. (Even back then, I realized that a BCom was a fallback pursuit for me.) That was a memorable year—straight out of one of the country's top schools with great marks, to being involved with many of the college's high-profile activities.

But I was on a crash course for arrogance. I knew it all, and spent too much time hanging out at the nearby St Xavier's College, where the smartest girls studied.

Then came the wake-up call.

The year was over—exams completed, vacation enjoyed. I sauntered back to Sydenham to look at the notice board for my results, certain I had secured nothing but the highest marks. Sheer arrogance compelled me to run only through the list of those in first class. When I didn't see my name there, I scanned the roll more carefully.

Nothing.

My heart pounded in my chest. *Surely, there's been a mistake*, I thought.

No mistake. An hour later, I realized I wasn't on *any* list. I had failed the year. Disbelief led to denial as each and every one of my friends and colleagues found their names on the first class list.

Then the reality sank in.

My first thought was: *My parents have made sacrifices to put me through college, and I let them down. This is the end of the line and the end of the world for me.* I had failed. All my friends would move on. A year wasted. Maybe

I would be forced to drop out. This failure would be on my CV and haunt me for life.

A day later, my parents were shattered. Curiously enough, I was not.

Sure, my ego and self-confidence had taken a whacking, but I was determined to get past the failure and learn from it. Isolated from my friends, I put everything I had into taking the classes again, to prove a point to myself as well as to set the record straight. I passed all the subjects I needed to reappear for, and was all the more proud for having done so. And those six months gave me time to think about what path I really wanted to take.

One would think that after having suffered such a failure, my confidence and clarity would have ebbed. Instead, I felt more confident than ever before—I wanted to do something on my own. And from that point on, I learnt to never take anything for granted. Ever. The reality check I got during those six months has given me my favourite motto: *All glory is fleeting.*

When it was all over and I had settled back into regular college, certain that the failure in my second year would never be repeated, my friends and I laughed about my misstep. In fact, one of the most enduring lessons I've learnt about entrepreneurship, and life in general, is the value of laughter. To take an event we initially thought might devastate us—something awful, horrible or disastrous—and redefine it for ourselves with a sense of fun, pride or humour is to take the sting out of it, to put it in its proper perspective.

I can't count the number of times over the last twenty-five years I've reminisced with one of my team members about a screwed-up project, laughed and said, 'Oh, remember what happened? God, we thought we were dying.' While at one point we may have felt that things would never be the same again, time and distance grant us perspective and smooth over a lot of those rough edges. So, often fears can be defused by thinking: *Six months from now, we're all going to laugh about this.*

◆

• It really does not matter what socio-economic background you come from, if you are from a big city or a small town, or if you have family connections. As long as you have the hunger to succeed, innate confidence in yourself and in your abilities, the guts and conviction to take sensible risks and a can-do attitude, you will prevail.

• There is no 'right age' to become an entrepreneur, and no one, except you, can determine when you're ready.

• Entrepreneurship isn't for everyone. Even if you are a leader in a company and looking to cross over, you need to make a frank assessment of your ability and your desire to succeed.

• I was bankrupt at eighteen, failed college the same year and it could have been the end of my dream for me. I chose not to let that happen. Never start thinking: *What will happen if I fail?* If you're half smart, you'll figure out how to survive.

• Never underestimate the power of humour. Laughter makes life's darkest events conquerable.

• Entrepreneurship in a nutshell: action and reaction; understanding, confronting and transcending fear; working, disrupting and succeeding; trying and failing. And then laughing about it all later, while absorbing lasting life lessons.

2
Opportunity Knocks, Open the Door

When you're new in business, ask questions without worrying about what
people will say or think. At worst, they might say no. When you start from
scratch, you've got nothing to lose. Setting your laser sights on the goal doesn't
allow insecurities or manufactured fears to get in the way of your dream.
You can't let that happen.
You won't let that happen.

One of my first forays into business was hardly a romantic fairy tale. Nor did it come with the high-adrenaline rush of my later entry into the media. Rather, my creation of Lazer Brushes in the early 1980s was more about balls than brains. Lazer Brushes didn't come about because I had a brilliant glimpse of insight or had hit upon a unique idea whose time had come. It was born and succeeded because I recognized the growth potential for a simple product that offered to fill a vacuum in India's growing market. That, and the fact that I was young, hungry and blissfully naïve—so much so that I did not let my inexperience get in the way.

In my early twenties, I did some front-of-television anchoring and had flown to the UK to learn more. Back then, my dad was the managing director of a company called J.L. Morrison, the makers of Nivea cream, hairbrushes, toothbrushes and other personal-care items. As fate would have it, my dad was in London the same time I was. He invited me to tag along for the Addis hair and toothbrush factory tour.

As we stood in the corridor waiting for our guide, I spied what appeared to be two brand-new machines waiting to be installed in the factory's toothbrush line. The units were of drab grey metal, broad, two metres high and a metre wide. Not imposing, but solid and built to last. They were like nothing I had ever seen in India. I asked our host, who had just arrived, when the machines would be installed. He looked at me as though I had gone mad. 'Those are headed to the scrap heap,' he said with a shrug.

What looked like new machines to me had actually been cranking out millions of toothbrushes for two or three years. So, as is typical of Western companies, it was time to get rid of them. 'Scrap?' I asked, incredulous. 'They're only *three years old!*' Already my mind had drifted to dreaming. Obviously, if that's what he called scrap, he didn't know much about India's business ecosystem in the 1980s. In the UK, machines were considered old before they had even been broken in; back home, they would be cutting-edge technology.

Right then, I knew I had to make him an offer. 'How long can a machine like this last?'

He thought for a moment. 'Ten or twenty years, I suppose.'

My eyes widened. 'Could you hold these for me for sixty days?' I asked with a smile. Everyone in the room looked at me sceptically. After all, in their eyes I was a twenty-something kid. Still, they politely agreed to let me inspect the machines. At the very least, they must have thought, this would shut me up.

◆

Those were the early days, when I wasn't always clear about the future. I didn't know much, but I knew I wanted to be an entrepreneur.

What I understand today is that entrepreneurs are built from the

ground up—by immersing themselves in the world and taking more than a few shots on the chin before succeeding. Today's entrepreneur needs to be more fundamentally rounded than those starting out ten or twenty years ago. She needs to get the big picture faster, quicker and better than anybody else in the room so she can make commercial sense of the information in front of her.

My own background didn't suggest any great acumen with figures (I'm Parsi, not Gujarati or Marwari), but I had an innate curiosity and a desire to understand the world around me, to make sense of the long-term implications of business transactions, to get a 360-degree perspective on things. All these are key to recognizing opportunity. When you open your mind to really seeing and pursuing opportunities, you'll find them. The higher your antenna, the keener your observation skills and your alertness; the more open and curious you are, the more likely you are to find an idea worth pursuing.

That's when opportunity strikes like lightning.

On that visit to London, I was open to any and all experiences and had zero agenda. I've been in that stage ever since—open, disruptive, curious. And there I was, standing in a British brush factory, staring at two bulky, grey, state-of-the-art toothbrush machines without a rupee in my pocket, no clue about the oral hygiene industry, and no strategy to import those hulking boxes back home.

◆

At that time, India still had a serious foreign exchange balance of payments issue, so second-hand machines could be imported. We made the numbers work and the deal was accepted, but only after a bit of frustration on the seller's part when I asked him to hold the machines for me for a month or two. He tilted his head and looked at me as if to say, *Who is this guy? And why is he giving me this huge headache?* I guess, out of kindness to my dad, he decided to be supportive.

Importing the machines and getting another decade or more of production out of them in India made perfect economic sense to me. At that time in India, in certain sectors, multinationals (MNCs) outsourced production to local entrepreneurs and small-scale industries

as they couldn't themselves set up manufacturing. *Wait a minute, I thought, the companies making toothbrushes are Procter & Gamble, Colgate and others. They can't make these on their own, so they must be outsourcing their orders. That means there's a market for our product!*

As soon as I hit the ground in Bombay, I went straight to them like a bull in a china shop, to convince them to contract us to make toothbrushes.

Simple as that, right? Wrong.

I was diving headlong into business sectors that I knew absolutely nothing about. I could have scrawled every bit of information I had about the toothbrush industry on the back of a business card, with room to spare. But half of everything is logic and intuition; the rest is deep knowledge, research, expert opinion and data-crunching. I knew where to find the information. For the first time, I trusted my intuition—the single trait every entrepreneur possesses—to seize the opportunity.

Without resources, funding was my next hurdle. Today, when I hear aspiring entrepreneurs share their worries about their first funding, I remember the feeling all too well. But the truth is, your first funding is the easiest. Bigger deals that require more capital come later in life, when there's much more riding on the line. So back then I did what I recommend to all would-be entrepreneurs: I found a way or made one.

I fought like hell to get appointments with companies, leveraging every ounce of influence I had in Bombay. To my delight, they were immediately interested in the machines' advanced technology, a first for India. 'Get the machines so you can begin production. What else do you need?' one executive prodded, anxious for us to get things up and running.

At the time, the machines were still sitting in a London brush factory. That's when I mustered the courage (or insanity) to ask for a purchase order. 'A purchase order?' one of the business suits barked. 'You're not even *in* business! You need to *exist* first and be listed on our register before we can make a move.'

'What will that take?' I asked, straining to mute the exasperation in my voice.

'Get yourself registered as a company, and give us your whole plan.'

I was learning as I went, using my youthful exuberance as a cover, to ask for things no seasoned pro would have asked for. When you're new in business, you can get away with such things. When in doubt, always ask questions without worrying about what people will say or think. Hell, what's the worst that can happen? They'll say no? Who cares? When you're starting from scratch, you have nothing to lose.

The business suit eventually relented a bit by giving me a 120-day letter of intent—not a purchase order—which required us to manufacture the brushes with the promise of later orders if the sample products were up to their standards. That meant we would still have to foot the cost of production.

So what did I do? I made the audacious request for an advance payment.

The answer was a flat 'no'. But here's the thing: my willingness to fight for an extra advantage and scrape for extra capital communicated my seriousness of purpose and focus on achieving the goal. Still, with all that, I hadn't cracked the code on landing capital.

Fortunately, the banks were willing to work with me. My collateral was the machines and my personal guarantee (which, at that point, was worth exactly zero). Venture funding just wasn't there, but banks had quotas for loans that had to be disbursed to small- and medium-scale manufacturing. With our blue-chip prospective clients and investment in high technology, we were viewed as safe customers.

In those 120 days, I needed to find a colleague, co-founder or CEO (since I was clear this wasn't going to be my full-time occupation); identify a technical director, woo him from an established company and dispatch him to the UK for two-weeks' training; recruit a core team of workers; understand everything about oral care; learn about the business of manufacturing toothbrushes; work out how to source plastic, moulds, handles, nylon, bristles, wire, packaging and more; scout for a factory location; turn on the power; and secure all the permissions.

I came to understand in those first sixty days of pre-planning that it was not in my DNA to manage a factory floor, the logistics of raw materials and a manufacturing business. Rather, I knew I could best serve the business by building a strong customer base, working

with banks to help us with capital to grow, sourcing the best global technology and, most importantly, backing the team and staying the course through thick and thin.

When the smoke cleared, we missed our timeline by about forty days, mainly due to delays in permissions. But we were in business!

Too often these days, I hear people say, 'I need to do my research' and 'I am doing my homework' as dilatory tactics to put their dreams on hold. Research and homework are vital, but deep knowledge comes from doing, from getting your hands dirty and from asking the questions others are too afraid or embarrassed to ask. Setting your laser sights on the goal and getting to work doesn't allow insecurities or manufactured fears to get in the way of your dream. You can't let that happen. You *won't* let that happen.

Dreaming with your eyes open means being alert to challenges but refusing to let them stop you.

◆

All manufacturing has its ups and downs, and we weren't immune to a lack of orders, and the hundred other things that could kill the business before it got off the ground. Many a times, we'd wonder if it was worth making forward investments in upgrades when our clients could potentially just cut us loose in low-order months. But having the balls to stay with the best equipment saw us through most of our downs. We were proven right: our growing list of clients—seven at our peak— recognized our clear advantage in quality because of our investment in technology.

While the first two machines were from the UK, the number one technology in the world for toothbrushes was from Belgium—so we got that technology on board. Fully automated and brutally efficient, these Belgian machines cranked out toothbrushes at a scale previously unheard of in India and put Lazer on the toothbrush map. In our first year, we started at about half-a-million brushes; over the next eight years, we ramped it up to four million a month, nearly fifty million a year.

We needed to fund this growth, but at the same time our reach could not exceed our grasp. Our most important task was to build credibility

with the banks. They were with us from day one; I felt it made sense to stay with one bank (or at the maximum two banks), to build comfort and convey the message that our interests were aligned. For all our raw materials and overheads, we got working capital limits by collateralizing our receivables, and for our capital expenditure we had five- to seven-year loans serviced from our profits and depreciation. We really did not miss external venture funding and, in a way, we were relieved we never took any.

Over that decade, we grew to scale because we took advantage of the largely untapped Indian market. In India, at that time, toothbrushes were used by less than 15 per cent of the population. (If you're a young reader, this might surprise you!) Most people back then used Ayurvedic tree barks to scrub their teeth in the morning. (Having said that, even today, toothbrush penetration in India is less than 40 per cent.)

The drill throughout my involvement with toothbrushes was a daily morning or evening call with the core team, and a visit to the plant every Saturday—first by train to Thane and, later, as we grew, to Kalyan and then pan-India, to Gujarat and Karnataka. Every weekend was spent at an alternate location.

I was fortunate to have phenomenal team members who kept in close touch with our corporate customers and assured them of multi-location benefits. I started off with a co-founder, Manoj Mehra, a friend from school who contributed a lot during the first two years before he moved out and migrated to North America. At that stage, three colleagues joined to head management, technology and operations. Mohan became our CEO, Murtoza, our operations head and Rusi, our technology expert. With our daily calls and weekend full-day site visits, we were in complete sync with operations, growth and how to deal with challenges. They all stayed till the end. As the company grew, I invited them to become co-founders. That's how we got to scale. And thanks to that core team and the great team under them, I could go on to build a media and entertainment company from scratch.

Team-building is critical at all times, but even more so when you're not involved hands-on. Not everyone you bring on board will perform at peak capacity from day one, some take a while to get into their roles.

But as a leader, you need to give each individual a clear mandate, the freedom to operate and make mistakes, and unstinted support. Treat your team members like colleagues and not employees. Then watch them shine. I say this not because it's a great HR exercise, but because that's the reality guiding a successful business.

Lazer Brushes is one of my best attempts at building a great team: Mohan, Murtoza, Rusi and others had my full mandate and support, had a sense of ownership as co-founders, and the confidence of their customers. They felt more accountable to themselves than to me. And, in a short period, they had become true-blue intrapreneurs. I was only the catalyst and the cheerleader. Mostly, I just put my faith in them and believed in them.

Every day, I draw from the lessons learnt more than two decades ago.

◆

My first major-league leap into entrepreneurship taught me how to spot and seize opportunity, understand the power of untapped markets with no glass ceilings for growth, and see inflection points where others saw uncharted, dangerous territory. I also wasn't afraid to look stupid by asking rookie questions. The sooner you can train yourself to do that, the sooner you'll achieve your dreams.

Make no mistake: those first 120 days when I had to scramble and learn the industry were some of the most intense of my life and the sharpest learning curve I've ever been on, preparing me for many other steep learnings in life. More than once, I thought, *Okay this isn't going to work out. Let us just pull the plug now and find something else to build from the ground up.*

But we didn't.

Stepping into action, staying the course during those months when we didn't have a single order, learning about a logistically complex industry and figuring out how the hell I was going to build a company from only the cash flow generated when I didn't have a rupee to my name—these aspects please me most about the story of Lazer Brushes.

◆

* When opportunity knocks, answer the door.
* Today, more than ever, you need to see the big picture faster, quicker and better than anybody else in the room. I hear of many aspiring entrepreneurs postponing or prolonging their decision-making and growth plans on the pretext of completing their research and 'homework'. The time taken to do this could potentially be an opportunity lost.
* Half of everything is logic and intuition.
* A lack of funding can never prevent you from starting or growing your business. My DNA compels me to just go for it with full confidence that I'll figure out where the money will come from. It's not a strategy or a solution, but an approach. And if well thought through, it can, and will, work.

3
All the World's a Stage

Culture is the lifeblood of successful endeavours. Everything you do and
everywhere you go creates opportunities to communicate in impactful ways.
Great communication becomes a part of a company's culture. The more deeply
it's embedded, the larger the company grows. The larger the company grows,
the deeper the culture.
It's a positive, self-perpetuating cycle.

The family's move from Grant Road to Breach Candy was more or
less permanent, at least geographically. Even after I married and moved
out of my parents' home, for most of my adult life I've lived within
200 metres of our first house there.

Not long after landing in Breach Candy at the age of sixteen, I took
a liking to theatre. Or should I say, theatre took a liking to me. My first
role (of many) on stage was at Cathedral as the Tin Man from *The
Wizard of Oz*, but my most memorable was the lead in Shakespeare's
The Taming of the Shrew—I was Petruchio, the scoundrel who falls in
love with Kate, the female protagonist, and has a wonderful, instructive
time trying to tame her. Even today, when dealing with a difficult
person, I'll sometimes utter, 'Let's go tame this shrew,' and elicit a laugh.

I started Lazer Productions, a theatre-production company, as a hobby. It turned out to be profitable enough to fund all my dates and gave me confidence at a young age. We did some magnificent theatre along the way and made lifelong friends. The productions that stand out for me even today are Ayn Rand's *Night of January 16th*, Mark Medoff's *Children of a Lesser God*, and the musical *The Wiz*. In fact, on the eve of the opening night of *The Wiz*, my daughter Trishya was born. I went back-and-forth between the hospital and the theatre for the first two days. For her whole first year, Trishya was nicknamed 'The Wiz baby'!

Theatre taught me skills that proved to be especially useful later, in television and other creative endeavours. But most of all, theatre strengthened my communicative muscles and gave me tonnes of self-confidence. Few things are as vital for an entrepreneur as confident communication and the ability to stay calm and collected in front of a crowd. As I reflect on the lessons I learnt during those early days in theatre, Shakespeare's *As You Like It* echoes in my mind:

> *All the world's a stage,*
> *And all the men and women merely players.*
> *They have their exits and their entrances,*
> *And one man in his time plays many parts…*

These lines, and the images they conjure, perfectly capture the essence of entrepreneurship. In business, you'll go through many stages and play many roles. But notice that first line: 'All the world's a stage'. No matter what you do or where you go, you must create opportunities to communicate in impactful ways.

Communication for entrepreneurs involves much more than elocution. Communication is a form of currency. And how you choose to use it—the speed at which you understand things, your clarity of thought, and your ability to deliver a strong message, so the audience has no doubt who is leading the show—can boost or burn your business.

◆

Communication cements a company's culture.

That's why I harbour a burning and abiding disdain for mobile

phones at meetings. No joke. Ask my team members. I actually have my executive assistant confiscate all phones at critical meetings. She walks into the room, announces that we offer a free, full-service 'mobile valet', collects all phones, and assures everyone that their devices will be safely 'parked' and protected before whisking the devilish devices away. It's a light-hearted approach to a serious matter.

Few things are ruder and quite frankly more *arrogant* than chatting on or tapping away at a phone and ignoring someone who takes time out of his day to sit with you one-on-one or in a group. The implicit message is that what you're doing is so vital and indispensable that an hour's absence or lack of input could bring doom and destruction to the organization.

Get real.

When arrogance and impoliteness creep into a company's culture, nine times out of ten it's safe to assume that team members have picked up these bad habits from the boss. I know CEOs who think that if they call a subordinate at any time of the day, they should bloody well get an answer. I favour a far flatter culture. For example, if I call a team member at eight in the morning or in the middle of the day, my first question always is, 'Can you speak? Are you free? Good time?' Communicating with courtesy liberates people.

I also go out of my way to avoid making people feel like they've got to drop everything and interrupt what they're doing to meet me at a moment's notice. Instead, I try a simple 'When you're free, let's meet...' True team empowerment cannot happen unless we've established mutual respect.

Attentive and courteous communication breeds a healthy corporate culture.

◆

16,000.

That's how many words the average human speaks a day. This means, this week more words will flow out of your mouth than fill the book you're holding in your hands. Whether it's crafting a marketing or product pitch, presenting a five-year plan, sharing research and

development findings, delivering a pitch for investor capital, or engaging in due diligence discussions about potential ventures, you're always 'auditioning'. Every word counts. Every sentence makes a statement.

Authenticity is at the heart of effective communication, though few entrepreneurs communicate as well as they should. One person who made a lasting impression on me in those early days was News Corp's Rupert Murdoch. After buying Star TV in the early 1990s, Murdoch visited India, and came down to UTV. For him and Star, the two key markets were India and China. So Murdoch, through his visit to Mumbai and to UTV, planned to understand India, local content and more.

We had a frugal basement office, a small audiovisual room and no meeting room. My office, no more than eighty square feet, doubled up as the meeting room when necessary. We were a tight-knit team, keeping things small and comfortable, with plenty of room for people to work without the ostentatious trappings. When you lead by example, you transform the culture of the entire office. A lively office culture doesn't always come from big spaces. In fact, the opposite is very often true. Offices of a certain size breed communication. The concept of the top-floor corner office is archaic and reeks of an isolated top management team.

Every day, I'd talk with every person in the office—in the pantry, in the hallway, while walking to the loo. That proximity didn't *force* us to communicate with one another; it presented us with opportunities for lively dialogue and the ready exchange of ideas. And because everyone in the office knew we were hosting an important meeting, every eye was on the staircase when Murdoch eased down the steps into the basement.

Interestingly and much to my relief, neither his body language nor his gestures betrayed the least surprise or disappointment. *What the hell have I gotten myself into? I've never been in such a small office! And in a basement!* Nothing like that at all. Instead, his reaction was completely normal. I think that's the first-generation entrepreneur in him. He must have descended into quite a few basement newsrooms in Australia; clearly he hadn't forgotten the 'can-do' culture of entrepreneurships.

He was here to do business, and that's what we did. The meeting

lasted two hours, including a ten-minute video on UTV titled 'The Whole Is Bigger than the Sum of Its Parts'. No coffee or tea, just straight talk.

Murdoch struck me as a direct and insightful communicator, speaking his mind with fierce honesty and thumping the table to drive a point home. 'You know I'm here to make big bets.' *Thump.* 'So let's talk about the big things Star can do in India.' *Thump.* But after he had said his piece and someone else started talking, he was in full listening mode. That ability to switch effortlessly back-and-forth from talking to listening reflected a high degree of genuine curiosity that struck a chord with all of us. In the past, I've found that Westerners often come to India with the assumption that the culture, mindsets and attitudes of their home country are universal. Then they're surprised when confronted with acute cultural differences and the inevitable failure that comes from not understanding who consumes a product or offering.

Murdoch valued words. He was a communicator who knew when to speak and when to listen, to make the most of his time and maximize his chances of success. Despite his gruff exterior, he had an innate ability to relate to others and the uncommon willingness, given his stature, to open himself up to people at a personal level.

◆

Disruptive ideas sometimes come from the most unlikely of places and people. You never know when you're going to discover an interesting product, a path-breaking concept or even a brilliant error that could revolutionize an entire sector. Consider some examples from history.

Post-it notes? The result of a botched experiment in developing new adhesives. Plastic? Well, the guy who invented it was looking for a replacement for shellac; he only succeeded in making a mess that didn't have any apparent application, until someone decided it could transform our everyday lives in a million different ways.

Both these 'failures' were exploited by entrepreneurs who understood that good ideas were *everywhere*.

That's why I try to reply to the bulk of over 300 emails that flood my inbox daily. I reply not because I'm running to become the prime

minister of India. I do so for three reasons: to lead from the front and establish an organizational culture that believes in reverts and courtesy; to stay aware, current and ahead of the competition; and to maintain constant contact with what's happening out there. You never know when a valuable idea will strike like lightning out of a clear sky. Keep yourself open to the thousand opportunities that present themselves to you daily.

You're the person who takes the call and responds to the email. You're the leader who seeks nascent ideas you can tap into for your next onslaught or innovation. Collapse distances, internally and externally, through effective communication.

◆

When running a mid-size or large organization, you can't be all things to all people. Great leaders will never be the most popular people in the office. But you need to be inclusive and set a culture of openness in communication from day one. The more deeply embedded this culture is, the larger and stronger the company grows; the larger the company grows, the more embedded this habit becomes. It's a positive, self-perpetuating cycle.

What should your daily communication goals be?

To begin with, befriend, get close to, earn respect from and inspire. But the true heartbeat of communication comes down to a word often used but seldom understood: charm. Most people think of the charmer as an outrageous flirt, a dashing character who could give Shah Rukh Khan a run for his money, or the cool lad with a great sense of humour. (By the way, Shah Rukh, besides being a charmer, is one of the smartest people I know and a true entrepreneur.)

Charm for me is the ability to persuade with your tone, your willingness to be inclusive in your engagement with everyone in the room or on the call, and your knack for being clear and articulate with your message. Disarm your audience by always listening keenly to everyone's views and sprinkling some humour into even the most serious situations.

But I don't have the gift of the gab, you lament. *Does that mean the*

entrepreneurial or professional life is off-limits for me? Of course not. Maybe you're not a natural orator. Or perhaps your confidence level isn't as high as you want it to be. My advice then is to hold on to those subjects about which you feel confident.

If you're assured in your knowledge, that's half the battle won. Now all you need is a communicative vehicle to deliver that knowledge, maybe a razor-sharp, well-crafted email. The point is, you don't need to enrol in an elocution class or become a world-class communicator. Rather, you need to utilize the mode of communication that allows you to showcase your strongest skill set. For me, this has always been straight talk, eye contact and brief, punchy sentences. If you can't get to the point in short order, chances are no one will stick around long enough to get your point, no matter how important or relevant it is.

◆

Of all the roles in theatre I have ever immersed myself in, the lead in Mark Medoff's *Children of a Lesser God* was the most challenging and taught me lessons in communication that I draw on every day. The play is a demanding two-and-a-half hour soliloquy during which the teacher, James Leeds, and the hearing- and speech-impaired student with whom he has a romantic relationship, Sarah Norman, communicate through sign language. Leeds speaks to his student and then translates her responses from sign language to English for the audience. If I sat down with a hearing- or speech-impaired person today, I'd still be able to communicate with her.

Since I 'read' Sarah's responses for the audience, I had to say her lines in one tone of voice and then my lines in another. Except for a couple of other characters who popped in and out, the two of us were alone on the stage, exposed. My job was to take the audience on an emotional roller-coaster ride using nothing more than words—the purest act of communication.

Children of a Lesser God taught me sensitivity in communication at a point in my life when it was important and necessary for me to understand how to connect with people. It also taught me focus. To prepare for my most difficult role, I used to sit quietly for an hour

backstage before going on, knowing the part demanded and deserved a level of preparation remarkable even for theatre.

Great memories, indeed. I think back on all my roles warmly, with some nostalgia. My mom and dad watched me perform often, and I always appreciated their support. Even now, forty years later, Mom admits that she has only one regret for me. 'Now that you've done all this, why don't you go back to theatre?' she asks. 'I wish you had never left.' She is wistful in tone and speech, the way only mothers can be. She's proud of what I've accomplished, but she remembers my early days as fondly as I do.

'I don't have time,' I tell her. And I suppose that's true. Maybe I *don't make time* would be more accurate. That's my decision, at least for now. I do know one thing. I'd never give up those experiences on stage or the lessons that theatre taught me.

◆

Effective communication is about getting things done under any circumstance.

I look back on the first big deal of a mature nature I ever closed and think about my early training in theatre. A few weeks after Murdoch's first visit to India and to our office, I got a call from his team in London. 'We want to take our discussion forward,' one of his senior colleagues told me. 'If you're interested, let's meet at the BSkyB office any time next week.'

Naïve, I flew there alone, expecting little more than to collect information on what News Corp had in mind. When I landed at 8.00 a.m. on the appointed day, I was met by a seven-person team that included the head of BSkyB, the strategy team, two lawyers and two investment bankers. I thought I was there to have a broad conversation. They were ready to propose a deal and close it that day.

'Where's your team?' one of them asked, offering me coffee. 'Your lawyer? Your banker?' And they began spelling out their proposal. Murdoch's group had shortlisted us as their content partner in India. They wanted a significant minority stake with no operational say in the business, had no concerns about us working with their potential

competitors, and overall, wanted to look at this as a strong, arm's-length alliance—one they'd build on as their India strategy strengthened in the years to come.

'I didn't bring anyone.'

'Okay. What do you want to do?' They clearly didn't think much would happen, but they weren't opposed to talking.

Three things flashed through my mind:

1) this was a strong quorum from their side and not likely to assemble again if I hemmed and hawed;
2) if we finished the day with no conclusions, they might feel free to explore other options; and
3) given their clarity and urgency, the team would have the mandate to report to Murdoch by the end of the day with a firm yes or no.

The way I saw it, I had to proceed with what I felt comfortable doing. It made sense for me to move forward alone.

'I'm good. Let's go,' I said. They were surprised that I was all in, but we negotiated through the day and hammered out a couple of details. By 4.00 p.m., their lawyers had punched out a Heads of Agreement on everything we discussed. Four hours later, I stepped out to make some phone calls back home to colleagues and my lawyer—whom I had put on standby during the day—while the News Corp team faxed the printout (mails were not so frequently used then) to Murdoch for his final approval. I was surprised that with everything going on with the company worldwide, Murdoch still wanted to read a document for a relatively small deal and alliance in India. Another mark of a true entrepreneur.

I was parting with less than half the company. I had never had an investor or partner until then, and here I was at the end of a twelve-hour day hurtling towards a career- and life-changing decision.

No doubt, the News Corp team was balanced and fair, but I was especially pleased that despite being unprepared, I was holding my own against a group of distinguished, experienced professionals. I knew I had to be comfortable with the terms—that was key. As for the negotiations, the process was akin to standing in an auditorium full of people with all eyes drilling into you. Being thrown alone into the pressure-cooker

makes you confident and sharp overnight.

When we were done in the conference room, I went back to my hotel and called Zarina (whom I later married). We congratulated one another. Never one for elaborate celebrations, I treated myself to a long walk instead. Walks are therapeutic for me. The longer the walk, undisturbed and without agenda or route, the more my mind flickers and sparks.

It was a cold night in London. I strolled around Soho, its streets dotted with bright lights, reliving the day and feeling pretty good about things. A lot had happened. For the first time in my working life I was bringing in a partner—and a Goliath at that. Life would never be the same.

Suddenly, I found myself face-to-face with two of the biggest blokes I'd ever seen. Before I knew I was being mugged, it was over. I never wear a watch or carry a wallet, so they took what little was in my pockets and vanished into the night.

As soon as I got back to the hotel, irritated but unscathed, I called Zarina and told her my story. Once she knew I was okay, her answer was perfect: 'You got something today and you gave some back. Good karma.'

Great communicator, my Zarina.

◆

• Communication is a vital ingredient in the recipe for success. It establishes a transparent, open, frank, non-political, non-hierarchical culture and organization.

• Respect each other's time by being fully present. 'Multitaskers', far from being focused, run the risk of letting their attention get split.

• Stay up-to-date with events outside your daily sphere by being open to and responding to others. You never know what opportunity will arise from the least likely of sources. Good ideas are everywhere.

• You can hold your own in any discussion or negotiation as long as you are clear about your goals and are comfortable with the outcome. If you can't live with the outcome, no matter how desperate you are to make the deal work, walk away.

4
The Outsider

The difference between predator and prey in a business ecosystem is determined by the strength of one's next idea.
It's like watching a nature documentary where the cheetah stalks the herd's weakest wildebeest. Happens all the time in the real world. You don't have to be the fastest wildebeest to survive. You just never want to be the slowest.
When the opportunity presents itself, pounce.

I know from painful experience that blockbusters don't just *happen*. For that matter, sustained and continued success is never a given, least of all if you are an outsider. I have got many battle scars to prove it.

Early in the process of ramping up our studio model in preparation of what I knew was going to be a long, hard journey full of ups and downs, I immersed myself in films to get a feel for what was out there, and to understand what worked and what didn't. In 2006, I saw Anurag Basu's slick thriller, *Gangster*. Immediately, I knew that Anurag was a special director—a born storyteller with a film-lover's eye, an artiste who created moods and responses, and an actor's director with the uncanny ability to draw out performances. Most of all, he had the guts to pull it off.

When I walked out of the cinema hall that evening, I called Anurag out of the blue to tell him how much I had enjoyed *Gangster*. We ended the conversation, agreeing that we should try to collaborate on a project in the future. Frankly, I didn't know if much would come out of our discussion—it had been my first real conversation with Anurag since his days in television; it had been a long time since we had spoken, and relationships and dynamics are known to change overnight in this business.

But I followed through relentlessly, and within a year and based on that one brief call, Anurag and I sat for countless sessions throwing out more ideas than we could develop. Things moved fast. We did the fabulous, edgy *Life in a Metro* in 2007. Coming as it did on the heels of some breakout movies from our fledgling studio, the film cemented our role as Bollywood outsiders, as innovators storming the ramparts.

Metro's four vignettes intertwine nine personal relationships in Mumbai. The film's creative genius and its audience appeal lie in this interconnectedness—the links between the stories and the comings and goings from beginning to end. The master stroke, a bit of cinema really disruptive at the time, was having a band of musicians singing and transitioning from scene to scene. On the strength of the film's critical and commercial success, Anurag and I decided to do his next two movies together. In Bollywood as in life, though, things don't always go to plan.

Anurag is a creative genius. Like most geniuses, he can be mercurial and eccentric. To reach his full creative potential, he needs to be left alone. He's the guy you talk to twice a day for weeks at a time, and then, suddenly, he disappears, off to dream and create—all a part of the process of working with a top-notch director's vision.

So, six months after finishing *Metro* and disappearing like a puff of smoke, Anurag popped up at the office one day with a slightly guilty look. He was there to tell me he had been approached by one of the industry's top stars and the star's father, also a director, to work together. The catch was—and this certainly explained his guilty demeanour—they wanted to produce the movie on their own. Our two-movie commitment would have to wait.

Anurag thought this could be his big break. He asked for my blessings for the project, even though we had an agreement. We've all been told, 'A handshake is sufficient and a word is as good as oak', but businesses often turn in unexpected ways. Although my policy is never to compromise, you've got to be realistic. If enforcing an agreement isn't productive, then do what's best to protect a long-term business and a relationship. If the long term is no longer relevant, maybe enforcing a clause is best. In India, legal remedies takes a decade or more. Even time heals wounds faster than the law!

Our discussion that day took all of two minutes. I wished Anurag the best of luck, with no hard feelings. In any relationship, professional or personal, one sees where passion lives.

Then, more than ever, we both knew that anything we worked on would have to be worth the wait. Anurag took almost two years to finish his pet project, *Kites*, with Hrithik Roshan. Seemingly undaunted by the experience, Anurag was game to start the process all over again with us.

'It's not all formed in my mind, and it's not a narration. A very basic screenplay,' Anurag said one day out of the blue about his latest idea. And he spent the next half hour framing the thinnest plot and storyline I'd ever heard. No dialogue, little action. Yet, as Anurag spoke, the emotions came through so strongly, with the characters springing to life, that I couldn't help being intrigued by the creative dance playing out in his head.

I sat with Siddharth (Sid) Roy Kapur, who headed our studio at UTV (and later became the managing director of Disney in India after I moved on), listening to the narration in stunned silence, moved to the core.

Anyone present at that meeting would think us mad to greenlight a film based on such a sketchy story. But I knew Anurag and his thought process. I could not only understand but also *see* how the story would take shape under the careful kneading of his capable hands. 'I don't think the movie will have more than thirty or forty lines of dialogue,' he said with a shrug. 'It's all in the mood, the *feel* of the story. The music. And most importantly, the three leads.'

Sid and I were at the edge of our seats, considering what could be another first in UTV's movie-making journey. *What the hell*, we thought. *If Anurag can't pull it off, no one can. And if UTV wouldn't take a chance with breaking new ground in filmmaking, who would?*

We dove headlong into producing *Barfi!*

Ranbir Kapoor, Priyanka Chopra and Ileana D'Cruz magically embodied the characters Anurag had envisioned in those early meetings. They quickly became iconic heroes after their stellar performances. As for the music, it *was* the narrative and set the mood beautifully.

Like all films, *Barfi!* had its own challenges—many of them. Our first schedule in Darjeeling saw heavy rain. We shot for over ten days and, after seeing the rushes, scrapped everything. Because the film revolved almost entirely around emotions, the time taken for each day's shooting stretched. Even with a talented and professional cast, the demands of the film were so immense, it took a toll on everyone.

But *Barfi!* broke hearts and trends and the box office. And in the end, it was well worth the wait.

◆

People forget that UTV's early days in Bollywood were anything but rosy. Selective memory, sometimes, isn't a bad thing for an entrepreneur—except when he forgets to hold on to past lessons. Because of our positive attitude and constant forward motion, we, at UTV, are remembered mostly for our successes.

Entertainment can be a fickle business. In films, have a couple of down years and slow down greenlighting, or let the wrong message leak to the popular press, and everyone around you sounds the death knell. The difference between predator and prey in Bollywood is the reception of your next film. It's like watching a nature documentary where the cheetah stalks the herd's weakest wildebeest. You want to look away, but you can't. Happens all the time in the real world. You don't have to be the fastest wildebeest to survive. You just *never* want to be the slowest. Think like a predator. And when opportunity presents itself, make the best of it.

Bollywood is also about making a statement—about being seen. For

anyone with too thin a skin, Bollywood can be a lonely, unforgiving place. If we had slowed down every time we had a bad year, our viewers would have a completely different perception about our movie studio today. It's the same with most businesses. How you react to your setbacks and your successes determines the way forward.

We struggled frequently for the first three or four years in this business vertical. Although we were proud of the work we did and what we were building, I could see the team was stressed with the load the studio model was putting on the whole company.

One day, Ronald D'Mello, my CFO at the time, walked into my room and sat me down. 'I think we need to partner with someone familiar with this model. We can't go on our own for the long term,' he said. And then he reminded me of what so many inside the company thought, even if they wouldn't say it out loud. 'We're outsiders, Ronnie. And we'll remain outsiders unless we align with someone.'

I could see his point, and what he said made sense. Ronald always spoke in the company's and the team's best interest. I told him I would think about his suggestion. Still, creative processes, greenlighting and managing talent and relationships aren't about reaching a consensus (in fact, this applies to most sectors and businesses); I was concerned that we would never be able to build our own identity or brand if we took on a partner.

Two weeks later, Ronald walked back into my cabin to ask if I had started any dialogue. Now, we both knew that I'm not someone who needs reminding, but he was right to nudge me. He could see 'not convinced' written all over my face! My deal with the team was that I would begin discussions and consider partnering only if everyone stayed totally focused on the company's growth plan. The last thing I wanted was to have the business division 'on hold' and decisions coming to a halt.

And so, I embarked on some interesting and varied negotiations.

My first phone call was to Yash Chopra at Yash Raj Studios. In his typical unassuming manner—as if he always had time for everyone at any hour—he told me I could drop in that day or the next.

I drove to Yashji's the next day, wondering along the way how

best to pitch the idea of a partnership. Sure, we had done some path-breaking work and were an emerging player, but here I was approaching a legendary family-run organization that had been at the top of the Bollywood heap for decades. Careful not to make my thoughts sound like a formal proposal—I could not take Yashji's interest for granted—we began a fantastic hour-long chat.

Yashji was one of the nicest human beings I'd ever met. Humble, approachable, always lost in thought—but lest anyone think him scattered, he was also the most attentive person in the room, conversing fluently on a range of issues from Bollywood to social justice and the politics of Kashmir.

He never really answered my question, though he wasn't rude or dismissive in any way. Instead, every time I broached the subject of a partnership, his replies took different, delightful tangents. We laughed and chatted. During my fourth attempt at bringing the reason for my visit back on track as subtly as possible, I mentioned how a combination of the two studios would mean a larger slate of films, and how we could combine our strengths overseas and grow the market. With that, Yashji, too respectful to tell me outright that I just wasn't getting his message, dived straight into the details of a great four-day trip he had recently taken to Australia for a festival.

A memorable visit. And one door closed.

Years later, when Yashji passed away, I recalled our meeting, and his abiding courteousness and humility. His body had been placed in one of Yash Raj's studio shoot floors for people to pay their respects before the funeral. I happened to be standing in a corner. An hour passed, then two, and only when the sea of visitors was asked to move on, did I make a quiet exit. Those were tranquil and contemplative hours for me, in a room with a soul I deeply admired.

My next port of call was Amitabh Bachchan Corporation Limited (ABCL). Amitabh Bachchan and his family were looking to rekindle the company and their studio model, so I knew this could be an interesting proposition for both sides. We had two detailed meetings. In the second, Amitji, Jayaji and Abhishek were present along with their management teams, bringing high-powered external resources to help them with

their decision-making. When an external resource or consultant joins any discussion, that entity needs to prove his value; often, his presence isn't wholly productive. That second meeting didn't get very far, and we let it pass.

At the same time, global majors Sony (Columbia) Pictures and Twentieth Century Fox were looking to expand into India with local slates, as their Hollywood fare in the country had failed to strike a meaningful chord. In fact, till date, Hollywood accounts for less than 10 per cent of the Indian box office. Both approached us for a possible joint venture or an exclusive long-term deal to develop movies together. Sony came in first, so with full transparency, we shared the news with Fox.

The negotiations with Sony were complicated, but we made good progress. In sixty days we had a draft agreement, thanks to some aggressive back-and-forth from both sides, and long calls and meetings. We also had two clear deal breakers. I had interacted with Michael Lynton, the chairman of Sony Pictures, in prior meetings before this proposal had come up. Michael is a phenomenal individual, extremely knowledgeable and clear about what he wants to do and why, and I had and have the greatest respect for him. Given how far we had reached with Sony and my trust in Michael, I was ready to bend on one of the two sticky points and looked to them to resolve the other.

On the first point, Sony wanted the right to exclude at their discretion up to three movies a year from the deal. For us it was all or nothing. The second point was the percentage we would charge as our production fee. On that, we were open.

At 9.30 p.m. IST, we began a call to close out the final issues. Unfortunately, Michael was not on that call. Less than two minutes in, one of the three or four senior executives on the line told us that they couldn't move on either point. We had until midnight, about two-and-a-half hours, to conclude the deal. Sometimes one sees American arrogance and superiority, with a know-it-all, we-call-the-shots approach. This was one of those moments. I also found it presumptuous that their team assumed we would stay up until midnight to take a call; if roles had been reversed, I know that not one of them

would have agreed to stay up in the US to wrap up a deal.

Clearly, if and once we signed, that arrogance wouldn't just disappear. The alliance, we decided, wouldn't be to anyone's benefit. 'No need for another call at midnight,' I told them evenly. 'We won't be going forward.'

After a moment's pause—I guess partly because they may not have been used to having such a request denied—they quickly offered to move their own deadline by a day so I could give the proposal some more thought. I declined. The next day we fielded some salvage calls, but for us the moment had passed.

Did I get the gravitas of what I was letting pass? Of course. Here was a major Hollywood studio offering to give us credibility with their endorsement via a joint venture. Sony were putting in 50 per cent of all costs and investment for a proposed period of five years—all renewable. At that time, their contribution would cross ₹5 billion (more than US$100 million then), and they would help with global distribution.

But what good would all that be, given our uneasy relationship before the deal had even been struck? Without mutual respect and trust, all alliances eventually crumble. If results suffered—as they inevitably would in an unhappy partnership—we would be the guys on the block, taking all the blame and accountability. Signing an agreement or a deal brings great excitement, but the measure of any deal is its ultimate success.

And so we engaged with Fox. We had history and a relationship, since News Corp had already invested in UTV. Again, we moved with pace and quickly came to an agreement on all points.

The one 'small' problem was that the executive team that had made all this progress had not sounded off the head of the studio, Jim Gianopulos, on the deal. Jim is one of the smartest executives in the world, charismatic the way Greeks often are, sharp as they come and blunt as well. He was clear that, though Fox was keen on the India market, the organization wasn't ready to back everything UTV had discussed with the executive team. For one, he wanted to cherry-pick the films that Fox co-produced. That made no sense to us. In the end Fox, too, was a closed chapter.

Eventually, we would partner with them for Mira Nair's *The Namesake* and Manoj Night Shyamalan's *The Happening*—but that was for the future—a future neither of us could predict while negotiating.

Great learnings from four varied interactions. Four closed doors and no solution in sight.

So when I sat down with my team to review my full odyssey, I sensed scepticism all around. *Come on, Ronnie. You never wanted this to happen in the first place*, I could see them thinking. *We know you. If you had set your mind to it, we would have closed this out by now.*

Honestly, I had given every negotiation my absolute best. In my four interactions, two of our potential Indian partners had told us, albeit very politely, that we were outsiders. They were probably right. The other two made us *feel* like outsiders.

At the same time, I was relieved in some small way at what had come to pass. I've never believed that consensus management makes good business sense in terms of identity and brand. In retrospect, if the joint venture had become a reality with any of those potential partners, we would have been a very different studio model in the overall UTV group.

What can you take away from our early experiences?

When you're starting out in any business, everybody gladly tells you, 'This is how you get things done.' Sure, recognize their experiences. But people tend to give experience more credence than they should and often overestimate the value of free advice.

Outsiders follow their instincts and those of their team and colleagues. That's how business gets done. If someone, even someone you trust, gives you advice that doesn't make sense, go with your own gut. Our 'outsider mentality' energized the team, and we never could have succeeded if we'd tried to copy everyone else's model or listened to those who had half-baked, well-intentioned ideas.

We were confident *because* going against the grain was our strength.

◆

You can't climb to the pinnacle of the media game in India—or

anywhere in the world for that matter—without a big screen attraction to your name. Our entry into Bollywood didn't leave room for half measures. By our fifth year, we had multiple films in production at all times and we were scaling. For more than a decade, we maintained that average. Our mantra was to learn from past mistakes, fail forward and fail fast, move on and keep that cycle chugging along, even if it misfired every once in a while. The successes were sweet, but never made us too high; the failures were expected, and never laid us low.

Even in the early days, our gut told us, *stay with this; you will succeed.* We did a lot of non-conventional cinema and positioned, marketed and distributed it to become successful commercially as well. I would say every other movie we made fell into this bucket and was clutter-breaking: *Khosla ka Ghosla, Fashion, Kai Po Che, Kaminey, Paan Singh Tomar, Peepli [Live], Udaan, Delhi Belly, Swades* and *Raajneeti*, among many others. Make no mistake, these were hardcore commercial films, yet they were unlike anything audiences had ever seen. Like most forward-looking entrepreneurs, we knew the market because of a constant connection with, and attention to, our core audience nationwide and via interactive touch points in our television and new-media businesses.

For instance, in 2008, *A Wednesday* took audiences by surprise, even if our research and gut told us it could be a breakout film. A seemingly straightforward terrorist plot unfolding over four hours on a Wednesday, the film turns on the fact that the suspected bomber is really a vigilante fighting for the rights of the common man. The movie was executed simply and realistically. Leads Naseerudin Shah, whose work spans four decades and over a hundred films, and Anupam Kher, a Bollywood veteran who also acted in Woody Allen's *You Will Meet a Tall Dark Stranger* and later in David Russell's *Silver Linings Playbook*, brought valuable experience to the screen. Both immensely talented actors were made for their roles in *A Wednesday*—Naseer as the vigilante and Anupam as the world-weary Mumbai police commissioner looking for a way out. Neeraj Pandey, a superbly talented first-timer who delivered the film's message with precision and clarity, wrote and directed it, winning the Indira Gandhi Award for Best First Film.

A Wednesday was an important part of the evolution of UTV in

Bollywood and contributed to my own learnings. In honesty, I hesitated to throw my weight behind the end product after watching the rough cuts. I had two nagging thoughts:

1) that the film's message was simplistic and the canvas small; once word got out, audiences would wait for the television release instead of seeing the movie in the theatre; and

2) that we should have made the film on a bigger scale, instead of a shoestring budget of ₹30 million (US$500,000).

I'm happy to say that I was wrong on both counts and I'm glad to this day that I didn't put my foot down on either point. Given my earlier recommendations of going with one's gut, you may think that my decision to go ahead with the film was counterintuitive. But here's a corollary to the rule—trusting team judgement is equally important, especially when the core thinking is in complete sync. In this case, the team took the right call. Stellar performances, relentless suspense, a quirky narrative and an unexpected twist made the movie a runaway success.

A year later, we released *Dev.D*, our riskiest effort till that point. A mad, whacky, edgy genre film that totally subverted the Indian cinema model, *Dev.D* required a lot of lateral thinking and balls of steel. Although both *A Wednesday* and *Dev.D* were massive hits, when I first heard the storyline for the latter from Anurag Kashyap, I had no idea what to think. *Wild* was the first word that came to mind, but after that…nothing.

The talented and eccentric Anurag Kashyap sees himself as the Martin Scorsese and Quentin Tarantino of India. In a way, I suppose he is. With *Dev.D*, he proposed a contemporary take on one of India's epic love stories, *Devdas*. Kashyap wanted to modernize it beyond recognition, yet stay within the fabric of the original story, which follows the growing relationship between childhood sweethearts, Devdas and Paro.

Combined with a powerful, live-music backing track, Kashyap's vision held promise. Besides, he had earned quite a reputation for keeping projects under budget while giving his movies a rich feel, which didn't hurt his chances for success. Zarina, Sid Kapur, executive

producer Vikas Bahl, Kashyap and I watched the first cut in the edit room. By the halfway point, everybody had fallen in love with the film, the characters, the narrative's freshness, the way the music blended into the story. We knew that moving forward with such a groundbreaking film would require a huge leap of faith. But that wasn't going to stop us. It never did. We backed it all the way.

For the premiere, we selected one of the oldest single-screen theatres in Mumbai, to give the film the atmosphere it deserved. Unfortunately, I could only stay until the interval, rushing to the airport to board a nonstop flight to New York City to negotiate a proposed joint venture with Bloomberg the next day for our business news channel. As the plane taxied down the runway at the Mumbai airport, I was flooded with texts from dozens of audience members, friends and family, all going ballistic about the movie. Each predicted a runaway hit.

The last text I received before losing network was from Sid, telling me that the film had got a five-star review in a top newspaper, the first such rating in a decade.

◆

The extent to which we were outsiders came home with one particular incident in May 2002 at the Cannes Film Festival. We had just started thinking seriously about forming a motion pictures division at UTV, so Zarina and I travelled to Cannes for the film festival for the first time (though we had been going to Cannes for the television festivals for years, so it wasn't all alien).

We were scheduled to be there for just three days. On the last day, we heard that there was to be a midnight world premiere of Sanjay Leela Bhansali's *Devdas* and that Shah Rukh Khan, Aishwarya Rai, Madhuri Dixit and Sanjay would be walking the red carpet. Zarina and I scurried for invites and, after much begging, pleading and waiting in line, managed to get two seats in the second balcony. We couldn't have been any farther from the VIP section. The invite said: 'Dress Code: Formal'. Since I've never owned a tuxedo (and still don't as it's always slacks, T-shirts and moccasins for me), off we went to rent one for the day.

At 11.00 p.m., both Zarina and I, dressed in a sari and tux respectively,

left our hotel to take a long walk down the promenade to the Palais Theatre. A strong crowd of over one thousand fans—yes, a *thousand* fans at midnight on the French Riviera for a Bollywood premiere—gathered to witness the spectacle. We ended up waiting along with them on the pavement to wave at cinema's heartthrobs. Soon, a magnificent horse-drawn carriage arrived with Shah Rukh, Ash, Madhuri and Sanjay standing in full glory, waving like the Queen of England. I was proud and inspired to see India, front and centre. Ash looked drop-dead gorgeous, Shah Rukh, his usual dashing and charming self (as he will look all his life), Madhuri, stunning and Sanjay, every bit the director maestro.

Zarina and I stood in line for forty-five minutes to get to our seats. Even though the movie started late, as everyone was more interested in the stars, it was three hours of magic that ended in the middle of the morning. We went back to the hotel, changed, dropped off the rented tux in the late-returns box at the shop and drifted off to sleep at around 4.30 a.m. The taxi arrived at our hotel two-and-a-half hours later to trundle us to Nice for the long flight back to Mumbai.

Neither Sanjay, Shah Rukh nor Aishwarya knew who we were that night, nor did we get a chance to say hello. And yet in 2002, Shah Rukh and I signed up for *Chalte Chalte*, our first co-production. We had known director Aziz Mirza from our television days. One meeting led to another, and there we were. That project was special for both of us—Shah Rukh's first movie from his own Red Chillies production house and UTV's first big co-production.

Standing on the pavement in Cannes and waving had got to me. I knew we had to move forward with our plans. Shah Rukh in his inimitable way told me, 'I *did* wave back, you just didn't notice.'

Sanjay and I laugh about that memory, too, when we meet. 'You and I are going on a ride in a horse-drawn carriage on the red carpet,' he promises with a laugh. Even though Sanjay and I have done some successful movies together, including *Guzaarish* and *Rowdy Rathore*, the carriage ride hasn't happened yet. I guess that moment has passed.

◆

From those first days in the industry, I think everyone liked and welcomed us because we were intentionally unimposing—confident without being arrogant, strong listeners without dominating every conversation. This was our true identity.

Too often in India, mid-sentence interruption runs rampant. 'Hey, I agree with you, but...' could be the country's motto. In the creative world, meetings are little more than opportunities for self-styled visionaries to talk over one another without hearing a thing anyone else says. So it's refreshing (and disappointingly rare) when someone actually listens and waits for others to finish, and crafts an intelligent, thoughtful response based on what had just been conveyed. It makes people feel respected. *This guy is really listening because he has noted all the small points and has come back on them.* A small overture, but I think it made a massive difference in the way we were perceived early on.

Never underestimate the power of the outsider. That me-against-the-world mindset opens doors to entrepreneurial experience.

How did our outsider status work for us?

Well, in 2008, two years after *Rang De Basanti*, we had the great fortune of releasing yet another groundbreaking movie, Ashutosh Gowariker's *Jodhaa Akbar*. It came with a risky plot and setting, and there were concerns that India's young populace wouldn't identify with the film's history and dialect—which was nothing like the Hindi we speak now. We needn't have worried. On the strength of a brilliant story and transcendent performances by Hrithik Roshan and Aishwarya Rai, *Jodhaa Akbar* became an international sensation, a big-budget blockbuster.

Since the success of *Rang De Basanti* in 2006 and until the release of *Barfi!* in 2012, UTV swept the awards for three of those seven years. In the same span of seven years, three of our films were India's official entry to the Oscars, and at the National Awards given annually by the president of India, UTV's films won twenty-five National Awards for nine films—ten times more than any individual or corporation has been awarded to date!

Such a clean sweep over such a short period of time was a great sense of pride for the entire team and the company as a whole. For,

truth be told, none of the films that had established us as outsiders was easy to greenlight. UTV drew heat, privately and in the media, for taking risks that no other studio or individual producer or director would take.

Identity is often built on branding and creating impressions. Here was a classic case of branding, not through a campaign, but by doing pioneering work one could be proud of. Having said that, if the creative talent who dreamt stories and characters hadn't come to the 'outsiders' in the first place, these breakout, important visions may never have come to fruition on the big screen.

◆

* As a professional, a leader or an entrepreneur, there will be times in your career when you'll be an outsider, either because you have changed sectors or jobs, or started a new business where full domain knowledge is not your core strength. Embrace this status, be a quick learner and an even sharper listener.

* Build a team that complements yet challenges you, and hones your skill sets, and get them aligned with the big picture sooner rather than later.

* I'm often asked about the keys to success as an outsider. The irony, I say, is that the raw material for any entrepreneur or leader to make an impact as an outsider comes from within. It's a lesson I have learnt and relearnt every day in the two decades I spent in the media and entertainment business.

5
Even If It Ain't Broke, Fix It

When we seek opportunity, human nature compels us to follow success.
Often, this means following the herd. But when we're following the herd,
all we see is the rear end of the person in front of us!
Don't ignore the extraordinary opportunities in India today,
the ones that reward the innovators and the disruptors.

Innovate. Disrupt.

In today's business world, you can't open a web page or pick up a newspaper without running across these buzzwords. In my experience, though, they're more talked about than understood.

Let me be clear. If you're building a business that hopes to last more than three years, and if innovation and disruption aren't at the heart of that business, you'll probably fail. Sure, not everyone can, or even desires to, build businesses that will be viable fifteen or twenty years down the road. Most entrepreneurs focus on the impact they can make in the present. Even so, to make the present count, you have to be highly innovative, ruthlessly disruptive and wilfully adaptive.

Business changes daily. No matter how focused your goals, you're aiming at a moving target. Forget the status quo. We all know it doesn't

exist any more.

Let's begin with disruption. Disruption doesn't force you to act rashly or with a false sense of urgency; you don't disrupt *to* disrupt. You don't smash the hornet's nest just to savour the chaos that follows; eventually, you'll get stung. Nor do you need to pursue disruption 24/7. In fact, disruption doesn't work when all it means is change today, change tomorrow, change the day after tomorrow. No—disruption needs to be accompanied by deep thought and a vision extending beyond the day after tomorrow. True disruption requires urgency across the long term!

Also, remember, when you're driven by your peers, you're not being disruptive. That's clamour, just a lot of noise. Pay attention to your own goal. That's why I like the quote: *I am too busy working on my own grass to notice if yours is greener.*

As for innovation, it is a highly deceptive term. A lot of growing businesses fall into a common trap—they assume innovation is a one-off great idea; they forget that innovation has a context and relates in some significant way to the present, failing which, it risks being misunderstood or being ahead of its times. Moreover, any innovative enterprise has to undergo a constant cycle of iteration before getting absorbed into the team's DNA.

But not all financial plans seem to follow a model of innovation and disruption. Does the following scenario sound familiar?

When first starting out, you think, *I'll work on growing the business until my next round of funding.* Your goalpost, then, becomes not how you're building the business, but where your investors will come from. When you focus on attracting investors through unnecessary or poorly directed innovation or disruption, your financial status becomes the goalpost. Your business, in the meantime, goes sideways.

I've sat in countless meetings, where otherwise smart individuals and investors ask the founder, 'So what are your top three priorities to raise the next round of funding?' Don't get me wrong, funding is an integral part of a high-growth business. But how will anticipating the source of the next three rounds of funding help the founder and entrepreneur build a rock solid, lasting and scalable business?

Your only goalpost is the business you build responsibly with an eye towards the future. Good capital will always follow well-articulated, focused and thoroughly executed businesses on high-growth, profitable paths.

◆

In our early days in the media and entertainment business, when our focus was TV production, the show that established UTV as an innovator, a disruptor and the creator of a new wave of Indian television was the daily soap *Shanti*, which had more firsts than anyone can recall now. *Shanti* was the first ever daily afternoon soap at a time when there was still no concept of *anything* being viewed five days a week, least of all in the afternoons, typically reserved for educational and documentary programmes.

Why daily? We wanted our content to be habit-forming. Each episode would have a cliffhanger such that you *had* to watch it the next day to know how the story went.

Why afternoon? Our focus audience was female, and in the afternoons women were more likely to be undisturbed, free of the dual responsibilities of kids and household chores.

When we dreamt up *Shanti*, no one had produced more than the standard thirteen to twenty-six episodes at a time. In 1994, there were no storylines that would extend for years, yet hold attention daily. However, here we were embarking on an odyssey to create *260 episodes each year*. The talent pool required to pull off such an audacious idea simply didn't exist. We needed to find, recruit, train and build a well-oiled machine in a very short time.

Looked at in today's context, starting *Shanti* from scratch was as challenging as starting an entire company in the space of tech, the Internet, or e-commerce. With no ecosystem or talent in place, we built from the ground up and created an entire back-end and logistics network to shoot and deliver at scale with precision and efficiency. Constant customer feedback to innovate, change and adapt was at the core of our success. We grew strong on account of the loyalty of the repeat viewer, the customer who came back every single day to watch

groundbreaking content.

In true UTV style, we broke down the issues one by one and came up with a schedule that allowed us to shoot an episode a day—*an episode a day*! Unheard of at the time. As preparation for this massive undertaking, the team and I watched countless telenovelas from South America—the champs of daily soaps—and realized that even they weren't cranking out content at the rate we planned to, even though theirs was an established industry with a wealth of trained talent. For us, the pressure was on.

But our crack team was up to the task. Since television at that time wasn't a mature medium for directors and writers, the show's director, Adi Pocha, came from an advertising background. We rented a warehouse the size of an aircraft hangar and air-conditioned it from the ground up, building a permanent set—or, more accurately, seventeen different sets in one studio—with permanent lighting to suit the various locations we needed to start filming those first episodes.

With the logistics locked down, we sought actors who could understand and appreciate the rigours of reporting to set at 7.00 a.m. six days a week and working through until at least 7.00 p.m., before heading home through Mumbai rush-hour traffic. When they'd get home, they'd read the next day's script, learn their lines and return the following morning bright and early for the day's shoot.

Lather, rinse, repeat.

Each of the actors was told upfront that the rigorous schedule would be a marathon, not a sprint. We decided *Shanti* would not have breaks or seasons. Instead, it was to be a true *daily* soap as long as the creative team and the story hooks kept the audience riveted. We were embarking on a year-round experiment in innovation in Indian television, one that would set a trend that carries on till date.

We found a host of up-and-comers to take on the minor parts. The most difficult role to cast was that of the female lead, Shanti. Two months and dozens of candidates into our search for a fresh-faced actress who could meet the demands of a daily soap, we finally set our sights on Mandira Bedi. Mandira clearly had what it took to be successful. Still, a bit stiff and self-conscious, she wasn't seasoned

enough at that point in her career to hold an audience's attention day after day. Three weeks from the first day of shooting, we had our leading lady, but there was still a lot of work in front of us.

The director had a brilliant idea. Over the next four days, he took Mandira and a small camera team into the streets of Mumbai and just let our lead actor loose at traffic signals, stores (there were no malls at the time in India), colleges and bus stops. Any place where she would be forced to interact with people in the most uninhibited manner. To get her to shake off her inhibitions and act naturally, the camera team shot from a distance. After every such interaction, the team would huddle in the mini-van to watch the footage. Mandira would study it and reflect over how she could change her next interaction to make it more authentic.

And in those few days of pounding the pavement...a star was born.

Even so, *Shanti* struggled for the first six months. Audiences didn't take to it easily (they had never seen anything quite like it before). We knew we needed to focus on the strength of the storylines, so we *tripled* the size of our writing and creative teams—not an easy task when writers for that kind of content, especially on such a rigorous schedule, were few and far between. We brought in people from advertising and films and even some book writers. The mix didn't work, at least at the outset.

The logistics of shooting an episode a day and without breaks took its toll on talent. As team members fell sick, we had to write them out of that day's episode—a difficult task and one that only slowed production and threatened to knock us off our schedule. Our learning for a task so large was that we should have budgeted for sixty days of trial runs—fine-tuning the details and anticipating the unexpected consequences of production at such a scale and pace. In a way, this was different from today when many companies plan a big-bang launch, believing that savvy marketing and a product on the shelf will do the trick. Mostly this does not work. The smarter companies do test launches and phased releases, which decades of study have shown are the most effective ways of taking a product to market.

After six months, with all of us struggling, we had our ducks

in a row and an audience that had warmed up to this new concept and habit. From there, *Shanti* ran for three years with close to eight hundred episodes. In that time, we trained more people for careers in the television industry than any other show. Many of the initial team's members went on to form their own successful companies or remained professionals and continue to do well. That's been my greatest source of pride from the show—creating, working with and empowering teams and colleagues, and watching them grow, move on and become leaders, entrepreneurs and creative geniuses.

The show's eventual success allowed us to explore the possibility of building a syndication model for Indian content, another first in the Indian media landscape. No one till then had looked at a market outside India for TV content to be syndicated globally. We realized that *Shanti* could be popular with South Asians as a whole, so we sold the rights to the show in more than forty countries.

I wasn't aware of how disruptive the show was in the television industry until we went on a promotional tour of Sri Lanka to support *Shanti*'s introduction there. After landing in Colombo and ambling out of the airport, expecting to quietly get into our cars and head to the hotel, we were deluged by a sea of humanity. Fans of the show lined the streets to wave at the cast, as if the prime minister or the president had just arrived back in the country. We all sat in the convertible and smiled at each other, not believing our eyes, but pleased that our instincts and hard work had paid off.

Shanti was a lesson in innovation and disruption early in my UTV days. It was also a prime example of my obsession for scale when it came to starting and growing businesses.

◆

So you have your team in place, everyone's psyched to be at the cutting-edge of a nascent market, and you're ready to hit the ground running. On your way out the door today, carry this thought with you: Today's entrepreneurial winners will be among those who deeply study and understand Indian demographics for their company or their new idea.

I break these demographics down into three broad segments: the

urban, the top 200 million; rural India, the 625 million who form the bottom of the pyramid; and the middle 400 million, the emerging markets. I want to focus on the last, to understand and analyse this wide-open and untapped market. Barring a few FMCGs and MNCs, how many of us talk about the fact that to date 80 per cent of our market comes only from the top ten to fifteen cities in India? Talk about a cup far more than half empty!

The questions we need to ask to define the target demographic and give shape to untapped markets are:

- Who are my target consumers—age, gender, socio-economic status, education?
- Are they going to be spenders or savers?
- What and how are they going to consume over the next five years and more?
- How do they move? Communicate? Stay in touch with the world?
- How (and how well) are they going to keep up with technology and social and media spaces?
- What will their daily lives look like?
- And, most importantly, what impact and role do I want to play in all this?

Understand your markets inside and out, and you will understand innovation and disruption in its purest form.

◆

In many ways, launching Hungama, our kids' TV channel, was one of our most disruptive endeavours. It all came about when Zarina walked into the room with a remarkable idea for a local children's channel during one of our brainstorming sessions. India already had six kids' channels, experienced global players who did exactly this sort of thing very well in 160 countries around the world. So our obvious first question was, 'Is there space for one more kids' channel?' Then we wondered if we were ready to take on these giants, who had over 5,000 hours of free programming in their libraries.

Nearly all the people we spoke to in the advertising world, where our

revenues would come from, told us the market had no gap. Worse still, all our research suggested that kids adored Cartoon Network and many of its leading shows. Fortunately, our gut told us there was a huge gap for a local channel and that a truly Indian brand could succeed.

For us, that's where the challenge, and the fun, lay. Fresh from our learnings from two shows we had done for other channels, *Shakalaka Boom Boom* and *Shararat*, we knew that if we provided the right content for the core group of kids aged 4 to 14, they would tune out of the daily soaps and horror shows they had become accustomed to watching. We saw the global majors, with their paint-by-the-numbers approach and their vast content libraries, as opportunities, not threats, as their approach gave us total flexibility to innovate, disrupt and think outside the box.

And disrupt we did, with trailblazing content from Japan, including *Doraemon* and *Shin-Chan*. Eight years later, these are still the top-running kids' shows on Indian television. We also launched locally produced live-action shows, the differentiator our audiences were looking for.

The channel's launch was an uphill battle. We got (and still get) our fair share of negative feedback from mothers for *Shin-Chan*. The first six months were nail-biting. As with *Shanti*, nothing worked instantly. The sceptics sharpened their verbal knives and were quick with their obligatory 'I told you so'. But after eight months, we stabilized, and turned the tide. I guess the kids finally prevailed over their moms. Whatever the reason, our positioning started to work.

Eighteen months forward, we were the number one channel in the sector. One of our global competitors bought the channel from us, thus starting our productive and long-lasting partnership with The Walt Disney Company that culminated many years later in their taking over UTV.

◆

In the business of films, one of our proudest and most disruptive acts was when we greenlit the movie *No One Killed Jessica*. Jessica Lal was a celebrity bartender at a Delhi bar when she was shot dead for refusing a drink to the accused, Manu Sharma, after hours. While there were

close to a hundred witnesses to Jessica's killing in cold blood, very few testified on her behalf, intimidated by the accused and his politically connected family. The ensuing trial shredded Jessica's character and exonerated Sharma.

Importantly, Sharma's trial had a connection to our film *Rang De Basanti*, which was released on 26 January 2006. One of the central events in the film is the death of Ajay Singh Rathod, a pilot in the Indian Air Force who flew one of the many Russian MiG aircrafts that crashed ever so often due to mechanical failures. In the film, the blame for the death rests squarely with corrupt politicians, and the revelation sparks off a candlelight march by the youth of India—a first in Indian cinema, as such shows of solidarity were not common then—to India Gate and the Tomb of the Unknown Soldier in Delhi.

Not quite a month later, on 21 February 2006, Sharma was acquitted—a grievous miscarriage of justice. The next morning, the headline in the leading newspaper *The Times of India* said it all: 'No One Killed Jessica Lal'. The nation's spirit was ignited. What played out over the next few days in real life was the candlelight march from *Rang De Basanti*, not just at India Gate but in the streets of cities and villages across India. For almost a week, media attention remained focused on the nation and its youth, millions repulsed by and angry at the verdict. The pressure on the government to bring Jessica's killer to justice was immense. When the case was reopened, witness after witness, reluctant to speak on Jessica's behalf during the first trial, now came forward to testify to the truth. Manu Sharma was convicted to life imprisonment.

From the outset, I knew this was a movie we had to make. *No One Killed Jessica* etched itself onto the consciousness of the country's youth; it also opened our eyes to that generation's values and tolerance in a world where these attributes aren't always present or passed on.

It's not often in your career you get to make an impact similar to that of *Rang De Basanti* and then watch the film unfold in real life a month later with a nation in rage. To have the opportunity to document Jessica's story on film was a rare honour, intensely emotional and deeply satisfying. Despite pressure, legal and otherwise, to mothball the film, we remained undaunted.

When you're being disruptive, there are no half measures. You go all the way, or you drop out.

◆

After selling Hungama to Disney, we went back to brainstorming new plans for broadcasting. Zarina walked in again like clockwork with a one-slide presentation telling us that we needed to focus on the 16-24 demographic, which was then being ignored by every channel in India. Only trendy music channels like MTV and Channel V catered to that core audience, but they were exclusively for music. We recognized a clear opportunity in this space, and Zarina's proposed youth channel would be at the foundation of our differentiated bouquet of channels. Her one-pager was spot-on, and the ten people gathered in the room got it immediately.

The best way to pitch a product, service, or idea is to start at its positioning and what it stands for. Zarina's aim was to test a core local Indian channel ('Desi Cool', on the left) that the youth would be proud of and identify with. The one-slide pitch was:

Let's Test This

Desi Cool	v/s	Chic Cool
Humorous, mad, crazy, outrageous		Sexy and slick
Aamir Khan in *Rang De Basanti*		Aamir Khan in *Dil Chahta Hai*
Believe it's cool to speak Hindi (reverse snobbery)		Believe it's cool to speak English

What followed was sixty days of nationwide focus groups while a core creative and marketing team in our office defined the channel's positioning. From that idea was born 'Bindass', the first youth channel in the Indian television landscape. After our appearance, most of our competitors moved to that positioning out of necessity, since we had created the space, a core viewing audience.

It's funny how a name can define a brand and its consumer following over time. Where would Twitter be if it had been called 'Jitter', a name under serious consideration at one point before cooler heads prevailed? What would Facebook be if its purpose and target audience weren't so clearly defined?

So, too, for both Hungama and Bindass. When we researched a name for our kids' channel, Hungama wasn't even in the top ten of our first list. But our audience picked it as the obvious leader and the name came to define the brand and what it stood for—mischievous, curious, high-spirited fun. Naturally, our content took the same shape and form. Similarly, Bindass was chosen by our core audience during research. The name said it all, and steered what was to be one of the more disruptive (and controversial, at least in the beginning) programming formats on Indian television.

An early show on Bindass, *Emotional Atyachaar (EA)*—inspired by the whacky, edgy theme song of our movie *Dev.D*—followed a format that has broken barriers. Here is a reality show where any unmarried girl or boy, who feels their boyfriend/girlfriend is cheating on them, calls *EA*. Over a five-day sustained period, we, under cover, follow the 'straying' partner, sometimes tempt him/her as a test; each episode ends with the suspicious partner being shown the five days of coverage, culminating in a showdown with the significant other. Millions of viewers took to *EA* due to its boldness (and still love it!), and many others loved to hate it. Indeed, at the outset, we received a lot of negative media. But within a year, even families and parents started getting involved; they realized that it was better for their kids to learn the truth when they were in fledgling relationships, than to discover startling facts after they tied the knot!

EA triggered an avalanche of emotions, discussion and attention, and launched the youth genre of programming in India—and with it, Bindass. While *EA* may not have the mass impact of some shows, it is now one of the longest-running weekly shows on Indian television, with a strong team innovating every season.

◆

India today has so many sectors on the rise that opportunities for entrepreneurs to innovate and disrupt are far greater than those in more advanced countries. Even if you come to the game late in India, you can line up close to the start. For instance, today, in *everything* to do with technology, India is still at day one. Health and education, day one. The Internet, maybe day two. Brand, brand awareness, all aspects of branding, day two. Tourism, leisure and entertainment, day one. Even though India's strength is its service economy, we're nascent in most other sectors. Opportunities for disruptive and innovative thinkers are unprecedented.

So what's the bad news? You need to look inward for an answer to that question.

When people seek opportunity, they tend to focus on one sector. It's human nature to follow success; often, there's money to be made by following the herd. At least, that's conventional wisdom. But when you're part of the herd, all you see is the rear end of the person in front of you. Don't ignore the extraordinary opportunities in India today for first-generation entrepreneurs entering untapped markets.

Anyone thinking he'll be late to the altar of emerging markets isn't just wrong, but also susceptible to seeking quick fixes on entering the game. Quick fixes never lead to longevity. The lack of a longevity plan never leads to success.

In each of our endeavours, we kept our edge sharp by remaining clued into market needs and making long-term thinking a habit. Ideas and businesses, like people, need to breathe and mature. And an understanding of when and how to innovate and disrupt is a crucial aspect of the growth process.

◆

* I'm sceptical about that age-old saying, 'If it ain't broke, don't fix it.' Whoever said it didn't understand the pleasure that comes from growing a business, pushing boundaries and crashing conventions along the way.
* Innovation and disruption don't amount to acting rashly with a false sense of urgency; nor do they signify change for the sake of change,

today, tomorrow and every day. Your goal is to build a rock-solid business for the long term. Capital, talent and customers will always follow if you are on that path.

• Remember, it's not easy when you are not on a trodden path. You need patience and perseverance; you need to be ready to struggle for weeks, months, maybe years, because you believe in what you are doing.

• A colleague, a part of my core team, sent me an email that I think highlights some of the traits I look for in entrepreneurs or leaders as I go forward: 'After four years, as I move on to take this leadership [post] in a new company, the lessons I take with me, having worked closely with you and observed you, are firstly your guts and balls to take bold calls (I have not seen this in many leaders); the fact that not all of them worked out for you but that never deterred you; your ability to grasp a new idea, problem, proposal or opportunity and ask those incisive Qs; your speed and clarity of decision-making; and lastly, your painstaking effort and your patience for taking the team along in the decision-making and execution process and allowing each member the chance to own it. I don't think you had all this so clear when you started your journey, but I believe you focused on these points and built on them, made them your pillars of strength as an entrepreneur and a leader. For you, every day is a new day to look at things afresh and question the constant.'

6
Tipping the Scale

Inflection points need to be pursued. Look round the bend, spot trends, set the bar high, and build a team and a culture forward-focused on scale. Tailwinds come from hard work, preparation and a willingness to seek out and take advantage of growth opportunities.

The bigger, the better. From my early days at Grant Road—when I collected money for the invites I sold to friends and neighbours to watch premieres from my grandparents' balcony—I've been fascinated by scale in business and in life.

Creating scale in business—that is, finding the inflection point that allows your products or ideas to grow into their markets—has to become as much a part of your daily routine as strategy, team-building and planning for your capital needs. When a business morphs from an innovative and disruptive idea to one that seeks growth, the cycle begins to feed itself. Think of this as 'tipping the scale'—an entrepreneur's ability to brainstorm and build a bigger, better business.

Starting a business, building and growing one, and scaling one, all require radically different thinking. They're three totally different disciplines with their own unique DNA. You have to be brutally honest

in your assessment of whether you're a starter, a grower, a scaler, or a combination of the three.

You can grow into all three, depending on the quality and calibre of the team you attract along the way and how you empower that team. You could be a professional with ten years of experience and therefore feel you are a grower and scaler. If that's the case, find a co-founder or colleague who can be a great startup person, as this could be a winning combination for the future. Remember, the scope of your vision and the extent to which you can honestly assess yourself will limit or unleash your company's potential.

But how do you spot inflection points? And, most importantly, how do you cause them?

First, understand that inflection points exist. Most entrepreneurs get stuck in a groove from time to time, find a comfortable niche and sit tight in it. Inertia stops many people from thinking big. Bodies at rest tend to stay at rest unless acted upon by some outside force. In the same way, modest success for a business in a small market—the fact that it happens to be big fish in a small pond—compels many entrepreneurs with otherwise far-reaching vision to stay put.

That's when the excuses for not scaling a business start tumbling out. Funding woes, getting diluted too early, a misjudgement of the potential size of the market, an inability to find the right team and just about anything else under the sun—these excuses only reflect a low level of ambition and a lack of confidence in your own ability and potential as an entrepreneur. Nothing wrong with that, if that's your goal. Five years from now, though, do you want to be doing exactly what you're doing today? Most people would answer with an emphatic *no!*

For me, scale is the first benchmark. In fact, if you're not looking at scale, you really don't need a strategy—for, you're focused on the here and now, not the future. Scale and strategy are inextricably linked.

The question I ask myself when I look at scale is: *What's my differentiator?* In today's fast-changing world, you can have a great idea, product or execution strategy, but without a way to differentiate your idea from all the others in the market, scale will be elusive. I've known a tonne of entrepreneurs who have blamed market size or the company's

nascence for not breaking out to scale. But for a clearly differentiated product, service or offering, ambitious and visionary entrepreneurs will always find a scalable market.

Start with these questions, if you haven't asked them already:

How big do I want to be?

What will it take for me to get there?

How am I preparing myself to build my business to scale?

Ambition leads to sacrifices; you can't have one without the other. Those with more ambitious goals will generally be more willing to make sacrifices to reach those goals.

Everybody dreams about scoring the finals-winning run in a cricket test match or a goal in the football World Cup. In the same way, entrepreneurs hope one day to head impactful, global businesses.

◆

I've faced many inflection points on my entrepreneurial journey. Nine times out of ten I've sought them out; maybe once, the inflection point has sought me. I know this is true for most entrepreneurs who build businesses of size.

Inflection points need to be pursued.

Look round the bend, spot trends, set the bar high, and build a team and a culture that is forward-focused on scale. Of course, it helps to be in the right place at the right time when you're thinking scale and inflection points. But tailwinds arise from hard work, preparation and seeking out opportunities.

The quest for scale has come naturally to me—even during my first days in cable TV in the early 1980s. Back then, the hurdles were many. How do you explain cable television and 'choice' to customers who have never held a remote in their hands, never changed a channel? How do you find stability and scale in a business when regulations don't exist? To sell the concept of cable TV, we set up hundreds of demos in building lobbies across the city, bringing residents their first taste of technology and choice in content. Over the next twelve months, we did over 1,000 demos and more than 3,000 door-to-door visits before we got our first connection. At that pace, we saw it would take years to get to critical

mass—forget scale.

So we took two initiatives to get us on our way. First, we targeted every hotel in the country for cable service. A no-brainer, really. Convincing one or two decision-makers in a hotel chain to come on board would get us 10,000 more paying rooms. Once a few hotels subscribed, the peer pressure for all the others to follow would make cable television a standard amenity.

Of course, the problems and challenges we faced were even larger than anticipated. Ten thousand multi-channel television sets were a real strain on the production output of manufacturers at that time.

Also, back then, even the grandest of hotels didn't have television sets in their rooms. Since not every customer would pay extra for the service, hotels knew they would have to bear the cost. The other big question for the hotel chains was whether to install black-and-white TV sets or wait for colour. That slowed decision-making and hampered our ambition for scale. We needed to work with hotels to allay their concerns, as well as manufacturers to increase their production.

Now you might ask, 'Why are both these *your* problems as you try to build your own business?' My response: If you're clear about scale and aggressive about your plans, you have to make these concerns your problems too.

And we did.

As compensation for the additional costs incurred by the hotels, we introduced an advertisement channel that allowed the hotels to cross-promote all their other properties as well as each of their restaurants. The idea worked. Even today, you see that channel in most hotel televisions. Once the manufacturers knew we were serious and the hotels were ready to make a massive purchase, they saw this as a once-in-a-decade opportunity.

After a year of hard work, hard-selling and patience, we convinced most of the major chains across India to buy in. I had another motive for the hotels initiative: once our core audience experienced cable television when staying in a hotel, they would be far more likely to want the same service upon returning to their own homes. Selling to individual homes, the idea went, would become easier. And it did.

Second, within nine months of our first connection, we had already expanded rapidly. Even so, we got a lot of customer feedback on the price point. Our charge was ₹200 per month per home for the service, more than a princely sum at the time. To put this in perspective, cable TV charges across India in 2014, more than thirty years later, averaged ₹150–₹200. Of course, in 1981, cable television was a unique offering.

For the next few weeks, after listening to our customers, and considering our options, I went on all customer calls to the homes that were willing to sign up at ₹200, as well as to those who resisted subscribing at that price point.

The solution was clear. Within a month, we launched a second tier of the basic service, offering a lower price of ₹150. We also upgraded the ₹200 service to a premium one, with an extra hour of telecast time and more tangible bells and whistles. On an airline, everyone flies to the same destination in first class or economy. We positioned ourselves using that model in cable television, in essence offering economy and first class subscriptions. If I had not personally gone for all those sales calls—where some didn't want to even let us through the door, and many asked us to come by after 9:00 p.m.—the idea of dual pricing would not have popped into my head.

We tripled our business in the ensuing year, keeping the competition that had joined the fray by then at bay, while scaling our business.

◆

Sometimes, scale comes from necessity.

In UTV's early days, our core was creating TV shows. Since there was only the state broadcaster, Doordarshan, we were limited to creating thirteen to twenty-six episodes at a time before cooling our heels for months.

In 1991, with the Gulf War's coverage on CNN, satellite television was drawing attention across Asia. A year later, India launched its first satellite channel, Zee TV. Tracking its progress and liking what we saw, the creative team and I gathered to make our pitch to Zee. In the middle of the meeting, I threw down the gauntlet: we would pitch to do ten shows for the launch, provided we were given a minimum commitment

of one year's run per show—fifty-two episodes of ten shows, or a staggering 520 episodes in total.

We wanted scale. This was our chance.

My idea was met with scepticism, to say the least. But over the next month, as everyone warmed to the task, we brainstormed over twenty ideas. The month after that, we pitched all of them and came back with a contract for 520 episodes spanning ten shows at budgets that were a win-win for both us and Zee TV.

But nothing's that simple.

Our creative ideas struck a chord. But why would a client, himself a pioneer, place his trust in our company with what would account for almost 40 per cent of all that he was commissioning? What was in it for the client to give *us* scale? We needed an answer to both those questions before we pitched while, at the same time, continuing to excel creatively.

To preempt the first concern, my approach was to pitch each concept separately with its own captive team, as if this were the only thing we had on our plates and so could give it our all. We never pitched a bulk contract of multiple shows—no one-size-fits-all, no predetermined number of shows. In fact, the goal of ten shows and 520 episodes was mine alone, internal with the team and not to be shared.

Each team pitched with incredible passion. As our shows kept getting picked up, no one counting or ticking boxes on a master plan, the effect was cumulative. Zee TV had independently and without connecting the dots greenlit ten shows from one company.

By the time they realized what had happened, we were ready with the offering of a cost advantage—scale with us, and avoid the challenges inherent in dealing with multiple production companies and additional costs. We had taken three months to prepare for this moment. Our creative offering was a mix of studio-based shows—games, quizzes and chats—coupled with dramas and soaps.

For all studio-based shows, we could be cost competitive by aiming to record five episodes a day, versus one episode a day, the best anyone had accomplished. Our detailed plan came together with military precision. We knew we could pull it off—six studio-based shows and four dramas and soaps. The cost at which we offered to do the six

shows, provided we got all ten (this was the time to play the scale card, not while creatively presenting) was rock bottom. As a cost package, it made total sense for Zee to go forward. And we, based on the economies of scale and brutally efficient execution, could come out with a decent margin, too.

No one in Indian television at the time had come close to creating content on that scale. But we were about to embark on one of the most ambitious experiments in the history of entertainment. The idea wasn't silly or maverick. We just recognized a rare opportunity and seized it. To succeed would mean never hesitating again to find scale in our operations.

That one year, I don't think I've worked harder, slept less, worried more, or put more stress on our 500 team members to complete those various projects on time and on budget. The sheer logistics were daunting—it was like setting up ten factories or distribution centres all at once. But unlike plants or warehouses, here I was dealing 24/7 with creative people, and growing something out of nothing with talent and teams willing to be stretched to the limit. In such cases, Murphy's Law not only can, but most assuredly will, apply.

Still, we insisted that creativity and quality take precedence over cost, and we learnt to manage multiple relationships. We had taken on a challenge without full clarity regarding how we were going to pull it off. The industry was absent in trained talent, so today, when I see the same struggle for quality talent in e-commerce, healthcare, education, agriculture or big data, I can relate intimately. I lived that life for the better part of ten years at a time when the media and entertainment industry was beginning to take shape.

At the end of the day, just because a job hadn't been done before didn't mean we didn't have a plan to succeed and do the job well. We needed to be nimble at all times, get feedback and make sure that bad news flowed up very fast. It was project management and multitasking at its core, and we enjoyed every minute of the pressure-cooker experience.

And in the end, we delivered 520 episodes as promised.

Restless again and in need of an adrenaline fix, a couple of years

later we launched India's first daily soap, *Shanti*. Clearly, we had learnt a few things. Who says B2B limits your scale? You're only limited by your willingness (or otherwise) to break barriers and scale new heights. And you need to stay hungry for scale—not just once, but all the time.

◆

Years after many of those forays into scaling, a mutual friend introduced me to a real maverick, Haim Saban. At the time Haim had his own hugely successful animation and production company in the US, but his main claim to fame was *Power Rangers*, the top-rated series for kids worldwide that debuted in 1993 and has since spawned countless related series. Haim ran an animation powerhouse, and he was open to outsourcing his work to India. We met for dinner at the famous Japanese restaurant Matsuhisa in Los Angeles. I experienced a strong sense of déjà vu at dinner that night, recalling my visit to the brush factory in London, the trip that led to the founding of Lazer Brushes.

Now here's what makes exceptional entrepreneurs and what allows them to soar. Haim had had an amazing next decade, convincing Rupert Murdoch to a 50/50 joint venture to launch a Kids Broadcast Network, with Haim producing the bulk of the content, since News Corp had no presence in the 4-14 age group at all. Many years later though, thanks to a combination of uncanny business sense, good fortune and some favourable terms in their joint agreement, Haim and Murdoch sold their channel, which had grown in the US and Europe, to Disney for many billion dollars, taking Haim's media aspirations to a different league—all this, built on the reputation and popularity of *Power Rangers*.

We didn't have an animation facility in India as yet, but based on our comfortable chat that evening and on the strong recommendation of our common friend Jay Itkowitz, Haim and I agreed that we would deliver a trial order of twenty-six episodes of one of their up-and-coming series for production in our yet-to-be-created studios.

So what was I thinking, committing to a project with no set-up?

I had studied the market closely and knew that China and the Philippines had built large outsourcing studios for animation. In India, the IT sector was starting to grab global attention, and my slightly

arrogant self felt I had done this once before with toothbrushes and so, knew what it would take. (In fact, I understood a lot more about animation than I knew about toothbrushes when I had taken the plunge years before.) But most of all, I was clear and confident that I could create a talent base, build and empower a team, and grow the creative business to scale.

Back in India two days after our dinner in Los Angeles, I sat down with our team and discussed how we could create India's largest animation studio. The more I looked at all aspects of the process, from creative to talent, the more I realized that we'd need to pioneer all the way. I envisioned a production facility large enough to cater to more than just the outsourcing of one animated show.

As a start, I brought on board the father of Indian animation, the deeply experienced Ram Mohan. We hired a studio head and five division heads from one of the top studios in the Philippines before launching an academy to train 400 animators, all of whom would eventually work in the industry. The top floor of our office facility housed our cafeteria and some pool and table tennis tables; we shut this down and converted it into our animation floor. Recreation facilities would need to wait till we regrouped with more office space. In four months, we were in business.

If my entrepreneurial DNA hadn't compelled me to keep scale at the top of my mind, I may not have taken up that initial contract without an animation facility. Nor would I have brought in global talent and scaled with hundreds of animators.

It bears repeating: If you're not thinking scale, you don't need to think strategy.

◆

Our first quantum leap, from TV production to broadcasting, was with a Tamil channel; it was also the first time I looked at growth via an acquisition (everything I'd done till then had been built from the ground up). My colleague at Warburg Pincus, who had invested in UTV, called me one day and told me that Vijay Mallya wanted to divest one of his channels (no guesses for figuring why it was called 'Vijay TV') and

wondered if we'd be interested. I joined my colleague for a meet with Vijay that very evening.

Up until then, UTV hadn't given much thought to entering the channel space. Certainly not in South India. But I wanted to understand more about Vijay's motivation and the opportunity. We landed at Vijay's seaside house at 11.00 p.m. and got the royal treatment from his staff. Tied up earlier in the evening, Vijay arrived at 12.30 a.m. When we finally sat down together, he appeared fresh, energetic and ready to hammer out a deal. He took my presence there not as a curiosity-seeker, but as an interested buyer. For the next hour-and-a-half we listened to his pitch, his expectations and his strategy to divest the channel. It was an informative meet, and over the next four weeks we spent time in Chennai with our team, researching the details.

We met with Vijay a couple of times later to discuss the transaction. The deal seemed like a good buy at a fair price, and I negotiated a deferred pay-out over two years, too. It was a push, but it worked.

Since our sales team had worked closely for many years with the market leader, Sun TV, we were familiar with the Tamil television space and knew a fair bit about Vijay TV from the outside. Our biggest challenge in putting together the deal was that Sun TV was our client and partner at the time. We produced content and sold airtime for them in four South Indian languages. In truth, our revenue with Sun was larger than the business we'd be buying at Vijay TV.

It was important for me to apprise Sun TV of the developments with Vijay. During my meeting with the founder of Sun TV—the sharp, reclusive man of few words, Kalanithi Maran—I assured him of strong Chinese walls between our production arm and our broadcast initiative. To his credit, he took me at face value and gave me his trust. He always lived up to his commitment that he would not upset our business partnership as long as we maintained our confidentiality agreement.

That settled, we acquired Vijay TV from Mallya and spent the next eighteen months growing it. Wanting to scale our initiative even further, I approached News Corp/Star TV, a partner and investor in UTV, with a proposal to join hands and look at the broadcast space in all four South Indian states. They had no presence in the south at the time, and Vijay

TV would give them a good head start. Within three months, we had entered into a 50/50 alliance to work exclusively in the South Indian broadcast space.

My learnings from those multiple negotiations with Vijay Mallya, Sun TV and Star TV were vast. The headlines?

1. Don't get yourself in a desperate, 'must do' situation, and you'll always pay the fair and balanced value. When you don't *have to* consummate a transaction and have the choice to do so only on good terms, the negotiations are fairly balanced. With Vijay TV, we weren't buying a distressed asset. But as there weren't many suitors in play, we could negotiate a deferred pay-out.

2. Trust and credibility are crucial for building strong, long-term business relationships and require some give and take. Both sides need to see a win-win situation for the long term. In this case we needed Mallya's trust, especially since we had a deferred payment and were taking over the asset from day one. We had to earn Sun TV's continued trust regarding confidentiality as well. With News Corp, it was a David-and-Goliath joint venture, not something they would normally have done. In that case, *we* needed to be that credible partner.

3. When working with organizations that are clients in one business but competitors in another, strong Chinese walls are critical and must be built into your company's culture.

4. Domain knowledge is important, but some quick steps—building an experienced team, fostering key alliances and getting a strong review process in place—will get you moving forward. After all, I did not understand Tamil or speak it.

Our negotiation with Mallya is one more illustration that inflection points are created; scale is a reality only if you're always looking forward and not in the rear-view mirror. In a span of two years, we were one of the largest content partners to the market leader, Sun; a 50 per cent owner in Vijay TV; and in a joint venture with one of the top global media companies for broadcasting in four South Indian states.

On a lighter note, we signed the joint venture just a couple of days

before my wedding. Since our deal with Star TV was big news at the time in the media, I agreed to do a closed-door press conference to make an announcement at a private room in the Taj Hotel, Mumbai—between the wedding ceremony in the morning and the small reception and dinner planned for 250-300 guests at the Taj that evening. The press conference lasted for an hour-and-a-half; I then went across to look at the arrangements in the main banquet room, headed home, changed and headed back for our reception. While Zarina knew what I was up to all along, my in-laws and parents only figured it out the next day. Fun and heady days, those were.

◆

Starting a movie studio was definitely the inflection point of scale for UTV and took the company to a different level. It was not by chance or accident that this happened; it was a gutsy, out-of-whack decision, born of the realization that scale and brand creation were of paramount importance to us.

In the first few years, we moved swiftly to build our movie slate and began to make our mark in that space. In 2006, the success of *Rang De Basanti*—which became a cult hit and made it to the top five box office hits of all time—was our turning point, when we knew we had *arrived* in our movie-making journey. To celebrate, we released quarter-page advertisements on the front pages of all the national dailies. Most of the other movies we compared ourselves favourably with were by the two big directors and production houses then, Yash Raj Studios and Karan Johar's Dharma Production. Touting box office success and comparing *Rang De Basanti* with other movies was taboo and, as I came to realize, a first for the industry. Everyone does it now, but back then it was frowned upon.

When the advert appeared, I got a polite but concerned call from Adi Chopra of Yash Raj Studios; he suggested that he and Karan would like to meet me the next day at his office. I agreed. As I've mentioned earlier, I have the highest respect for Yash Chopra and for his son, Adi. I also love what Karan does. In fact, my plan for UTV to get serious about movies emerged after I saw Karan's brilliant *Kuch Kuch Hota Hai*,

a landmark movie. I sobbed through most of the second half and loved it enough to send a mail to Karan, whom I didn't know then. Although overseas, he replied promptly. That meant a great deal to me.

All that was some years before our meeting regarding the advertisements. I walked into the room expecting a polite reprimand for raking up competitiveness in 'an industry that does not do these things'. The meet was cordial but formal for the first half, but soon we all loosened up when it became clear that our intentions were pure. Adi and Karan loved *Rang De Basanti* and spoke of it with admiration. That day, my respect for Adi and his dad only increased. Karan and I became not just great colleagues but close friends.

A month later, Yash Raj Studios came out with a full-page advert hyping their hits for the year and proclaiming themselves as the top movie-production house. That ad inspired me to really think about scale for our own movie studio. Till then, as new kids on the block, it made sense for us to go step by step, feeling our way through unfamiliar territory. We now wanted to take a serious look at scale, not in any sort of competitive spirit but to reach our own benchmarks. In typical UTV fashion, we shot for the stratosphere, envisioning a pan-Indian and global distribution organization. Of course, that would mean creating or co-producing ten to twelve movies a year, at the time the largest production schedule or slate for any company in India.

To a lesser extent—but no less important in the long run for sealing our reputation as aspiring industry leaders and outsiders—our modest inroads into Hollywood gave us a completely different profile when just about everybody else was still dissecting the insular and increasingly homogeneous market in India. *The Namesake*, a 2006 Mira Nair film based on a novel by Jhumpa Lahiri, and *The Happening*, written and directed by Manoj Night Shyamalan, were tipping points for us.

Director Mira Nair and I had known each other for some time and had stayed in touch over the years. One day, I got a call from an excited Mira, who wanted to meet. We settled on breakfast at Mumbai's Willingdon Club. A bundle of energy, Mira's positivity brims over with great ideas. And on this occasion she could barely contain herself. She had recently stepped off a flight having read award-winning novelist

Jhumpa Lahiri's *The Namesake*, a story about a family's emigration from Calcutta to New York City and their subsequent struggles. By the time Mira had turned the last page, she wanted the book to be her next movie project. Zarina had read the book and loved it too so, indirectly, I shared Mira's enthusiasm. Mira has a foot in both India and the US, and she thought it important to have an Indian connection for any production of *The Namesake*. We ended our Parsi breakfast of Akuri eggs on a positive note, and a promise to keep in touch.

I picked up the book and read it over the next few days, drawn into a special story that had resonated with readers. I knew that if anyone could bring the novel's emotions and multilayered relationships alive, Mira was the one.

I told her so. And just like that, we were on.

Although *The Namesake* was an English-language Hollywood movie clearly targeting a Western audience, things moved rapidly over the next few months. Fox Searchlight, a division of Twentieth Century Fox came on board when they recognized what we all saw in the book, and in the script and screenplay that unfolded with some great writing by Mira and Sooni Taraporevala. Within two months of our breakfast meet, with Fox taking the lead, we were hammering out an agreement in a conference room at their studio in Los Angeles.

Mira was ready to roll. Before the ink had dried on the agreement, she had the film cast, including Irrfan Khan and Tabu from India and Kal Penn, who already had a connection with US audiences with his *Harold & Kumar* series. Zuleikha Robinson, who debuted in *The Namesake* and went on to do more great work, most recently in *Homeland*, was cast as the Bengali character Moushumi Mazumdar.

The Namesake made us proud. Mira took a fantastic book, screenplay and script to a new level of narrative performance. The film received positive reviews and did well at the box office. I expected it to do better worldwide, but it particularly resonated with audiences in the US.

Based on that experience, I wanted to take our 'Indian' connection in Hollywood to the next level. I had watched and loved *The Sixth Sense*, which totally disrupted the traditional Hollywood narrative. The life cycle of Manoj Night Shyamalan's most famous film paralleled that of

George Lucas' *Star Wars*. Like Lucas, who showed his film to every studio, only to have it passed (before Fox finally took it), Shyamalan confronted studio heads who were sceptical about his creation and whether audiences would 'get' his vision. Much like *Star Wars*, *The Sixth Sense* became a breakout film and a massive hit. Shyamalan became a household name in filmmaking.

A fan of Shyamalan's work, I wrote to him twice over two years but got no response from him. On the third try, many years later, we connected. The first time we met was at the Four Seasons in Philadelphia, Pennsylvania, after a twenty-three-hour hop from Mumbai. (Even though Shyamalan's movies look like they've been shot all over the world, most are filmed within miles of Philadelphia, his home for much of his life after being born in Mahé, Pondicherry.)

I arrived at the hotel at about 8.00 p.m. and was delivered the script of *The Happening* to read on the condition that I wouldn't photocopy or record portions of it under any circumstances. Shyamalan and I were to have breakfast at 7.00 a.m. the next morning. Jet lag or no, I ordered room service and read the script straight through that night before turning in.

I carried the script with my notes down to breakfast the next morning and was pleasantly surprised to see Shyamalan there with his wife and kids. Our meet-and-greet gave me a vibe of openness and transparency, which summed up Night (as he is mostly called). He was grounded enough to hear comments and critiques on his script even with his family there.

Night has a reputation as a quirky, eccentric character who listens to criticism but understands and trusts his own disruptive creativity. I found him quite pleasant, a loner, intensely confident, and clear about what he wants to do, all traits I see in myself. From then on, I was confident about his intentions and comfortable about working together.

Night's first project, *The Sixth Sense*, was such an enormous hit that his second and future acts inevitably became more challenging. That's the dilemma in every aspect of life—to continue to better your act, even after tremendous success has led to the sort of scale you could only have imagined a decade before.

Later, after watching the rough cut of *The Happening* in Los Angeles with my daughter, Trishya, who was in film school there at the time, I met Night at the Beverly Hills Hotel and was quite candid with some of my comments—that the movie was a bit too long, credibility and reality got stretched towards the end, and the ending was underwhelming. He was curious, genuinely interested in my feedback and open to the collaborative process film demands. By that time, we had built a good rapport.

The Happening was a co-production with Fox and Spyglass, another strong Hollywood studio brand. The two go back a long way. Spyglass backed *The Sixth Sense* when no other studio would touch it. *The Happening* grossed over US$160 million at the box office (and much more with television and ancillary rights thrown in). In due course, we learnt the hard way that the studios take the big profits with their distribution fees and more, and make reasonably one-sided contracts.

But for a movie that was budgeted at a third of the box office, our experience with Shyamalan was another 'scale moment' for us.

◆

Once you've built your business, you need to figure out what moves the needle. Finding scale isn't easy; if it were, every entrepreneur would pursue it. Most of us look at life in increments, so a jump to scale may be unfamiliar and uncomfortable.

Just to be clear: I am not evangelizing or pushing you to think scale. Boutique is good. So is specialist. Where you end up depends upon your vision and the combined vision of your team and colleagues. You have to define your own sense of scale based on your sector, whether you want to create a brand and where you want to take it, and the aspirations of your team members.

Now that you have the right approach, how will you train yourself to see inflection points, and more importantly, create them?

First, remember, size and scale, vision and ambition come from the leader or the founder, no matter how big or small the organization may be. Sure, the team and colleagues may participate in the process, but only based on your lead as the founder. You apply a personal context to

the scale you envision. As the owner or leader of the business, you and only *you* truly know its direction and velocity.

Many of you might rely on consultants and advisors to tell you what you already know. That's fine, to a point. The external view is one facet, but at the end of the day, it boils down to *your* call as a leader.

Also remember that while growing your own company, you are also growing the sector by adding value to the overall ecosystem—not just competing and conquering. The twenty-first century—governed by technology, the democratization of the consumer base and access to information—is all about collaboration and winning, not killing the competition and taking it all as the winner.

For me, your focus on creating a brand is a critical step on the journey to scale. This is not an easy task, and far more complex than the common view would have it—that brand-building requires little more than spending on marketing. But once you create a brand that stands for something, speaks of its own standards, has recall value with a large consumer base and brings credibility to your service or product, it can be a great inflection point for your company.

For instance, we wanted the UTV brand to stand for innovation and disruption from the start, exemplified by cutting-edge creativity—a diversified, synergistic entity spanning all aspects of media and entertainment. Part of the brand, of course, was the UTV logo— red, green and blue, the core colours that make up all visual pictures. Designing the logo, defining what it stood for and determining where it would appear was a subconscious brand-builder. We *never* spent money on advertising the brand, but rather on shaping how our various audiences perceived the brand on myriad screens: mobile, laptops, tablets, television, the big screen and more.

Ask a hundred people today what they recall about the UTV logo and specifically, what it connotes. Their response: creativity, passion, ideas with energy, innovation and especially, guts. At our peak on a given day, the UTV logo would be on multiple television channels beamed across forty countries and into more than 180 million Indian homes, on 5,000 movie screens, 100 million mobiles around the world, on the flights of twenty-five airlines, and more.

Entrepreneurship is a lot like life. Sometimes just asking the right questions presents you with half the solution—in this case, inviting you to see and seize opportunities you otherwise didn't know were in your grasp. That's why you chose to be an entrepreneur in the first place. You're accountable to the people who work for you, your consumers and your investors. And because you understand scale, your vision includes an element of restlessness and an obsession for growth.

◆

* Starting an enterprise, growing one and scaling one require radically different thinking. Be brutal about your own assessment and ambition levels and plan accordingly.
* As you scale, fine-tuning your company's 'differentiator' is critical.
* Inflection points need to be pursued; they don't just happen, you have to stay restless.
* At each new level of scale, the organization will need your team's focus and your attention to understand the consumer first-hand. This is not the best time to be delegating or multitasking. The vision and velocity for scale must finally come from you as the leader.
* If you are clear about your brand strategy, it can work as a multiplier while building scale.
* If you are ready to scale, take the plunge, not once but many times in your journey. So you're averse to risk? To hell with risk. Failure never stopped anybody who didn't want to be stopped.

7

Failure Is a Comma, Not a Full Stop

Insulating yourself against failure doesn't ensure success; it only makes success more elusive. Plan for failure. Embrace failure.
Tomorrow will still be there, no matter how dire today feels.

Like every experienced entrepreneur, I've had my share of failures at every stage.

After the initial growth of UTV, becoming a diversified media entity was high on the agenda. We were making inroads as a movie studio and a bouquet of broadcast channels. And although we had missed the bus in the main line general entertainment space, our new media and mobile games initiatives were getting good traction. Now, we were on the prowl for one big idea and initiative with a global skew.

In the mid-2000s, a UK-based console games company with some interesting intellectual properties under development approached us for acquisition. Games were all the rage and console gaming companies were doing better than the largest movie studios and media companies worldwide. It seemed like the move we had been waiting for.

However, many of my colleagues felt that entering the console games space could be a distraction for us and cause us to lose focus. Maybe they had a point. Although we had the founding team of that UK-based company staying on post the acquisition, we had limited domain knowledge about games. In fact, I think we made all the classic mistakes—not evident in those years during which we continued to invest.

Games creation, unlike creating most other content, takes two or three years to complete a cycle. During that time—an eternity in the world of technology—the creative work remains under wraps. The tastes of young consumers change daily. Predicting how creative work will be received by an audience is always a challenge, and any idea that takes three years from conception to launch risks being outdated for its core audience. Sure enough, console games became a poor cousin to social, multi-player and mobile games. The only success stories to come out of the sector then were the sequels of popular game franchises that a generation had grown up on and continued to play. In short, we got stuck in a time warp.

I realize now that arrogance had also crept in. I had worked successfully with creative teams in television and movies for a decade. We had proven ourselves repeatedly as brash outsiders. Our sense was that in the domain of games creation we could be successful simply by being great creative catalysts.

Flat wrong.

When your own deep knowledge of a market is low, you become even more dependent on the judgement of teams too close to their projects to be objective. That's a dangerous point for any sector or business. And that's exactly when things tend to go downhill.

Midway into our foray into games, we received an offer for one of our companies to be bought out at twice our initial investment. We turned it down. Arrogance again, as we were already facing headwind on many aspects of the initiative. Instead of seeing the offer as a neon lifeline screaming 'EXIT THIS WAY!', it only endorsed our view that we were on the right path and increased our confidence (overconfidence, as it were) that in the end we would succeed, creating massive value.

Little less than a decade later, Mark Zuckerberg said the same thing—that Facebook was his best idea and that he wasn't willing to share it with the world until he was good and ready. It worked for him. But for mere mortals, the story doesn't always end well. My instincts for diversifying into console games didn't play out as planned. Worse, I got most things wrong.

Within a year of our entry, console games were losing their cachet. While my experience should have taught me to recalibrate based on possible outcomes or even to pull the plug, my thought processes weren't rigorous enough. To succeed in games globally was a seductive, disruptive thought—if we pulled it off, the rewards would be disproportionate and enormous. For that reason, logic and a brutal review of the state of the industry and its direction worldwide went out the window. When I had the answer I wanted—that to stay in games was our best play at that point—I stopped thinking ahead.

Strong learnings for the entire team.

'If everyone is thinking alike,' General George Patton said, 'then somebody isn't thinking.'

The only consolation was that our initiatives in the mobile games space in India worked well. We remain market leaders till date. But the postmortem on our gaming venture wasn't pretty. We had made enough glitches and had had enough signs to suggest that we were headed in the wrong direction. The problem for me, more than not admitting defeat, was that the deeper we were financially invested, the harder it was for me to take a call. There were many days when I would debate the issue endlessly in my mind. Another classic mistake and error in judgement.

Envisioning your startup or your established company as the Next Big Thing is tempting and dangerous. I was infatuated with the idea of making something of the console games sector at the wrong time. Although its ultimate failure is something I regret till today, I took away three important lessons:

1. there are consequences to getting your selection of your team and leaders wrong;
2. the importance of acquiring domain knowledge—or at least the

ability to ask the right questions if you want to succeed in a new initiative at scale—cannot be overstated; and

3. it's vital for a global operation to ensure rigour in review procedures and constant consumer dipsticks to make up for a lack of line-of-sight control.

These learnings will stand me in good stead in my second innings, I'm sure. I've earned the indelible scars of failure.

◆

Failure is inevitable. One of the hardest and most enduring lessons everyone in business learns is that not all great ideas succeed. Plan for failure. Embrace failure. But understand that failure is a comma, not a full stop. You don't fail in life when one thing goes wrong. Tomorrow will still be there, no matter how dire today feels.

Looking back on more than two decades of constant engagement with one business endeavour or another, I see a pattern. India, in general, lacks confidence as a country of entrepreneurs and leaders. Confidence is built over time. Not all of us with dreams are capable of jumping off the cliff, even when the water is deep. And when we summon up the courage to take the leap, some of us are so petrified by the idea that we forget to breathe once we hit the water, and simply drown.

First comes survival and then success. A realistic success plan should be your focus—it's why you embarked on your dream in the first place. Your survival plan, on the other hand, better equips you to react to setbacks and come through stronger than ever. It's not a Plan B, just a considered option for endurance.

The success plan for most startups and mid-sized companies aligns costs and goalposts when things are going well, but often fails to account for recalibration when those inevitable bumps are hit. Without a survival plan, every bump appears as a failure rather than a setback. And survival begins with knowing and accepting failure.

Maybe you're sitting on the fence when it comes to realizing your entrepreneurial dream. In that case, the possibility of failure is probably

your biggest impediment.

Or maybe you're seven years into your journey, and you think you've already crossed that bridge, that 'failure's not an option'. The truth is, you'll *never* cross that bridge. Once you feel bulletproof as a leader or founder, your false sense of bravado has already sealed your fate.

You've got to understand sacrifice. Ask yourself, *What am I willing to give up to succeed? How dedicated am I to staying the course when I meet my first setback? And how hard will I work to recover from my second setback? My third?*

Understanding and accepting failure now will give you the clarity and the resolve you need to survive the big bumps. No matter who you are, how solid your connections, your financial status, or any of the thousand other factors that determine the success of a business, understand one thing: *At some point, you're going to fail. And not just once.* Internalize that reality and make it part of your entrepreneurial and leadership DNA. The only question you need to answer is: *When I fail, how will I respond?*

What's worked for me over the years is to recalibrate and consider my worst-case scenarios, gauge my ability to cope, and work on viable solutions without panicking. Once you can do that, you're already on the road to recovery.

Pen and paint your thoughts clearly. Discuss the direction you wish to take with a small group of people whose judgement you trust, or with your spouse or your parents. Besides finding the process of sharing your crisis therapeutic, you'll be surprised at how supportive family and friends can be when they see pain and uncertainty on your face. A fresh perspective always brings with it a sense of calm. When you've come to grips with the worst case, then begin to paint more positive scenarios— tough to do when the world is crumbling around you, but necessary for your success.

You're the head of the company. Everyone looks to you for leadership, particularly at the most difficult junctures. Whether you have ten or ten thousand team members, the best way to turn a setback into an opportunity is to take your team along with you. They'll be your source of support and celebrate with you when you surmount your

setbacks and reach your goals.

◆

From our early days in media and entertainment, we focused on understanding the consumer and audience as well as they knew themselves. That constant interaction with consumers led me to consider pioneering home shopping in India. The idea of home shopping then was as groundbreaking as cable TV was a decade earlier. However, the line between pioneering and being before your time is often hard to see—and as we went on to build the home shopping model, I realized (much later) that we were well before our time.

In the mid-1990s, Indian consumers weren't very interested in buying products that they weren't able to touch and feel first. To see a product on TV and then place a call, buy it and have it delivered to the home was an alien process for most; for an entrepreneur who dreamt of introducing India's huge, untapped market to the convenience of shopping from home, this was a formidable barrier. In addition, no real infrastructure existed for home delivery or payment by credit cards. In other words, we were staring at a logistical nightmare.

Of course, none of that stopped us. The Tele-Shopping Network (TSN) was born.

One of the key first steps was to hire a strong team, from the CEO to managers for product sourcing and logistics. I often see startups and mid-sized companies getting their level of hiring wrong, as they understandably want to control costs. But a judgement call can shape the destiny and the growth of your company, which depends upon your ability to hire quality people. Keep hiring for the scale at which you're currently operating while growing more than 50 per cent a year (which most early-stage companies do), and you'll outgrow competence every six months. Hang on to a team that can't keep pace, and your growth suffers. Keep flipping teams, and your learnings go right out of the door. It's a hard call, but be clear and take it.

At TSN, we focused on products that didn't need the 'touch and feel' element, depending instead on impulse buys offered at a bargain price. Our instant hit product was a roti maker that sold like hot cakes.

Ironically, this early brush with success caused us to lose sight of whether we were pioneering or were before our time. A single product doesn't make a business, especially a business with scale, and soon the small manufacturer of the roti maker, who had suddenly shot to fame with 'As Seen on TV', couldn't cope with the demand.

As if the short supply of our top-selling product wasn't enough of a problem, we had another setback on our hands. While we had late-night slots on some satellite channels, our main audience and consumers came from our slots on Doordarshan, the national broadcaster that reached out to more than half of India's population. One day, out of the blue, and with scant regard for our written contract, the new head of Doordarshan decided that home shopping per se was 'consumerism' and therefore not suitable for a state broadcaster. We were unceremoniously pulled off air with less than a week's notice.

These serious setbacks were all suffered by the end of our first year. Seventy per cent of our revenue came from only one product, the roti maker; our main channel had taken us off air; and we had an inventory, staff and costs to justify a much larger operation than we had been reduced to. Perhaps worst of all, the Indian consumer hadn't taken to home shopping on TV with open arms, nor had the logistics of delivery and collection been made any easier or more efficient.

While wondering how such a good idea could come to grief so quickly, I arrived at two important learnings for the future:

1. a survival plan should have been a necessity, since we knew we could be ahead of our time and would need to pace things accordingly, especially our costs and burn on capital; and
2. I wasn't focused enough to succeed in the environment in which we found ourselves. At the time, I was also busy building UTV. TSN was a diversification, which was why I invested in a strong team from the outset. At the end of the day, though, when faced with so many challenges, TSN demanded my personal focus and attention as well. I had not been able to give it my all.

Still, not once did I think we wouldn't make it.

I truly believed we were breaking new ground, and we did our

best to stay the course. Over the next two years, though, a lot more happened to suggest that home shopping wasn't going to work. For one, though we managed to establish a presence on other channels, the lack of depth of those slots couldn't fill the void of Doordarshan. We also reduced our dependency on the roti maker because we continued to have difficulty matching demand. With these setbacks, the core team moved on. Although we got private equity to back us—which meant we weren't the only ones who believed the business had legs and scope in the long run—the expanded board brought in a new CEO who seemingly did everything in his power to drive the business into the ground. He was the wrong hire, and the accountability was all mine. I realized only later that not acting on this like a sledgehammer and sending him packing was my foolish mistake. Again, my lack of focus had taken a toll.

In the meantime, I continued to think big for TSN. Whistling past the graveyard.

I believed a partnership with a global player would be a good move for us, so I approached Home Shopping Network (HSN), the largest home shopping company in the world, with a cold call. I followed that up with an overnight trip to Tampa, Florida, two months later to meet the senior team at HSN and check out their set-up, studios and entire back-end. Two weeks later, I was on a three-day break in Goa with Trishya, who was nine at the time (I was a single father then), and tucked her to bed before beginning a long conference call with the team at HSN. So as not to wake her, I whispered my way through some serious clauses in a term sheet for a close to 50/50 joint venture, which we locked that night on the phone. But in the months ahead, as we started digging into the nitty-gritty of it, with their teams coming to India and sharing working notes, styles and models, it became obvious that the partnership wouldn't pan out.

When a company like HSN is so phenomenally successful in its country of origin, that success brings with it the assumption that what works on home turf will work everywhere. In many Western countries that may hold true. But in the India of the mid-1990s, our partner wanted us to focus on the top of the pyramid and sell premium

products with a minimum price threshold. I was adamant that we needed to reach the mass segment, both in terms of product selection and price sensitivity, while keeping our fixed costs low.

Eventually, my gut proved to be correct. The joint venture was a non-starter.

In hindsight, a bad call on my part? I don't think so. We brought in two of the savviest, fairest and most supportive private equity investors from Silicon Valley. The US was in the middle of the dotcom explosion—wave, boom or bubble (depending on where one had invested)—so most of our board reviews revolved around three questions:

1. forget profitability—how do we grow revenues?
2. how long will the cash last and when do we go out to raise more?
3. how do we move home shopping online?

Since we were a business ahead of our time, we wanted to keep the pace slow and steady, even if we were being prodded quite aggressively to expand into the online space. To my mind, diversifying into online shopping while working to overcome the challenges of touch-and-feel issues as well as delivery and collection logistics was a bad idea. But our CEO embarked on a global sourcing of products when we had more than enough to exploit here in India and invested heavily in a web presence—meant more to impress the board than to drive sales. Both were costly distractions.

By most metrics, my home shopping experience was a failure and a huge financial setback. I was still hand-to-mouth and not drawing much of a salary from UTV. It was also the first time private equity investors took a shave on their investment in me—a failure that stings till date. However, even today, when I consider everything that went wrong, I feel that we could have held on and stayed the course.

If we hadn't got distracted with the web.

If I had had a survival plan from the outset.

If, if, if.

I should have followed my gut, spent more time on TSN in that last year. If we had stayed with it, the scale and size of the enterprise today,

both offline and online, would have made us the undisputed market leader.

But that's life.

As with any failure, you have two options: live to fight another day and move ahead with full energy; or walk away. With the failure of home shopping, I could have wrapped myself in a cocoon of self-pity. But the experience gave me massive learnings that stick with me to date—ways of seeing and dissecting the ecosystem and predicting how it will evolve. The fact is, every failure, far from being an impediment, can open the door to a treasure trove of learning.

Even now, in 2015, two decades after my tryst with home shopping, I would like to sound a word of caution: There is *never* an unending flow of cheap capital that can continue to fund businesses without strong fundamentals or those not focused on profitability.

◆

Insulating yourself against failure doesn't ensure success; it only makes success more elusive. To learn from failure, you have to be able to define it, benchmark it and put it in its proper perspective.

Failure means something different to everyone. But if you want to succeed, it can never be an endpoint. Be clear about what failure means to you. Remove the roadblock that is failure from your thought processes. Dealing with the inevitability of failure should be cathartic, not crushing. Even the way you think of failure and the language you use to describe it makes all the difference. Take the stigma out of the word. Think of failures as *setbacks*. And when you experience a setback, you reconsider, recalibrate and rebound.

Go into projects thinking you have a one-way ticket, no return. That way, you're in for keeps, through thick and thin. If you have the option of retreating to a safe zone, you'll head there eventually. From day one, my thinking has been one-way, never allowing for entrepreneurial retreat. That mindset has seen me through many tough times. When looking back isn't an option, the forward view isn't as daunting as you might think.

So maybe you set a goal for yourself and you didn't reach it. Maybe that failure was public, not private. I understand these situations better

than most. I come from an industry where every failure *is* a public failure. No matter how insignificant the setback may be to the daily lives of those reading the story, every detail becomes an item for public scrutiny, every misstep an opportunity for second-guessers to try and make themselves sound smart and connected. The media will pile on with enthusiasm, only adding to the negativity. If all you hear is the constant din of failure and fear your life is headed south, you'll never be inspired to step into the world. But if you learn to deal with it, as I urge you to do, then at most times, especially when things go *north*, there's nothing more satisfying.

In India, we've become part of a self-sustaining echo chamber critical of people who work hard to realize their dreams. Competitors, naysayers and dream-killers, from their safe perches along life's sidelines, criticize and pull people down instead of joining life's beautiful, wondrous, often shambolic, dance. Most of those critics have never created or built anything, nor will they ever understand the challenges and the great satisfaction of steering a ship to its destination. Even so, they act as though they're the experts in the room. Hypocritical to the extreme.

But leaders have to endure this, too. That's the real world. Let criticism and public failure strengthen you, not diminish you. In the end, you're not answerable to anyone but yourself. Be your own best critic and handle any setback with strength, perseverance and dignity. The art of recalibration requires confidence and the courage of conviction.

It's like climbing any mountain—you tip your head back, look towards the sky and wonder how on earth you're ever going to reach the summit. When you've calibrated your worst-case scenario, the fear ebbs, failure becomes an abstraction, and you take that first step forward into the future.

◆

Embracing failure opens doors.

Like world-class footballers who mesmerize with their footwork, successful entrepreneurs change course and adapt on the fly with deceptive ease. Half of all businesses don't end up at the destination

imagined by the founder at the outset. Smart entrepreneurs pivot. Even smarter entrepreneurs shrug off their latest failure and move on.

Failure isn't always about things going horribly wrong or not to plan. Failure is often about missed opportunities and unfortunate timing, both of which can be life-changing events in the destiny of a company, its employees and its shareholders.

One of my biggest setbacks was missing the first wave in the satellite television broadcast space, when it all started happening in 1992. Rupert Murdoch had just bought Star TV from Li Ka-shing for just US$1 billion (which seemed like a fortune at the time and an incredible bargain now)—but then, Murdoch has always been known for his brash moves coupled with the incredible power and patience to stay the course. On most occasions, that combination delivers for him big time.

Many Indian companies were lining up in Hong Kong to grab a share of the satellite boom in the Indian subcontinent. Subhash Chandra, an Indian visionary and a personality as strong and gutsy as Murdoch, ushered in the TV boom with the launch of Zee TV. Indian television hasn't looked back since. While we were proud to play an integral role in Zee's launch and success in those early years with our large content output, I didn't consider being a broadcaster, never realized that scale was within my reach. As a first-generation entrepreneur nascent in the media space and with limited or no resources, I didn't think I could pull it off.

One would not call this a failure per se. But I thought of it as a failure later, when I began our delayed entry into the broadcast space and understood for the first time what our hesitation had cost in terms of scale and overall success. Of course, one assumes everything would have fallen into place after such a substantial gamble. But if we had stayed the course as the early players did—and it wasn't smooth going for any of them—I believe we would have prevailed.

◆

Here's one lesson I learnt at a very early stage of UTV's journey: When facing a serious setback, when everything begins crumbling and employees and investors start asking existential questions about the

company, you've got to *communicate* candidly and lead from the front. In these situations, people will look to you for answers. Give the wrong answer, droop your shoulders, or act defeated, and you've lost your team before you've had a chance to recover. Instead, stay on top of things. Be the strongest and bravest person in the room. Have all the answers. That's why *you're* the entrepreneur, the leader.

Business partners and clients will look to you for clear communication. You need to be proactive. You'll be amazed and gratified at how much support you can muster when you communicate openly and with a realistic sense of hope that you'll prevail. Everyone has to go through ups and downs. They just need to know that *you* can still see the light at the end of the tunnel.

In UTV's third year, through no fault of our own, we hit a bump that looked a whole lot like the end of the road. Our mainstay at that time was the television shows we created and telecast on Doordarshan. One in particular, a twenty-six-part quiz show called *The Parliamentary Quiz*, aired an episode with the question, 'Who is the *show boy* of the Indian National Congress (INC)?' For some reason, a few members of parliament misheard the question as the 'playboy' of the INC. An innocent enough mistake. But the ensuing misunderstanding created a massive uproar in parliament.

We got a late-evening call summoning us to parliament the next morning to explain ourselves. Armed with the facts, we sat before a group of understanding senior members of parliament. The ongoing controversy was easily clarified, but the show was still yanked off the air.

I knew in my heart that, once gone, the show would never make it back. The model on television at the time was that the production company, in this case UTV, would bear all costs for the production of a programme, recouping the initial investment and ideally turning a profit from sponsors who paid for the airtime. All episodes were pre-recorded, so the spends had already happened. The show was dead, which meant we had no way of recovering a single rupee of our investment.

In the early 1990s, we didn't have shock absorbers in place to take such a financial hit. At that stage, every single one of our thirty-five team members understood the impact of that simple, profound

misunderstanding. The office carried an air of gloom and uncertainty, with employees wondering about their place on the payroll and whether they ought to start looking for jobs elsewhere.

First thing in the morning after returning from the parliament meets in Delhi, I shoehorned the entire team into the largest room of our tiny basement office and levelled with them on the situation. 'We all need to get razor sharp on any and all costs for the next three months,' I told them, glancing from one concerned face to the next. And then the difficult part. 'I'll need a one-month delay on half your salaries for three months. There's no question of a slowdown. In fact, we need to increase the tempo on all our activities.'

Some of the team was visibly shaken, others unhappy at the situation we found ourselves in. But we moved from relaying bad news to chat mode, attended to many 'what if' questions, and then brought a bit of humour into the discussion. As dark as the purpose of that meeting was, it was important to have laughter to take the sting out of things. Nothing like a few laughs to act as a balm during even the grimmest of days.

When we were done, I saw palpable relief on the faces in the room. Not just because they were pleased that someone in charge was speaking with a level of confidence, but because they were all emotionally attached to the company and committed to working through the setback. The even bigger relief for most was that their career paths were intact.

Fourteen members of the team insisted on taking me out for a drink that evening, knowing well enough that I don't drink. But they needed to show their solidarity. An emotional day for us all, to be sure, and a huge leap in establishing UTV's culture for the future. The team's commitment levels soared, and many continued with the company for years afterwards. Today, they remain the company's strongest ambassadors.

For the next three months, everyone was on constant red alert and at battle stations. Not a single cost went unnoticed. Discipline and frugality became a part of the company's template for the next decade. Our creative team camped in Delhi to work on a new show with

Doordarshan—which, on its part, was feeling bad about our losses and was empathetic to our problems. We got them to greenlight a show in short order and then had to convince our sponsors for the quiz show to back us blindly on the new project, to trust us enough to give up an advance payment. The sales teams in our other divisions went on overdrive for new business. There was a fair amount of media coverage on this silly fiasco and so we did have the industry's support. Even our creditors stood behind us, thanks to our visiting each and every one of them personally at their offices.

In the end, we recovered from the setback, all because thirty-five committed team members recalibrated and stood together.

On the day I addressed the team, I couldn't be sure that we'd survive. But I was a hundred per cent sure the team and I would do everything in our power to find a way through.

No one enjoys setbacks, but bumps in the road beleaguer all of us at some point and contribute to our continued growth as entrepreneurs and leaders. You and your organization can never learn and evolve to the next level without setbacks and failures. It's in your DNA to take risks, make mistakes and even fail, provided you don't repeat any error in judgement twice. Remember this, and the highs will be even higher and a lot of fun.

◆

• Failure is as much about missed opportunities and poor judgement calls or procrastination as it is about things going wrong.

• Think of failure as setbacks. Dealing with failure should be cathartic; it should lead to introspection and not be crushing.

• To recalibrate after setbacks requires confidence and conviction and, most importantly, your entire team's support. Open and frank communication is the most powerful tool for springing back from setbacks; you need to share your problems and not carry the full cross on your shoulders.

• What's worked for me is to privately have a success plan and a survival plan (the latter is not a Plan B!).

• In the twenty-first century, it's all right to not be the first one to hit

upon an idea. It's fine to be a smart second or third, with a lot of insights from others.

• In the next decade there will be more books published on 'how I failed' than 'how I succeeded', when publishers realize what entrepreneurs already know—that failure is more interesting and instructive than success.

• At the end of the day you're still here, with the courage and the confidence to write your own story—the one about how you took a few missteps on your journey and, in the end, succeeded anyway. Write that book. After all, failure is a comma, not a full stop.

8
Stay the Course

If failure is the most difficult obstacle for aspiring entrepreneurs, your greatest
attribute is your ability and willingness to stay the course;
this is the Holy Grail of business.

Grit and determination are the keys to success. Mangalyaan didn't make
it to Mars without a dedicated team that took on and overcame every
obstacle in the path. Nobel Peace Prize winner Kailash Satyarthi has
saved more than 80,000 children from child labour and faced roadblocks
at every turn. So why do remarkable people do what they do? To
challenge themselves every day, reach their limits, push against them
and transcend every impediment in the hope of realizing a dream.

And they get where they do by staying the course.

Everybody feels fear and uncertainty when things aren't going well.
Ups and downs are part of life and business. If you're like most people,
you focus more on the downs, the unexpected problems that confront
you.

But staying the course is about preparation, planning and agility
in difficult times. It's about overcoming that crisis of confidence and
ploughing on to reach your goals. This doesn't mean you can't pivot or

cut your losses if you see something is really not working. In fact, that's a part of your strategy of staying the course for the long haul.

If failure is the most difficult obstacle for aspiring entrepreneurs, your greatest attribute is your ability and willingness to stay the course. In business, things won't always go your way. People will question your every decision and insist that the direction you've chosen won't allow you to reach your goals. Your competitors will strike mercilessly when they sense a weakness. Staying the course isn't the most complicated business philosophy you'll come across, but it *is* the Holy Grail of business.

◆

Once I experienced the intense adrenaline rush of entrepreneurship, I knew I'd never do anything else. The more I strove to make things happen, the more resilient I became when things didn't quite pan out. I slowly learnt what it took to bounce back.

As I mentioned, one of UTV's first investors was New York's Warburg Pincus. I've stayed in touch with the team that was on our board for many years. On a flight to Singapore about the time I was moving out of Disney UTV and media and entertainment, I had a chance encounter with Dalip Pathak, one of the firm's partners. We sat just across the aisle from each other, settling down for a four-hour nap on the short flight.

'Good to know you're starting off on your second innings, but I've got to tell you something,' Dalip said with a smile. 'When we dealt with you, we always knew you would do just what you told us you'd do. That was crucial. Sometimes it worked and sometimes it didn't. Hell, I remember five, six times when things could have gone south and the end was near. I'm sure there were many more occasions I don't even know about. But here you are.' He shook his head.

In those few seconds of silence, I raced back through the events he recounted, a bunch of close calls that could have signalled the end of things even before we really got started.

'Normally, a cat has nine lives, Ronnie. You've had more like twenty!'
'I think you're right!' I agreed. And since then, the nickname has

stuck: 'Cat of Twenty Lives'. I took that title as a badge of honour. We had a good laugh over those shared stories. Later, the true impact of that chance conversation hit me.

Were we unique for having navigated the minefields for as long as we had and coming out at the other end, stronger for the daily challenges thrown our way? I don't think so. But we were persistent, despite having more than our share of problems: bad timing, poor judgement calls, missed opportunities, near-death experiences and many, many stomach-churning days, weeks and months where nothing we tried seemed to work. A quick mental count offered up many more than twenty times in my career—not just within UTV but from the beginning, in theatre, toothbrushes, cable and beyond—when things could have gone far differently if we hadn't stayed the course.

Entrepreneurs face extraordinary challenges every day. Maybe your product or service didn't find the massive market you thought was out there. Maybe you ran out of money, didn't get the next round of investment, or made one big bet and lost it all. Maybe the founders split or growth just dried up. In business, it seems, a whole lot more can go wrong than right. Success is never an accident and seldom occurs overnight, far from what the media sometimes writes when touting the next killer app or must-have product.

So what separates industry leaders from obituaries? Staying the course is a crucial, unsung, often thankless task that falls to the person in charge and the core team. My experience tells me that value creation often comes from just lining up with everyone else at the start line.

Hit the tape at the finish and keep running.

◆

When we embarked on our cluster of TV channels, from Bindass to UTV Movies, from UTV Action to UTV World Movies, I also personally wanted to enter the business-news space. CNBC was far ahead of the pack, and this offered us a unique opportunity. We launched as UTV Business News, tied up in the initial days with ABC (thanks to our Disney connections, since ABC is a part of the Disney family). But to get to the next level, we needed to partner with a leading brand in business.

Bloomberg was the obvious choice and a perfect fit for us.

I knew in my heart of hearts that approaching Bloomberg and working out a deal for a proposed Bloomberg-UTV business channel would be a challenge. The field was extremely competitive, and we had a small problem. Michael Bloomberg had made it clear publicly that Bloomberg did not franchise its brand and product out, nor did it make joint ventures easily. In fact, the organization prefers to build from the ground up when taking on worldwide initiatives.

Knowing this, I started to convince their leadership team that they needed to make an exception in India and allow us to forge a content alliance, by co-branding their channel with UTV and calling it Bloomberg-UTV. We received positive feedback from them. Keen as they were, though, there was still no deal. From our side, we couldn't achieve our goals without a co-brand.

So, for the next twelve months I stayed in regular touch, dropping in to meet with them whenever I was in the US. Twice, I made a day-trip to New York City just to continue my credibility-building exercise— landing in the morning after a sixteen-hour nonstop flight, spending two hours with them to stay in touch, no agenda, and then grabbing another fifteen-hour (tailwinds) nonstop back to Mumbai. Those were gruelling flights, but well worth the effort. Because one day, on one of those 'just-in-the-neighbourhood' visits, the thaw happened.

Bloomberg, at that point, was looking at the best way to expand into countries where it couldn't operate its own channels. A couple of months of negotiation followed, the foundation of which had been laid over a year and multiple meets, culminating in a call to me as I spoke at an investor conference at the Taj Mahal Hotel in Mumbai. Bloomberg had completed its internal discussions early morning in New York. I stepped out of my session to take the call, standing on the staircase of the old Taj building on a Mumbai evening. We had three hard points to close—a fixed, non-negotiable license fee, a small equity stake subject to regulatory approval and strong synergies with the Bloomberg terminal business—and the deal was offered on a take-it-or-leave-it basis.

It was a fair deal. We went with it.

With a tremendous sense of satisfaction coupled with a stray bit of

conviction in myself, I leaned on the staircase railings of the Taj and stared up at the iconic dome that would later, tragically, be blown up by terrorists in the 26/11 attack. I'd put a great deal of time and effort into cultivating this relationship, a first for Bloomberg as well. One of the iconic global names in business had agreed to co-brand with UTV. It said a lot for our own brand. Our agreement became a template for Bloomberg and, as the leadership team proudly informed me later, it is a format they now follow in many countries around the world. What I did in securing that deal wasn't extraordinary. But I learnt a couple of strong lessons regarding entrepreneurship:

1. staying the course is a conscious strategy and helps you achieve those goals that would have been out of your reach had you called it a day; and

2. success comes from thorough preparation and positioning in the early stages; absolute commitment to an idea and laser focus on your goals; the ability to build credibility for you and your team; and the confidence that comes from acting with determination and with a clear, uncluttered mind.

◆

The more I introspect about the past two decades of experiencing and witnessing business, the more I attribute much of our success to our ability to stay the course. In an honest moment, I would also chalk up a few of my biggest failures to my unwillingness at the time to persevere—our dive into home shopping being the best example.

Entertainment and media can be a sexy, seductive industry. But the energy and passion that lures entrepreneurs in the first place to the glitz and glamour of the media only carries them so far, before a lack of expertise and the law of averages catch up. UTV was founded in 1990. Statistically, the majority of entrepreneurs in the media have a seven-year life cycle. That means our twenty-plus-years run puts us close to the right side of the longevity curve. Our move into Bollywood and broadcasting changed our profile and took UTV to the next level. Even though we were strangers in a strange land in every way when we

arrived in the late 1990s, we went in eyes wide open.

The secret to working through difficult situations—whether these are with teachers, rivals, competitors, friends or parents—is to never show that they bother you. Level your gaze beyond the horizon. Life is too short to allow others to make you feel inadequate. That sort of determination often predicts success and begins with a focused, committed thought process. Do what needs doing. Figure out what went wrong and fix it. Look out for the truck that's about to run you down and sidestep it. Plan for success and insist on survival. The very worst thing that can happen to you as an entrepreneur is that you will go out of business and back to base camp. To survive is to give yourself a fighting chance to succeed.

◆

When planning for the future, it's critical to build your team for the long haul, too. Your team needs to believe in your vision and commit to not jumping ship at the appearance of every high wave. That said, you can't always know at the start, when you hire, who's in for the long term and who will be gone before you've said hello. But as a leader, it's for you to spot talent, nurture it, share ideas, involve team members and reward them until both sides are on the same page.

We're not talking about a 'till death do us apart' commitment, of course. In this 24/7 world, prevailing wisdom holds that everyone at some point looks at his career in terms of quick turnarounds. The arbitrage opportunities seem much better for most professionals or intrapreneurs to keep jumping careers—but that's where you as the leader come in, to convince your team of the big picture and why the best learning, growth and wealth creation can happen if you all stick together. In UTV, I worked hard to create a strong sense of ownership. Many of the team members stayed for the full first cycle of our growth over a decade, and many for the second. A few, including my co-founders, stayed the full course. In the toothbrush space, too, it took me about two years to identify who was in for the long haul, once they felt a common vision and passion.

At the risk of generalizing, it should take no more than six months

for you to know if you've made the right hire; the same holds for the person joining your team, once she has had time to define her role within the company, see her way clearly, and think about the company and her future as a part of your team. It takes about two years for both sides to gauge whether long-term success is on the cards.

I can't sum up the value of teamwork, retention and staying the course, mentoring and leading from the front while creating a culture of ownership better than Sid Roy Kapur, when he wrote me a mail in early 2014, just after taking over from me as the managing director of Disney India:

As I complete twenty years of my association with UTV today, I cannot but reflect when I was seven years old and your bringing all this amazing technology called cable TV into my thrilled household. I was amazed that the owner was coming to check each and every connection and how good the reception was. Inspired by what you were doing in media, which was exactly the route I wanted to go down, I took up an internship at UTV in 1994. I have today framed my first letter of appointment signed by you with my stipend at that time of ₹2000 per month. I worked in the in-flight department with late night edits and brainstorming, and was amazed that you as the founder were also still in office with us at 3.00 a.m., there to do a voiceover and check the capsules before they went out. It also happened to be the fateful summer when News Corp invested in UTV and *Shanti* was launched. As a young, ambitious intern, there seemed like no better place to work in media and no one cooler or more inspiring to have as a role model!

A decade later, after doing an MBA, working with P&G and then with Star, with whom I was based in Hong Kong as one of their youngest VPs, when you called to ask me if I wanted to come back and work with you to build the movie business, since you'd just greenlit *Rang De Basanti* and *Parineeta*, I was on the next flight back to Mumbai! And here we are a decade later with you moving on to your second innings and passing on the mantle

to me of this new combined entity. There is so much more than serendipity here. It's your vision, always forward-looking and ten steps ahead of everyone else. We will all cherish and miss your planning and mentoring by inspiration and osmosis than by design, and that's one of your most amazing traits, as a leader and an entrepreneur.

◆

Some of the most specific memories I have of my career are small events that take on much larger significance later, reminding me why I became an entrepreneur all those many years ago.

In 2003, *Swades*, one of my favourite movie projects ever and later the namesake for our Swades Foundation, was filming in rural India. Shah Rukh Khan plays Mohan Bhargava, a NASA engineer and Ivy League graduate in the US, with a successful career in aerospace, who returns to his ancestral home in India after the death of his parents. The more he sees and learns of his former home, the more intense is his desire to stay back in India and to bring about change. Torn between two worlds, he must make a life-altering decision.

The main location for the film was a place called Wai, situated at the foothills of Panchgani and Mahabaleshwar and known for its temples and the ghats leading down to the Krishna River. It was quite beautiful, but rustic to the core and an hour's drive each way from the hotel where the cast and crew stayed.

On one particular day, filming took Shah Rukh's character to a village that was a train ride away, to meet one of its poorest inhabitants, an old man. His return would invite some soul-searching, the visit compelling him to rethink his attitude towards his old home in India.

Now, *Swades* was directed by Ashutosh Gowariker, who had hit the limelight a couple of years before with the Academy Award-nominated *Lagaan*. Ashu has a reputation in Bollywood as an unyielding stickler for total authenticity in a film's every frame. He insisted that the old man's hut be the real thing, set in a desolate area with sparse mountains surrounding it on all sides.

We embarked that morning on a long drive, an hour on the other

side of the normal location. Shah Rukh was having serious back problems at the time and contemplating surgery immediately after filming wrapped. He and I rode together to give each other company and to catch up on the drive, during which we traversed some of the roughest terrain I've ever seen. Shah Rukh gritted his teeth in agony as we bumped up and down.

Shah Rukh is a dreamer and a doer, a true-blue entrepreneur taking big bets not just in film, but in business and in sports, always following his gut. He leads from the front while inspiring his team and giving them the freedom to operate. He is also 'Sleepless Shah Rukh', as he is constantly abuzz with infectious energy that inspires everyone fortunate enough to be near him.

In that three-hour drive, we were either cracking up laughing at his never-ending sense of humour and his stories, or squirming with pain every time we hit a pothole on the dirt road. When we arrived, our enthusiasm was short-lived. We were greeted by an absolutely desolate, barren piece of land adorned with one tiny hut. Shah Rukh, stretching his aching back, incredulously scanned the scene and shook his head. 'There's nothing around here. We could have shot this at Film City,' he said flatly. He was right. The studio spread in Mumbai has floors with dedicated mountains in the backdrop, some scenery for every situation.

Even with my high respect for Ashu and his commitment to authenticity, I wondered along with Shah Rukh why we were in this place. But after that one comment, Shah Rukh spent the rest of the day focused and engaged, as if we were in exactly the right place for the shot.

Later at lunch, we all sat under some makeshift umbrellas in the scorching heat. My curiosity got the better of me, and I had to ask that nagging question. 'Ashu, I've been wondering, what's so unique about this location? What do you want your audience to see?'

He gave me an intense look and pointed over my shoulder to an unusually shaped, three-peaked mountain far in the distance. He wanted that remarkable piece of scenery as his backdrop when Shah Rukh entered the hut to meet the man.

Three seconds of screen time in a three-hour-and-fifteen-minute film. But when I see those three seconds, I'm proud of the team that stayed with its convictions and supported the captain and his vision.

◆

- Staying for the long haul is about planning, agility and overcoming any crisis of confidence, as much as it is about stamina, audacity and conviction.
- Fear and uncertainty, when things are not going as planned, are natural, but this is also when your convictions are truly tested. Generally, the difference between success and failure is about staying the course.
- The key to staying the course, whether you've already spent a few years on the entrepreneurial journey or you're just placing that first foot on the path, is to believe in your dream and live it every single day.

9
Trucks and Trends

Identifying trucks and trends is one of the most valuable skills any leader can possess. In startups and mature businesses, your ability to spot potential trouble is especially critical, saving you time, energy and grief in the long run. Lose your focus for a minute, though, and those trucks will run you over before you know what's happened.

In business, knowing how to spot a trend matters. And identifying the truck or train that's going to smash you head-on if you're not paying attention is doubly important! Although I've seen my share of both, the trucks are always memorable.

In 2010, the movie *Chance Pe Dance* was a loaded truck coming towards us at top speed. On the surface, it was a delightful film starring Shahid Kapoor, a star-struck transplant to Mumbai who struggles to find work in Bollywood, and Genelia D'Souza, a choreographer who sacrifices her own dreams for a chance to find love.

So far, so good. Initially, we thought, 'It's Bollywood. How can we go wrong with a musical?' And the same director-actor combination had successfully launched Shahid for his first movie.

Then we proceeded to make every wrong turn on the way, including

missing the 'trend' with a film that, even when viewing the raw edits, we knew would go nowhere.

From the beginning, *Chance Pe Dance* didn't come together. After more than a decade into our Bollywood studio model, we had enough experience producing films, watching dailies, and learning and sensing what worked and what didn't to spot the red flags. Though my gut insisted that something wasn't quite right, and I shared this unease with the team, I let that truck scream down the road right towards us anyway.

For a straightforward genre film, the music, on the whole, was catchy. Everything else, though, was a disaster. The disconnect between vision and execution is hard to define, but easy enough to see. The more we tinkered with the story and the editing, the more we failed till, in the end, it wasn't worth any tinkering.

Worse, we had a core creative team with no buy-in on our judgement. That's not a point of criticism against the creative team, since anyone intimately involved with such a time- and resource-intensive project wants to see it through. But even after a fair bit of reshooting and tweaking to make the movie respectable, we knew it was a lost cause.

We could have pulled the plug and cut our losses after we were 40 per cent into the cost—but that's also the toughest time to make any business call. If you pull, you're almost certainly writing off the full cost. But who's to say for sure it's a complete write-off? That's when 'hope' and 'who knows' comes in—and those two rarely pay the bills.

Needless to say, we didn't pull the plug. And we paid the price.

We faced a similar situation with the movie *Joker*, a genre mash-up of science fiction and comedy, whose promotional posters featured the inauspicious tagline, 'Sometimes being alien is the only option!' We read the script and all agreed, 'Right, a bizarre genre styled in a make-believe world. Great fun and a whacky concept that could be successful if it lands.' Unfortunately, the only sound *Joker* made when it hit the ground was a *thud!* That film wasn't just a truck, but a whole train with twenty bogies attached.

Sid Roy Kapur and I both had a hunch when seeing the first-half raw cut that even after the director and editors would have a chance to

go back and fill in the gaps—the 20 per cent often missing in the first cut—the film wouldn't hold together. There wasn't any reason to watch a single frame of that movie; it was one of those moments when every bone in your body shrieks, 'Why are we doing this?' We should have taken the hard call right then and there, and aborted. We didn't.

The learnings from both films were steep. You have to take hard calls in life. Not always the popular ones, but what you think is right. We got totally entangled in quid pro quos and balancing acts, which can never work in any business. Things could only get messy. The director of *Joker* was the husband of Farah Khan, who we were about to sign for her next film. In addition, the lead, Akshay Kumar, had devoted a lot of time to prepare for the first half of shooting. He was in no mood to scrap the film or bring in another studio in our place, which would have meant straining our working relationship with a commercial star.

In short, we did everything wrong. We compromised. We grinned, cringed and suffered through the next six months, trying to put up a brave and supportive front when we knew the inevitable outcome.

What we didn't know was when to cut our losses and walk.

Get that wrong more than once, and you're floundering as an entrepreneur and a leader. That happened to me. It was wrong and foolish. If working relationships need to get strained because you're following your convictions, then let them.

I've also learnt that time heals a lot. If I had put my foot down that day, what's the worst that could have happened? We'd have had a head-on with both Farah and Akshay, but they would privately have understood and accepted our hard call. Finally, another studio would have stepped into our place. They may have compensated us for our expenses, at least in part, and the movie would have been released. And it still would have been a disaster.

Life moves on. We tend to duck the unpopular, hard decisions, not realizing that eventually when the results are out, we're not going to be popular anyway.

Even today, I believe that spotting trucks is one of the most difficult aspects of leading any enterprise. In fact, if everyone could see the trucks coming without fail, the business world, and the world in

general, would be a very different place.

Wait. What's so difficult? You just jump aside, right? We're taught from a young age to do so when crossing the street. But in business, you've got to make sure your team gets out of the way, too. Far from being seen as a saviour or a soothsayer, the leader who abandons his team, or worse yet, knowingly and willingly throws them under the truck, undermines his own credibility and erodes the foundation of trust and respect so vital to success.

Your other option, of course, is to stand in the way and get hit. Not much of an option, if you ask me.

Make those tough calls and get your team on board, and everyone, though momentarily disappointed that their hard work didn't come to fruition, will thank you in an honest moment. Establishing that level of trust with a team, particularly a large one, requires all your talent and focus as an entrepreneur and leader. But when you're all on the same page, the payoffs and the camaraderie are well worth the effort. Teams rely on the leader's vision and judgement.

In startups and mature businesses, your ability to spot potential trouble is critical, saving you time, energy and grief in the long run. Lose your focus for a minute, though, and those trucks will run you over before you know what's happened.

◆

Trends in business remain nothing more than good ideas until acted upon. Often, we think trucks are somebody else's problem until it's just too late.

Seeing around the bend—that is, doing your best to define all the unknowns that might come your way in the future—and spotting both trucks and trends is, foremost, about becoming a better communicator, asking the right questions, encouraging your team to do the same, and together developing plans of action for the best way forward.

Preempting trends and gauging the future require:

1. a deep understanding and the ability to analyse the past (as that embodies empirical evidence);

2. making sense of the present;
3. spending at least 30 per cent of your time 'out there' with customers and peers; and
4. a knowledge of relevant global trends and adequate time alone to absorb this mass of information and thus sharpen your thinking and gut instinct.

To a lot of people, the idea of seeing around the bend in business sounds more like magic than common sense. That's why I notice a lot of raised eyebrows when I tell my team members or external colleagues that one of the biggest problems getting in the way of an organization's honest and frank interaction on trucks and trends boils down to one word: presentations.

Yes, I'm referring to those twenty to two hundred or more slides we take *more* than a day to prepare for and *less* than an hour to go over in the next day's meeting, when in reality the top person in the room only wants to see the last three slides.

When you present upwards, to a group of people higher on the organizational chart than you, you will, without fail, tell them what they *want* to hear. The truth gets buried under an avalanche of bullshit. An entrepreneur and a leader needs to be direct. On more than one occasion, I've had to say, 'People, let's cut to the chase. I need to know the plan versus the actuals. I need to understand the challenges and what we need to do differently. Are we on track, or do we need to review our short- and long-term goals? Is the team on the same page and charged?'

Of course, if people have spent significant time preparing the presentation, you don't want to demolish them. Most conference or meeting rooms have electronic blinds that drop for presentations. The lights go off, giving everyone in the room implicit permission to do everything but listen to the presentation, including checking their mails or WhatsApp messages. In most cases, the presenter's body language tells you much more than the words or the image on the slide, but you can't see these non-verbal cues in a dark room. My blunt and direct way to end a presentation is to press the button for the screen to go up and

the lights to come on. 'Look, I think this is a great presentation. You've spent a lot of time on it,' I say. 'But right now, we need to discuss the issues at hand. Mail it to me and I'll study it tonight.'

Instead of putting the presenter on the defensive, you've defused the situation and refocused the team's attention on your reason for meeting in the first place: *Look me straight in the eye and let's discuss the issues at hand. I'm reading between the lines of what you're saying here and I want to talk about our best course forward...*

Much of how you're received when you encounter that jarring predicament goes back to how well your team understands and buys into the culture you've established. Pull down someone who, in good faith, has given you his views on the state of the company, and ten people will stop listening to you immediately, too busy being pissed off at you or worrying about how they can avoid getting gutted when it's time for them to speak. A counterproductive mindset to say the least.

Great communicators communicate.

To boil business down to PowerPoints, Excel spreadsheets and numbers is to ignore the advantage that experience brings to the table. Looking around the bend and spotting trucks and trends all sound good on paper, but without a team behind you, none of it matters or is even possible. Throughout this book, I've emphasized the importance of open and honest communication and counting people, not information and certainly not money, as the most important assets your company will ever have. Lose your best people and no amount of data or money will lead to success.

From the early days, when we were just a team of thirty, I've firmly believed in town halls and team gatherings. That two-way communication and open planning is vital for culture building, allowing the team to feel as though it's 'part of the story' and not just 'being told a story'. For years, outside of regular interactions at group levels, I've anchored that sense of belonging in a wrap-up mail to all team members at the end of each calendar year, capping our accomplishments during the previous year and setting out challenges and goals for the coming year. All to increase our sense of being in this thing together and creating something we will be proud of.

I think back to another time when I asked six colleagues to join me for an emergency Saturday evening meeting. None of them had cars then, and it happened to be the day of a taxi strike. Everyone discussed logistics and wondered if we could meet early Monday morning. So I drove down myself and picked my colleagues up at their homes. After sitting at the closest coffee shop and completing the meeting, I dropped each of them back home. To them, it was a meeting. To me, it was a way of setting the company's culture.

I recall receiving a farewell mail from Myleeta Aga, a long-time colleague at UTV who joined our trendsetting core team in Singapore, before marrying and relocating to the US. 'You made everything look easy. I know it never was and certainly not for you, but because you made it look simple and doable you had many believers,' she wrote, summing up the culture and work ethos I always strove for at UTV and every other company I have founded along the way. 'At most times we knew we were doing brave and out-of-the-ordinary things and it could go wrong at any time. But we did it because you [believed] in it and, I guess, in all of us.'

I couldn't have been happier or more proud to have her endorsement. In the end, though, her words didn't have anything to do with me. It was about the entire team and the culture we created together through open and frank communication.

◆

How do entrepreneurs spot trends and convert ideas into action? Earlier, I shared how we created a whole ecosystem when developing the concept of daily soaps, *Shanti* onwards, based on a trend we had spotted. We took the leap and opened the floodgates, letting India become the soap capital of Asia—much like South America had become the soap capital of the Americas and the European Union before that.

A similar epiphany led us to the belief that Southeast Asia was ripe for disruption, and our outreach to Singapore and Malaysia in those early days was about spotting a trend and being bold and path-breaking in our execution. Our plan to expand into Singapore and Malaysia began in a New York hotel, where I was speaking at a media conference. An

old school friend, Firdaus Kharas, happened to be in the city as well. After school, Firdaus had emigrated to Canada and joined politics there in the state service as a senior member of the government for immigration. He was in New York for meetings at the United Nations.

Over room-service dinner that evening, I shared my views on expanding to Singapore and Malaysia, telling him that I needed someone with his experience to suss out the details. In Singapore, I knew it would be important for us to connect with the government at all levels and to reach out to the country's two main media groups to see if they would be willing to work with us. Equally important for us was to secure the support of the Singapore Economic Development Board (EDB). Likewise, in Malaysia, we needed a local Bhumi partner to give us access to the main players in the media and entertainment space.

Firdaus was winding down his role in the Canadian government, and he had great connections in Southeast Asia. 'I'll be happy to take on the challenge,' he said, sounding almost as excited as I was about the prospect. So dinner ended with dollops of ice cream (both of us have a sweet tooth) and an agreement to work together, with a success fee for Firdaus if things worked out. The company would cover his expenses for sixty days and see what sort of progress he could make in the meantime.

We stayed in touch twice a week with calls, started the process of approvals from India for our prospective expansion into Southeast Asia and identified key colleagues at UTV interested in moving to Singapore or Kuala Lumpur. It was important to start 'day one' in both countries with the culture we had built in India—creative disruption and innovation, frugality and the highest level of passion. Plus, neither Singapore nor Kuala Lumpur had an established talent base or infrastructure, so we would need to train our new team members and possibly build our own studio. All this planning was a bit premature, of course, as we had not decided anything yet. In true UTV style, though, we hurtled forward with confidence and clarity, identifying a trend and doggedly setting out to make the most of the opportunity.

Three months after the New York meeting, Firdaus, three of my colleagues—who were on board to move to Southeast Asia should all

go as planned—and I were crammed into a room at the Shangri-La Hotel in Kuala Lumpur with whiteboards and charts. Firdaus laid out his findings. 'The EDB is keen to support us,' he explained. 'And we've found a Bhumi partner in Kuala Lumpur. None other than the son of the ruling king of Malaysia, who has heard good things about UTV and is eager to partner with us.'

After hearing the news, we munched on delicious complimentary chocolates in the hotel room. Ninety minutes later (out of which fifteen were spent discussing the merits of fine complimentary chocolates), I stood up and said, 'Enough talking. Let's just do this. Though first, we'll need some more chocolates.'

That was the start of another journey in our media and entertainment career.

◆

It's not enough to spot trends if you're not in a position to push the envelope before everyone else has had a chance to join up. The need for a leader to stay abreast of both the macro and the micro picture has never been more crucial than today, when information overload threatens to overwhelm the team. You need to know the difference between important data and background noise, and become adept at handling the mundane day-to-day details as well as long-term thinking. Mastering the micro picture means staying in touch with colleagues, finding solutions to the problems you've identified together, preempting trucks and empowering your team. At a macro level, stay in touch with everything out there by meeting your customers and understanding their future plans, and thus, spotting trends for your organization.

Most of all, you need sharp business acumen—not only understanding numbers and financials (which are undoubtedly important), but also displaying overall commercial savviness. Only then can you take an idea, create an opportunity and convert that opportunity into a commercially viable plan. *To spot trends or trucks, you need to know everything about your enterprise and everything about business.*

Because once you pass the start line, the race doesn't stop. Ever.

Throughout, Murphy's Law will apply: 'Anything that can happen,

will happen.' That's why you're the leader. Peace of mind (and a good night's sleep) comes from knowing that the job is in the right hands. Streamlining your operation, hiring well and letting others share your vision as you spot trucks and trends will see you through seven out of ten times.

In business, we would call that success.

◆

Looking around the bend requires a constant state of alertness—no room for complacency. Get accustomed to the notion that you can become outdated in an instant. You don't have to be the smartest person in the room to be a great leader, just the one who knows the most about *every aspect* of your organization and can make decisions based on its best interest. The discipline required is *relentless* analysis.

For the first five to seven years or more of building a company, you'll need to set out some time to think about strategy. What you'll discover, though, is that the day-to-day issues zap your time in ways you can't even imagine. Maybe you're growing so fast that you're hiring people who are turning out to be less effective than you'd hoped. Or you're bringing on good people who take a while to get up to speed. Or you're having a tougher time than you'd hoped establishing the culture of your business. The truth is, everything and anything that comes with growing a business can come at you at once.

Entrepreneurs embrace such frenzy. The downside to staying on top of things, though, is that you're not giving yourself enough time to think. In that case, make time, knowing that your ability to see around the bend will be that crucial differentiator for your company, your investors, your team and your stakeholders.

Looking around the bend also fortifies your retention of people. The minute you get a handle on the trucks and trends and prove to your people you're an honest, competent leader, they buy into the culture you've created, learning and growing as team members (and perhaps even as aspiring intrapreneurs or entrepreneurs)—which is what you yearn for as a leader.

Naturally, some stress and a sharp learning curve come with

constantly being on the alert. But it's nice to lead a team that you can call into the conference room at lunchtime once every couple of weeks to think about the future trends affecting the company. Having someone at the helm who every so often breaks out of that get-it-done-yesterday mindset refreshes and rejuvenates colleagues and strengthens the respect of peers, team members and external contacts. Otherwise, as a leader, you can be a very good operational person, but you won't earn absolute respect, the all-in vote of confidence that prompts your team to think, *I really want to work with this person because I'm learning something new every day from her.*

'So what is the process that will allow a successful entrepreneur and the team time to think?' I'm often asked. The question tends to come from sceptics unconvinced that such use of time can be productive. 'Do you just *sit* there? Physically *go* someplace else? Tune out and turn everything off for half the day?'

'Don't view "thinking" in terms of a regimen, but discipline,' I answer. 'When focused on the process, find your zone—on the treadmill, when out for a walk, while listening to music, in the bath, on a drive. I hate driving in Mumbai, but sometimes when something's troubling me, I drive. Just let my mind go.'

In fact, driving in India is a neat metaphor for looking around the bend. One half of your driving skills amounts to how *you* drive; the other half preempts how *everybody else* drives. That's just India. No lane traffic, absolute chaos and a heightened sense of alertness and anticipation that accompanies the (normally) simple and safe act of driving.

As a leader and entrepreneur, be vigilant. In the best possible way. Keep your head on straight. When everyone else talks about a new trend or an idea that sounds too good to be true, the red flag should go up and you ought to take over.

Like the intrepid Indiana Jones, you'll walk up to the mouth of the cave, stick your head inside and say, 'It's a trap. We're turning around.' And get the hell out of there.

Your team will thank you. One day.

♦

• You have to take the hard calls. Not the popular ones. There's no room for compromise; if you do that today, you'll find a reason to do it always. You have to know when to pivot, or cut your losses and walk, and that's the toughest part of building any enterprise.

• Don't make trucks somebody else's problem. Trends, unless acted upon, just remain ideas.

• Communication within your company has to be frank and open. Watch out for those 'presenting' upwards as this never gives the true or complete picture.

• You need to have sharp business acumen and commercial savviness; there is no substitute for these qualities.

• At the end of the day, people—not information and technology and certainly not money—are the most important assets your company will ever have.

10
The World Isn't Flat— and Who Cares?

Even though 99 per cent of us feel we are unequal to a task at some point in our
lives, entrepreneurship provokes us to confront and conquer that myth.
Luck and inequality are two sides of the same coin. When you have that coin in
hand, throw it as far as you can and walk away. You don't want it.
Now, start building your dream.

When it comes to luck, few of us will admit to getting more than our share.

Does this sound familiar? *Other people are lucky. I carry on despite being dealt a losing hand. I'm not successful because I haven't been gifted a wealthy family, proper education, ready funding for my business.*

'Luck,' David Levien writes, 'always seems like it belongs to someone else.' I know a lot of people who would agree. Maybe you do as well.

But I'm not a big believer in luck. Not if by luck you mean that any one person or business has an inherent advantage over another. I do believe you could be in the right place at the right time in your career.

Taking advantage of this, however, requires effective planning, a high level of preparedness and openness, and an evolving mindset.

But one of the most prevalent and persistent obstacles in the path of entrepreneurship in India today is the notion that luck, or its lack, plays a major role in how successful (or not) you'll be when you unleash your ideas into action. At all stages of your journey, you need to downplay the idea of luck as a necessary ingredient for building strong businesses. Rather, the *real* source of success is people who generate their own breaks by working hard and focusing on a goal.

A common and prevalent superstition in theatre is to wish actors good luck by telling them to 'break a leg'. But no actor worth his salt will go on stage without knowing his lines. In that sense, acting and business are alike—both demand proper preparation and foresight before the journey even begins. Lacklustre preparation never leads to the desired outcome, which is why many a sports coach has told his players that luck is where preparation meets opportunity. Positivity, a forward-looking plan and self-confidence are also necessary for the road to open up in front of you.

Evangelize your ideas, share them with anybody who will listen (and even with those who won't), and talk to other entrepreneurs, professionals or mentors. These interactions create opportunities through various levels of contact. You never know when you will strike a chord with someone who says, 'I like the idea. Have you met so-and-so? Can I put you in touch with him?'

You gain confidence and start to think, *This is going to happen. If it doesn't happen today with scale, it'll happen at some other stage. I'll keep going.*

Sometimes, though, we spend too much time over-analysing the situation. When I talk to someone caught in that cycle, I tell him, 'Create opportunities by being *less* selective, not more.' So many of us mull and think and then mull some more. Before we know it, the moment has passed and so has the opportunity. We all know that 'fortune favours the brave', but fortune can't help the 'not present'!

In my early days, whenever a meeting, call or travel plan didn't result in a solid lead or a possible deal, I considered it a waste of time. But as

I saw 'the circle of life' play out again and again, I changed my mind—like, when a meeting several years ago with people in one organization became a great starting point for fresh engagement as they moved up and on in their careers; or when a get-together with ex-colleagues or a series of meetings with a potential global partner or client came up dry, only to turn into a great opportunity a few years later with an unexpected call; or when a pitch that seemed like a colossal waste of time and team investment morphed into the biggest creative idea or product one had ever put together.

Maybe what I've just described is luck of a sort, that willingness to keep open multiple options and create a culture of inclusiveness, listening to ideas and storing them away for future reference. From the outside, however, what appears to be a lucky break could instead be the result of years of cultivating leads and following up on the longest of shots. Unless you actively seek opportunity, you have no idea how many doors could open for you.

Over the years, I've also learnt to stand by people, colleagues, clients, suppliers and partners when they're down and out of the race, powerless. It's not a natural reflex. In a highly competitive world that demands so much of your time, standing by people sounds like your last priority. I'm not recommending this as a strategy. It has to be genuine and heartfelt, or else don't bother. But rest assured, when they bounce back—and bounce back they will, everyone does—you and they are going to have a much stronger bond and a deeper understanding of each other's ambitions and goals, perhaps sowing the seeds for an opportunity neither saw coming.

◆

If you do all the right things, are you inviting what people will call 'luck' when you succeed? Let them call it what they want. In his book *The World Is Flat: A Brief History of the Twenty-first Century*, Thomas Friedman described how global technologies and the free exchange of goods and services have levelled the playing field in business over the last couple of decades. A lot of observers took Friedman's claims to mean that the advantages some leaders, CEOs or entrepreneurs had

over others would be erased by the new rules. Anybody who has spent much time in the trenches, though, realizes that the world will never truly be flat. And who cares?

Not everybody flies with tailwind. Some entrepreneurs start out with more momentum than others. The key to success is not perceiving what others have as an advantage or a disadvantage. A common concern from those not to the manor born is that others have a massive advantage when it comes to starting and growing a business—they have wealth, no worries and all the freedom in the world to do what they choose! Stop wasting your time worrying about what everyone has and realize that, at more than one stage in your career or business cycle, you'll find yourself in the right place at the right time.

Maybe wealth gives one person a leg up on another who has to work hard to score in that first round. But money only helps cushion that start. Wealth in no way ensures success. Life is about the next ten years and more, not just today, and the law of averages works for each of us—leaders, professionals, entrepreneurs—just as it does for everybody else.

Come to think of it, the ingredients that make all great leaders or entrepreneurs look a whole lot like the recipe for luck.

◆

The first time we sought to go public at UTV, the markets crashed.

The second time? Right into the tank.

After that one, some investment banker made a snide remark in passing. 'Hey, Ronnie, are you planning to go public? Because if you are, I'm exiting the market.' Even though he was joking, his point was valid. I wasn't someone with tailwind on my side. And if I hadn't developed a thick skin over the years, I would have taken those remarks personally and thought, *I'm never going public! Twice. Come on! What are the odds? I'm unlucky!*

When I had some time to think about it rationally, I wondered, *Why the hell am I sitting here with the weight of the world on my shoulders? Global markets have crashed. Who am I to think this has anything to do with me, that the cosmos cares in the least about my public offering? Hundreds of thousands of people must have suffered the same setback or worse.*

Not everyone is dealt a straight flush. It would be unfortunate indeed if you have a thirty-year career and never get a solid break. But if you're running a vada-pav shop in a small town, what can you expect in terms of luck? That one fine day everyone's going to say, 'Hey, I've got to have a vada-pav and I know exactly where I'm going to get it!'? Suddenly your sales go up 3x? Not going to happen.

But this other guy on the other side of town has booked space in a new mall with growing footfall. In three months, his sales are thrice yours. Did he get lucky? Did you get unlucky? Neither. You create your own environment. Then you take advantage of the opportunity.

When the team and I envisioned Hungama, many media observers, colleagues and others saw the channel's eventual success and its subsequent sale to Disney as a stroke of luck. Not true. The idea worked because of a laser vision, tremendous planning, disruptive programming and bold marketing. Most of all, we went with our gut and stuck with our convictions. As I think of it now, I recall it was one hell of a lot of hard work, a great deal of fun and excitement and very little luck. People only believe in coincidences when it's convenient for them to do so.

We had a similar experience in movies. After a solid track record of almost ten years in the industry, I still hear from people all the time, 'Wow, you caught a few breaks to get to the top, didn't you?' As if the odds were always in our favour, the outcome a foregone conclusion. Maybe I should be encouraged by the great numbers of people who seem to have forgotten how many times we failed over the years.

The truth is, as outsiders, we put ourselves out there on the high wire without a net. To fail and not to rebound would have proven our detractors right. Our greatest successes in film had little to do with lucky breaks. We brought persistence, a strong understanding of the market and the audience, confidence in our team and the director's vision, a gut for good scripts, a deep desire to push the envelope and a willingness to do whatever it took to bring it all to the big screen.

When our movies flopped, and many did, were we unlucky? When they were big hits, had we got lucky? Neither.

Exactly how much the odds were stacked up against us and how

little luck had to do with the outcome came home to me during one particularly interesting interaction with Rupert Murdoch. When News Corp still owned a good part of UTV, I was in Los Angeles to meet Murdoch in his frugal suite: a modest office (for the leader of one of the world's largest media companies) with an adjoining meeting room that held a maximum of eight, and a small outer space for his two executive assistants. After a twenty-minute chat on the overall India macro-economic scenario and an update on the media industry, he got up from his chair and walked me over to an old aerial photograph of what would eventually become Beverly Hills and Century City.

'You see this massive patch of land? The buildings? Fox owned all of it. When *Cleopatra* bombed in 1963, the company was forced to sell three-fourths of it. The company was left with this,' he said, tapping his finger on a much smaller parcel. 'It's some of the most expensive real estate in the world today.' He smiled as we moved towards the outer office. 'Of course, all that was before my time, before I bought Fox.'

Murdoch wasn't really making a specific point. UTV had yet to even consider getting into the movie business. But his message was clear. Business, at its core, can be unpredictable and fragile. Those trucks can come barrelling your way at any time. Despite your biggest, most disappointing setbacks, you can and do move on. After all, here was a leader talking about his insights with pride and clarity. Although he could easily have afforded the best art in the world, Murdoch decorated his conference room with a *memento mori*. Not by accident.

As I walked to the parking lot, I thought about my conversation with Murdoch. The world sees *Cleopatra* as one of the magnum opuses of all time, a grand success that swept the Oscars that year. My mind goes back to the wonderful chemistry between screen legends Elizabeth Taylor and Richard Burton, and I can only think of that film as a classic.

As with most things in life, there's another side to every story.

◆

One of my most important lessons from the media and entertainment business was not taking anything for granted. We took big risks and had the gumption to back them, digging our heels in when necessary. Those

challenges allowed us, *forced* us, to build a robust, resilient organization. We created opportunities where we could attract more partners because we situated ourselves at the right crossroads, looking at scale when we broke through with innovation. Sometimes, we also got it wrong.

Higher risks pay higher rewards. That might sound like luck. It's anything but. What we discovered, and what so many entrepreneurs who stay the course and make their own 'luck' discover, is that the outcome is in direct proportion to the risk and effort.

However, it sure as hell wasn't all roses. On more than one occasion, I waited alone to take that final call, not knowing if our next product would succeed or crash and burn under its own weight. But on each occasion, I felt I was in the right place at the right time with the right offering, the right team, the right effort and the right instinct...and when you put so many rights together with passion and the desire to climb, you push yourself to the summit.

And when things go wrong, as they so often do, you need the resilience and maturity to accept, recalibrate, communicate, fix, learn and move forward. Blame it on bad luck after so much preparation and you're only fooling yourself.

Because I was so enamoured with the idea of becoming an entrepreneur, I embraced the uphill climb from those early days, understanding that when I tested my limits, planned for the future and committed to a clear vision with a strong team, I would make my own luck.

With nothing ventured, how can even Lady Luck help you?

◆

The days leading up to the premiere of *Rang De Basanti* provided interesting learnings in innovation and resilience. It was also a movie that—once it had released and become a runaway success at the box office—became known to a lot of media-watchers as a lucky strike.

Despite how groundbreaking we knew the film could be, it wasn't easy to greenlight. In fact, a week after the release, I asked Aamir Khan over to our office to address our entire company. 'I know I was attracted to the movie, as it was a great role, and for Rakeysh it was

path-breaking,' he told the gathered team. 'But I have no idea what got Ronnie to go for it. More than balls and guts. I guess he saw something that moved him too.'

The plot bears little resemblance to any Bollywood stereotype. Our movie has a group of male friends with no serious love interest; a third of the movie is told in flashback, so the narrative moves from the past to the present; there is an English female lead, Alice Patten, who plays the British documentary filmmaker Sue McKinley and delivers her lines beautifully in accented Hindi; and in the end, all the heroes die, targeted as terrorists by the state.

When we saw the rough cuts, our team was riding high in anticipation of the movie's reception. But we were in for a big surprise. When it was time to get our censor certificate, usually a formality, the chair of the censor board called me with some bad news. 'We are not ready to issue the censor certificate,' was the apology. 'Not that we found anything offensive about your film, just that we want you to get approval from the air force and the defence ministry before we sign off.'

The movie's military angle, the death of pilot Ajay Rathod in a Russian MiG crash, hit close to home. That much we knew, since the censor board hesitated to issue a certificate. The implications, though, were disturbing. The news would have been unwelcome for any of our films, but *Rang De Basanti* was UTV's grandest effort then and, with a budget of ₹400 million, our largest investment at that time. We were confident it would be our breakout movie. All those who worked on that film—from Aamir to the up-and-coming actors who poured their hearts into the movie, to the crew and director Rakeysh Omprakash Mehra and me—had given their all to make it.

When news of the censor board's concerns came in, we rallied the troops and planned a meeting with Rakeysh, Aamir and the other principals. By the time we gathered at Aamir's place in Bandra, the censor board chairman had got back to me with some additional news. 'Look, we're trying to get a special screening organized tomorrow on an emergency basis with the head of the air force,' she said, trying her best to sound helpful. 'We just want them to see the movie.'

I knew the censor board was just doing their job. As much as I

disliked the thought of not getting a censor certificate, it was a no-options directive, for sure. No one had objected outright to the movie. Until we got the sensitivities out of the way, though, *Rang De Basanti* wasn't going anywhere.

Of our group, Aamir was most vocal about protesting if things didn't go in our favour at the following day's screening. He truly believed in the film's powerful message. His stake in the film was at least as significant as everyone else's. 'I think we've made the movie with a very clean heart,' Aamir said, with the gravitas of an orator, to the group at his home that evening. 'We've done it in the right spirit. Movies are movies, works of fiction. Nothing more can be expected or demanded of us.' He looked around at the sombre group and nobody said a word. We all nodded in agreement.

'We're as patriotic as the next guy. I'm telling you, Ronnie, if they want us to cut a single frame of that film, I'm not going to allow it. In that case, let's not release it.'

I appreciated Aamir's honesty and his passion. A few people applauded and voiced their support. Despite having a lot of skin in the game, I completely agreed with Aamir's point-of-view.

Nagging me at the back of my mind, of course, was also the reality of business. We were on the hook for a ₹400 million loss, plus marketing costs already incurred if the movie got struck down by the military powers-that-be. We could certainly fight any decision of censoring the film. Without making the requested changes, though, the process could drag on for years. In that time, we would be left with a historical artefact, not an artistically and commercially viable movie. Every story, no matter how important, has a shelf life. So while I agreed in spirit with Aamir, I knew our stand wasn't without some potentially serious consequences.

We went to Delhi and held the screening as scheduled. The scene outside the auditorium was surreal—Bollywood, the purveyor of fantasy, rubbing elbows with the most powerful military leaders in the country. When word got out about the unusual gathering, no fewer than 200 media people greeted us at the gate with cameras and microphones, hungry for any information they could get about the

clandestine goings-on. Little of substance had leaked to the press. We hesitated to talk about such a sensitive issue, especially when it could so quickly turn against us. Assaulted by a flurry of questions, our group squeezed by the crowd and headed into the screening room to learn our fate.

Inside, we had our second shock: Not only was the head of the air force in attendance, but the heads of the army and the navy, as well as the then defence minister, Pranab Mukherjee. Sharmila Tagore was there as chairman of the censor board, as well as one of the film's leading ladies, Waheeda Rehman, who played Ajay Rathod's mother in the film. The defence minister was flanked by those two stoic, beautiful women as he took his seat. Rakeysh, Aamir and I exchanged greetings with the dignitaries, besides nervous glances with one another, before settling in.

Two-and-a-half hours later when the lights came up, Rakeysh, Aamir and I went in front of the group to answer questions. The heads of the army and the navy both liked the film and had little to say. 'I really enjoyed the movie, too. What's the problem?' the defence minister asked with a shrug. In *Rang De Basanti*, much of the blame for Ajay's death falls on the shoulders of the defence minister. Clearly, Pranab Mukherjee wasn't bothered by the parallel.

The last to speak was the head of the air force, who looked pointedly at each of us while composing his thoughts. 'Mr Khan, Mr Mehra, Mr Screwvala, thank you for sharing your work with us,' he said, choosing his words carefully. 'I think it's a fine movie. We've never done this before,' he made a sweeping motion with his arm to the assembled audience, 'and we would never censor a movie except under extreme circumstances. You should do whatever you plan on doing. Go ahead and release the film.'

He paused. We all breathed a sigh of relief, the crisis averted.

'All I can tell you,' he continued, 'is that I get about ten calls a month from the mothers of my boys who fly the MiGs. Of course, they're concerned about their sons' safety. We all are. Who wouldn't be? But after this movie, I'm going to get *a hundred* calls a month.' With that, he sat back and folded his hands across his lap. 'Best of luck.'

We were elated at the military's response and grateful for their support, but the words of the head of the air force also struck a strong chord with us. This was reality. When each of the heads drove away from the screening, they sportingly gave interviews to the assembled media.

After coming within a hair's breadth of having our film made irrelevant by an unfavourable censor hearing, we couldn't have bought more or better publicity. News of the meeting was on prime time news for an entire week after the screening.

A part of me understands that if the film hadn't been released, we'd have had different challenges. I'm equally confident that, even in that case, we'd have worked to find solutions. At the end of the day, when your job is to lead, you'll adapt to the circumstances that are presented to you and move forward with the best intentions.

Rang De Basanti succeeded for us because everyone in attendance at that screening understood that we were showing respect. When you are really, truly genuine about something you believe in, your intentions will come through. We volunteered to hold the screening when we didn't have to. Also, we made a film that wasn't *too* 'Bollywood'—one that focused instead on learnings, introspection and the value of life. That made all the difference.

Nothing says more about an individual and his team than the reaction to the unexpected. How you handle those situations predicts a lot about your future as an entrepreneur. In the end, we went the only way we knew; we followed our hearts. We were fortunate to have colleagues like Rakeysh and Aamir on board. It was a great team all around, and none of us was satisfied doing things the way they had always been done. We disrupted a century-old model with a fresh take on film, showing others the way in the process. That's the thing about great teams. When you're confident, strong on conviction and willing to adapt to whatever your business throws at you, you've got nothing to lose.

What still fascinates me till date about the reception of *Rang De Basanti* is how many people told us it was a lucky break. When I heard that, I thought, *exactly which part of that was lucky?* Nobody backed us.

We were out there on our own and pulled it off. To my mind, there was *nothing* lucky about it.

Consistency and the guts to stay with what you believe in tend to silence the naysayers.

◆

Inequality is a given. You can take inequality as a challenge, or move on, because it never goes away completely. To be honest, that's not necessarily bad news.

Starting out as a first-generation entrepreneur, I had no external or financial inputs, no real godfather or mentor. Even with the limited success of Lazer Brushes, I discovered that nobody wanted to fund a contract manufacturing business. When I began in the nascent media space, people didn't even call it a 'media industry' yet. Those were good times, though, because I learnt to cut my coat according to my cloth. Rather than becoming despondent about any perceived inequality, I embraced the challenge.

I get quite rattled when I hear a young person today say, 'But I'm not getting funding. I'm not getting support. I don't have luck on my side,' as an excuse to forgo a dream.

'So wait a minute,' I respond, 'you've asked for ten million rupees and nobody's willing to give you even half-a-million?'

'I need ten million,' he insists. 'Why would I go around asking for half-a-million?'

'Because no one is ready to give you ten million! Why don't you pick up half-a-million and work hard to get the next million after that? Go from there. Build your dream a piece at a time. Have you ever thought about it that way?'

'Uh, no.'

Silence. End of conversation.

And that's my point.

If you can structure a plan to build a business with half-a-million rupees or even less, chances are you'll figure out how to get the money. Find a starting point and get on with it! Even if you're alone at base camp, the energy and momentum of your idea will take care of that

initial funding, which despite what you've probably heard, and as I've already said, is the easiest funding you'll ever get.

When setting out on your entrepreneurial journey, beware of the thought that equates inequality with failure. Too many entrepreneurial dreams have been crushed by unfounded pessimism. *This isn't for me. I don't come from the proper background to make this happen. I'm at a disadvantage in a third world country. How could I possibly make it work?* I've heard these comments far too many times. You set extraordinary obstacles for yourself when you get into a negative feedback loop and allow doubt to take over.

Also, the cemented social structure is strong in India—perhaps a bit less strong than in the past, but still a deterrent for an entrepreneur not self-confident enough to jump in with both feet. You need to talk realistically to your family about who you are and aspire to be. The problem with inequality isn't that it makes realizing your dream more difficult in reality, but that it distracts you from your vision. Look in the mirror, not at everyone else, when on your entrepreneurial journey. There, you'll see the truth and the inner strength that will keep you moving in the right direction.

When I took that fateful trip to London and found the toothbrush machines at the plant, I needed £2,400, the customs duty and a license to import post-haste. I didn't have that kind of money. But I didn't let that make me feel unequal. I knew I wouldn't get the money from my parents (I didn't ask), but the ecosystem was one where, even though I had to work that much harder to get our first client's letter of intent to secure the loan, the money was available if I proved equal to the challenge. Finding a means to an end and creatively solving problems is all a part of being an entrepreneur. No excuses.

In fact, a lack of funding today is less of an issue than it has ever been. Frugality and bootstrapping are assets in any business, anywhere in the world. An entrepreneur with frugality in his DNA will make fewer mistakes, build more efficient cost models, plan better for the future and increase his chances of success over the person next door who just got well capitalized and feels, mistakenly and arrogantly, that he doesn't need to make those difficult decisions. When you think some

people have more, chances are they take a lot more for granted. When you work for everything you have, it means more to you. At the end of the day, the probability of your success may be higher than the other person's, the one you think has an insurmountable advantage over you. *Therefore, you're not unequal.*

That simple statement is the essence of the entrepreneurial enterprise. Believing yourself unequal marks the mindset of retreat. Think more like General George Patton when he realized that his tanks didn't have any more gasoline. 'Screw it,' he said. 'We're going on foot. We'll push the Germans back to Berlin.'

◆

The minute you say, 'I'm disadvantaged', you're comparing yourself to everyone else. And therein lies much of the challenge for India, with a generation of entrepreneurs ready to dream their own dreams, but facing fear and uncertainty, a conservative mindset, a low appetite for risk, no gift of the gab, no backers, and a general lack of confidence. In most cases, when someone with a dream doesn't accept the challenge of making it real, you can trace the diffidence back to one of these reasons.

Maybe for you, and for a lot of others, inequality means, *I come from a smaller city, I've not stepped out. What could I know?* But if I could sit down for two hours and discuss your family's background—Dad's in the army or working with the Indian railways, maybe you moved from small town to small town every two years, or whatever else it may be—what do I see? An opportunity for you to take advantage of the *real* Indian market—the small cities that will be major consumption centres in the future, the rural markets you understand so well. I do not see the distorted picture you do—of your 'luckier' classmate who went to a university in Delhi and aspires only to create the thousandth most popular iPhone app.

Entrepreneurs don't worry about whether or not the world is flat. They're too busy building businesses.

◆

* Entrepreneurs and leaders at any stage of their journey need to downplay the notion that luck is vital for building a strong company. They should also avoid making the absence of 'luck' their most persistent obstacle.

* Stand by people when they are down and out and they will be with you when they bounce back.

* Go for calculated risks that you can afford to take, and then dig your heels in. Higher risks do yield higher rewards if these risks are backed by great execution and pre-planning—this has nothing to do with luck. When things go wrong, it's not ill luck, just an opportunity to accept, recalibrate, communicate, fix, learn and move forward.

* Taking advantage of being in the right place at the right time requires effective planning, a high level of preparedness, openness and a progressive mindset.

* Stop drawing comparisons with others, and measuring yourself against what they have or don't have. It's not going to help your cause, only distract you. Also, remember, inequality is a given; but, inequality does not portend failure. You can take it as a challenge or move on. Let your positive approach destroy all notions of inequality; indeed, entrepreneurship provokes us to confront and conquer the myth of inequality.

11

Exit Stage Left?

Ask anyone who has successfully exited a business,
and he'll tell you—you can't time exits.
Exits don't require strategy. Building strong businesses does.

Since moving out of the media space at the end of 2013, I've been approached by a lot of people who say, 'I'd just like to chat with you regarding exits...' I didn't think much of the request the first time, but after the fourth or fifth call, I wondered: Am I really *that* person? Why do they think I know so much about exits?

Sure, over the years various opportunities for unlocking value or 'exiting' have presented themselves. Each afforded me an opportunity to look at where the business was, where I wanted it to be and recalibrate based on the available information. The part that surprises a lot of people (and they often don't believe this) is that each of those exits was entirely unplanned. In my entrepreneurial journey, I have never started any business with an exit in mind. If a business were into its thirtieth year and still going strong, I'd be happy so long as I could continue to create, innovate and grow in that space.

Some entrepreneurs readily jump from one cool idea to the next—

though the media tends to exaggerate the frequency of rare successes and ignore the very common crashes out of the starting gate. Other entrepreneurs hold on for dear life, seeing exits as signs of failure or, worse yet, disloyalty to the business a family has built over generations. Every businessperson views exits in his own unique way; none has the foresight to predict them with any accuracy.

As an entrepreneur embarking on your journey, you're going to be faced with one burning question the minute *your* company is no longer 100 per cent yours: *Where's the exit?*

Let's clarify three things.

First, most observers see exits as akin to 'abandoning' a business. Not true. Once faced with the option or probability of an exit, you make a decision only after taking into account what's best for the company, the stakeholders and your team. What may be an exit for you is only a transition for the company, brand and business as it moves forward, hopefully to the next level of growth. Of course, some realignments may occur during the process of exiting, but you can think of these primarily as functions of passing the baton.

Second, providing an exit for your investors and partners does not always imply an exit for you. Exits don't always unlock value. In fact, in most cases, quite the contrary. Your obligation as a leader is to create a liquidity event for your stakeholders at the appropriate time. As the founder, you can create more value if you're willing to stay on and build a great company, team, brand and business for the long term, not for interim investor benchmarks, which are not only distractions but flawed business strategies.

Third, at the time of exit, clear and open communication with your entire team and colleagues is critical. Proper communication requires meticulous planning and must come with integrity, clarity and good timing—and these are things people appreciate. For me, communication has always been a vital part of a smooth transition; it helps retain the company's value and culture going forward. People want to hear it straight so they can make their own independent calls. They appreciate the care, concern and planning that go into ensuring a smooth transition.

When entrepreneurs build businesses focused around exit strategies rather than ensuring the day-to-day health of the company, the decisions that keep a business vibrant, agile and on track become more difficult to make and execute. I've sat through board meetings where exits are pitched as ways of creating value. *Two years from now this will happen. Three years from now this. And then we'll be ready to...*

I can now say with certainty that every one of those presentations has been a piece of fiction. The bottom line: *You can't time exits.* Ask all those who have actually successfully exited a business. They'll all say the same thing: 'It was never really planned, nor was it my intent at that time.' I can bet that in 95 per cent of successful exits, the outcome for both the incoming investor and outgoing founder has been win-win, with the exit being driven by the buyer.

If you're building your business just to build a business, you'll be presented with multiple opportunities to exit at the right time, if that's what you choose to do. Simple as that.

World over, just twenty years ago, entrepreneurs didn't create businesses with an eye towards selling and exiting them in three years. Today's Internet culture—instant global communication, online social apps, daily examples of unthinkable wealth posted on blogs and in the media—has stirred the imagination of a new generation of energetic, ambitious entrepreneurs. They follow the examples of these successful people: the team that built a billion-dollar business in eighteen months; the twenty-five-year-old college dropout who overnight turned his mother's basement into the hub of an international social-networking site; the college kid who developed a GPS app from his dorm room. We're seduced by the stereotypes associated with this rare breed; their accomplishments are evangelized—as if such rapid success is commonplace, always pre-planned and as simple as opening a Twitter account. Nothing could be further from the truth!

Ask any of those visionaries, entrepreneurs and leaders, and they'll tell you that the challenges and sacrifices to get to the point of being courted by deep-pocket suitors were many—fraught with close calls and near misses, at a time when success was anything but certain. But they persevered relentlessly, without any grand plan for a timed exit. What

they always did right was to stay on track and build an exciting and valuable business, product, offering or customer base.

◆

When I think about my exits from business, I recall how each took on a life of its own. As I mentioned earlier, I started out in the cable television space, deeply passionate about pioneering a business with a concept that could easily have been ahead of its time. As cable television mushroomed into a cottage industry, and competition increased, transparency decreased. Because the space wasn't fully regulated, everyone made his own rules. Even though regulations can sometimes stifle growth in business, basic rules add a few necessary frameworks for a sector to thrive from healthy competition.

By the fifth year of the cable business, I had a creeping feeling that we would have difficulty succeeding in such an unregulated environment.

Because we hadn't taken any external money, we were under no obligation to get out. Seeking to distance myself from the day-to-day operations to gauge the pulse of the business, give it direction and free up my time for other ventures, we brought in professional management. Even so, I knew within a year that cable TV wasn't the business I wanted to stay in for the long term. I don't even think I was mature enough as an entrepreneur then to consider the word 'exit'—if somebody were to ask me what an exit was, I'd say the door out of a theatre—but I was open to whatever opportunities presented themselves.

I had two or three detailed discussions with my then father-in-law, who was also my senior partner and co-founder. He wanted to stay the course. I wanted out. By chance, the COO we'd appointed came to me one day with the news that he had decided to move on. I sat him down for a heart-to-heart. 'So what's the plan?' I asked him.

'Well, there's this large group from the south of India that is into holiday resorts and real estate,' he said. 'They want me to join them and start a cable business from the ground up and take it national.'

'I think you should go,' I told him. 'But I have a proposition for you. Why don't you speak to them and tell them that not only will you join

them, but you can also buy out the existing business and get a head start on everyone?' The words just popped out. And with that, I had created an opportunity that was, by the looks of it, a win-win situation for all.

The COO spoke to the people at his new organization and the proposition made complete sense to them. Within two months, we'd hammered out a deal. Zero pre-planning. I didn't know the word.

Come to think of it, that's the way a lot in business unfolds.

◆

Over my twenty-five years across various businesses, we've had many partners and investors who have also exited companies, but very rarely have I used an investment banker. To clarify, I think investment bankers are needed intermediaries in the ecosystem. But on my part, I've always found them fraught with conflicts of interest. In most cases, to show their perceived 'value add', they suddenly became the facilitators for and experts on everything in the room, and eventually the cause for lengthy and costly delays.

If you're looking for investors or partners for the first time, an intermediary is a godsend who can open doors to people you can't reach. And from here on starts the conflict, in my personal view. Investment bankers are very well networked. That's their job. On most occasions, the potential investor is also the investment banker's past and future client. Hence the conflict.

The investment banker views his role as two-fold—to gauge how far you're willing to bend as an entrepreneur; while at the same time understanding what the potential investor's 'fair ask' is, making your best case for you and selling it to potential partners. Having understood each one's threshold, the investment banker presents what, to his mind, is a win-win proposition. In reality, it's a complete and blatant conflict of interest.

In my view, that's not how things get done. You hired an investment banker to make the best case for your company, not find the best proposal that *he* thinks is right and fair for *both* sides. I'm willing to bet a rupee that 95 times out of 100, the value that you and the incoming

investor negotiate directly will be 10 to 20 per cent higher than any offer you receive via the investment banker.

If it's your first time in the world of external interaction, use an investment banker if you have to but,

1. negotiate directly with the other side (keeping the banker in the loop);
2. for some specific points, fire off the banker's shoulder; and
3. lead all discussions pertaining to timelines and take calls on all open matters.

A fee just for the right introductions and not much more, then, is acceptable, but only for the first outing. If you open up and share all your expectations with the investment banker at the outset, chances are you've played out your hand, leaving little room for upsides.

After all this, your business has to be its own magnet and your existing partners and investors, your best guide to the outside world. Otherwise, count on getting shortchanged again.

◆

Were there days when I would introspect, worry about whether I had exited too early, or if I could have done better (or worse)? Of course. But to what end? The same holds for entrepreneurs, who fall in love with an idea so highly personalized and integral to their personal brand that the question of having it subsidized by somebody else seems incomprehensible. That's one of the trickiest aspects of handling exits in businesses.

For instance, if I had the advantage of hindsight (which I don't, no one does), I would have kept the cable TV business intact, and we would be the largest such operation in the country *by far*. Already established and poised to grow exponentially over the next few years, if I had captured that first wave of broadcasting with UTV in 1992 and held on...

Or if I'd stayed the course with home shopping...

Or if I'd persisted in Southeast Asia and become a pan-Asian media company on a massive scale...

If, if, if.

I can reminisce all day about what might have been and grieve over how often I got things wrong. Sure. But if any one of those businesses had taken a downturn, there'd be no nostalgia, only a nightmarish worst-case scenario. It's ridiculous to mourn any business in hindsight.

Life and business are messy. Neither boils down to a spreadsheet nor foreshadows myriad unexpected and unforeseeable twists and turns. People look for perfection that doesn't exist, neat and tidy ways of creating and nurturing businesses that won't cause them discomfort, but will provide astronomical returns. Get real.

Exits aren't about giving up, they're about seizing opportunities. If you think you're abandoning anything when you exit a business, you're fooling yourself and forgetting why you became an entrepreneur.

◆

In India today, one of the most contentious discussions on exits focuses on family businesses. Millions of family-run businesses, from modest to massive, form the backbone of India's ecosystem and are often the cause of exasperation for today's generation of entrepreneurs chosen to head decades-old legacies. Deciding the right time to exit a business or a part of a business that's been passed down from your great-grandfather through four generations can be every bit as difficult as any decision the CEO of a corporation makes. Even if you have the best interest of everyone in mind, you're probably concerned that the exit will reflect poorly on the family. After all, that business is a part of your history, a symbol of your standing in the community.

First, understand that the decision is in your hands and your hands alone. If you go in with a pure heart, you'll do what's best for you, your family and the business. 'Exit' questions are bound to arise more often today, when every decade or so the world changes five times over. Your grandfather had no idea what the world would look like forty or thirty or even twenty years down the line. Now, you find yourself running a low-tech manufacturing business, a steel conglomerate, a trading or distribution operation, the neighbourhood kirana store, a pharmacy, or a family restaurant. All stable businesses, but hardly the dynamic

opportunity you had envisioned when you caught the entrepreneurial bug.

In terms of viability, your family business could be an anachronism or need a B2C element for real growth potential, or it could be an entity that throws up decent cash flow to make things comfortable for the family but nothing more. Perhaps your business depends far too much on state and government regulations, and that's not your cup of tea. Or maybe it just doesn't make you want to jump out of bed every morning and get to work. In any of these cases, you could be a hero just by selling the business and getting fair value for your family.

But the business came down through the generations, you think. *How will it reflect on my family if I sold it?* Ask yourself: How will it look five years from now if you're not completely passionate about continuing your family's legacy? How will you help your family if the business can't go to the next level because of a shrinking market? Or even worse, on account of your lack of passion? How many other more exciting opportunities are you passing up to keep slogging, all for appearances?

Life moves on. From manufacturing to service to technology to… who knows what. When it comes to exits, do what's best for you and the business. Your family will thank you.

◆

The first time the public at large started to look at what we had done during an exit was with Hungama, the kids' channel that started UTV's relationship with Disney. When we conceived the idea for the channel, nobody on the team said, 'Hey, let's build the channel, get it to the number one position and sell it in two or three years.' Nothing at all of that sort. In fact, Disney's was an unsolicited proposition.

As we built Hungama in India and Malaysia (where the channel was called Ceria), the Malaysian broadcaster approached us to invest 26 per cent into Hungama. We were ready to ink the contract when the media broke the story.

The day after agreeing in principle to the 26 per cent investment, I was in Los Angeles to meet Fox regarding the details of our co-production of the film *The Namesake*—when I got a call from Andy

Bird, the chairman of Disney International. Andy and I knew each other, having spoken together on panels at international broadcasting conventions over the previous decade. Still, I was surprised to hear him at the other end.

'I just read on a newswire that you're divesting 26 per cent of Hungama,' he said. Despite having been in the media and entertainment business for decades, I'm always amazed at how quickly news, good and bad, travels. 'You know that we run our Disney channels in India. We've been following Hungama with a lot of interest. Great ideas and programming. What do you think of selling the channel to *us* instead?'

My response was immediate. 'No! Why would we want to sell the channel? We were just looking for an investor, nothing more. And we're on to something good here.'

One of Andy's best qualities is his persistence. I knew I couldn't shake him off that easily. 'I'm calling from the LA airport and flying out. How about having a think on it over the next week and let's talk. When you're in LA next, come and meet us.' He thought he was calling me in Mumbai.

'I'm actually in LA now,' I said, savouring the coincidence.

'Super! Would you be willing to meet Kevin Mayer, our head of strategy? Exchange views. See if something interests you. I appreciate the fact that you don't want to sell the channel. Just talk to him. See what he has to say. No strings attached.'

In my two-hour conversation with Mayer the next day, one thing led to another. 'Okay, so what will it take?' he said, pushing the issue once we had got the pleasantries out of the way. Andy and he were birds of a feather, both persuasive to the core, which is why they were highly placed at a behemoth like Disney. The more Mayer talked about Disney buying Hungama and building it into their Indian bouquet, the more I wondered if it could make sense for UTV.

But I enjoyed the back-and-forth and we struck it off in that first meeting. I'm candid and get straight to the point. Kevin, too, is a savvy, no-nonsense guy. That focused the discussion and opened us to all options. 'We like UTV's model. We're in India and we want to expand. Let's think of a broader relationship outside the sale of Hungama,'

Kevin said with a grin.

He wanted roughly fifteen days to pull together a proposal and get back to me and requested us not to move forward with our present arrangement during that period. If we were to consummate the deal for the 26 per cent with the Malaysian broadcaster, our dealings with Disney would become moot. We agreed and went our separate ways.

My first responsibility was to update the Malaysian broadcaster, our partner and friend. They were disappointed at this turn of events, but ultimately supportive. They understood the big picture for us, and we assured them of our support for Ceria.

A fortnight after speaking with Andy Bird and meeting Kevin Mayer, we got on a call late India time to hear Disney's proposition for a clear financial offer to buy 100 per cent of Hungama, with an additional 14 per cent investment in UTV. We didn't need to wonder any longer why they were interested. Besides, for the first time, we understood what a deal with Disney would mean, both in the present and for the future of UTV.

We'd made a popular kids' channel. But it was a single channel, not a part of a bouquet. This potential investment was more of a strategy discussion for us—not about selling a channel, but about seeing the big picture. In the end, we got a strategic partner, resources from the sale of a channel, fresh equity in the company and opportunities to scale our business overall.

And with that, the deal was done.

Except, it almost never happened. Nothing is closed...till it's closed. We all invest so many hours in documentation to ensure smooth and timely closure. But let's face it, if either side is uncomfortable with even the smallest detail, they can, and will, walk away. Nothing you can do about it. That's the reality, and I think it's fair. Don't take anything for granted.

Case in point: At that 11.00 p.m. call, we had all broadly agreed on a valuation. On that basis, I closed the door on our other proposal. Of course, what followed in the next three or four weeks was this—Disney began doing its financial and legal work, culminating in an all-party call to go through any points of contention or concern. To my mind, those

raised on the call with Kevin and Disney weren't material to our deal. What followed was the beginning of a renegotiation that felt much less in keeping with the spirit of our earlier discussion.

At that point, I called a halt, telling them that we didn't want to negotiate. We had agreed on an overall proposal in the right spirit and not negotiated, and so there was nothing material here to call for a new price discussion. In less than ten seconds, twenty-five people from all over the world thanked each other for their time and hung up. On our side were my colleagues Ronald and Amit, respectively CFO and head of business development and strategy, and Zarina and I. Ronald and Amit, I learnt much later, went out for more than one drink to work off what they thought was a rash and impulsive reaction on my part. Zarina and I drove off, discussing on the way home a fresh tomorrow with renewed vigour. I remember sleeping peacefully that night, thinking the chapter closed.

The next afternoon, I picked up the phone to call Kevin, who had travelled overnight to London, to thank him for all his work and patience. I didn't want our relationship to end as abruptly as the call had, even though I was at peace with our decision. Kevin and I got chatting again, and since we had already struck up a good rapport and strong mutual respect, we kept talking. Before long, we were discussing our differing views and had brought the deal back on track. By the end of the call, we agreed to move forward with a fair resolution.

So much for 'pre-planned exits'.

Even while telling the story now, I understand that it sounds like a pattern—how I sold my toothbrush business; pioneered cable TV and sold it; bought Vijay TV from Vijay Mallya, grew the business, brought in a strategic partner in Star TV and divested; started another channel and sold that eighteen months later.

But with the Hungama sale, we took advantage of an opportunity that was solely the result of our thinking ahead and envisioning a kids' channel in Malaysia. No kids' channel, no Malaysian partner and their first proposal. If we hadn't been willing to get a 26 per cent partner in, we would never have fielded Disney's offer to buy us out.

If the team had said, 'Let's start a kids' channel and in three years'

time either Nickelodeon or Disney will buy it', we would have had an abject disaster on our hands, a channel conceived on what Disney or Nickelodeon wanted to see. More concerned about fulfilling someone else's vision than our own, we wouldn't have called it something as disruptive and insane as Hungama (which everyone at Disney found difficult to pronounce for almost a month). We'd have given the channel a Western name, we'd have gone for more Western programming instead of Japanese animation. And in the end, it simply wouldn't have been the channel *we* wanted. Hungama would have been one more face in an increasingly large crowd trying to ingratiate itself to the market by building a business in someone else's image.

Even after the Hungama deal and what transpired with Disney many years later, I can't take credit for Disney's idea of finally acquiring all of UTV. The deal worked because Disney, a strategic partner, had its own establishment in India. We brainstormed a lot about the future of UTV and what we could do together over the next ten years. Companies like Disney are forward-looking and great with five-, ten- and fifteen-year planning, so they were quite happy to include me in their discussions of what UTV and Disney could do respectively over the long term in India. We rarely set an agenda in these sessions. Over time, the more we discussed our future with Disney, the more apparent it became that we were two companies with parallel visions in a similar opportunity space. When we looked at the big picture, we knew we could work together. In the end, the waves collided. I take no credit for the deal; it was the result of dozens of talented people working hard to reach a common goal.

What I do take pride in is the fact that, over the years, each of the companies I've exited has gone from strength to strength even after a deal has been struck.

The cable startup created a massive industry and the company is a part of a lasting legacy.

The toothbrush business is in great hands and continues to service its multiple clients with top-notch technology.

Vijay TV became the beacon for Star's regional language diversification plan and the channel itself holds its own in a hyper-competitive market.

Hungama for Disney became a game changer overnight as a leader in the 'kids' genre. Later, *Doraemon*, the most successful show on Hungama, moved to the Disney channel and made that channel number one.

UTV's integration into The Walt Disney Company has been completed and the combined entity derives scale, a diverse presence in the media landscape and, most importantly, a great team from both sides with an even stronger culture. It's a little early to say how the combined entity will build Disney's ambitions in India. The jury is out and time will tell, but Disney takes the long view.

◆

In my first innings, right to the time I moved out of the media and entertainment industry, we pioneered a lot, built everything to last and had our fair share of exits. In that period, we had investments from Warburg Pincus, Canadian pension fund La Caisse de Dépôt et Placement du Québec (CDPQ), Indian majors like IL&FS, Japanese investors like Mitsui, Silicon Valley investors Walden and Draper, and strategics like News Corp/Fox, Disney and Bloomberg. The list goes on. Given such experience, I should have an almost supernatural understanding of how, when and why exits work, right? Wrong. Absolutely wrong.

To be honest, if I started a business today with an eye towards the exit, I wouldn't know where to start. I'd be hard-pressed to sit down and say, *Okay. Now at least I've got my legs back under me and I know what's going on. I've lived the story. I've thrived from good exits, survived bad ones. Now perhaps, I can draw some hard-and-fast rules from some of those experiences.*

Whether you're twenty-three and looking for your first entrepreneurial break, or a grizzled veteran transitioning from the workaday world to fulfil your own dream, there's going to come a time in your entrepreneurial journey when you'll reach the crossroads of an exit and ask yourself, *Should I get off or should I stay on?*

The only thing my experience has taught me is that exits are about creating value and letting go when the need and opportunity arise. This

might sound like a non-commitment. But a timely exit can be the best business decision an entrepreneur makes in the same way that a poorly timed exit can be the worst.

◆

* Most exits are entirely unplanned. We do not have the foresight to predict them with accuracy.
* All of us view exits in our own unique way, but remember, exiting a business is not abandoning it. In fact, it's more about passing the baton for future growth.
* If you are taking charge of your family business that has come down for generations, you need to ask yourself all the hard questions and do what is best for the business; do not hang on to a legacy only for the sake of it. Your family will thank you for your resolve eventually.
* At the time of an exit/sale, clear and open communication with the entire team is critical. Your job as a leader or entrepreneur is to build a strong team, brand and long-term business strategy. Stop obsessing about exits.

12
Second Innings

A second innings isn't about starting over. Life is about continuation,
not reinvention; it's about persevering and finding wisdom, not complacency.

In life, as in sports, your second innings will depend a lot upon your first—what you've learnt and absorbed along the way and how you've used, and will use, those learnings moving forward. The mistaken assumption, though, is that a second innings can only be meaningful if you've left a mark or created wealth in your first. Absolutely not!

Maybe your first innings didn't end the way you planned. Perhaps, setbacks forced you to move away from your pet project or business. Maybe you were on the brink of bankruptcy with nothing to show for all the work. You may have spent the last two years recovering from a crippling illness that left you far behind on the career ladder—only to start again because you have the drive to succeed. Or maybe your second innings is just starting as, after ten great years as a professional, you're ready to take the plunge into something of your own.

I hear quite often that second innings are only for those past forty-five. Untrue! Some of you reading this book and preparing for the next act in life may only be in your thirties. A second innings is a bookmark

or a cornerstone, nothing more. In life, unlike in cinema or sports, there is no scheduled interval. Rather, life is seamless, often enigmatic, full of crossroads and switchbacks. And if we look for it, the time to introspect.

Why do I consider the present juncture in life as my second innings? After all, I've had many twists and turns in my entrepreneurial journey over the years. However, I don't consider those endeavours different from one another; as I moved on, I realized they were all individual panels on the same enormous patchwork quilt.

I was fortunate to be a part of the creation of a media and entertainment company. I'm proud to have been a part of many businesses that helped build and shape a nascent industry in India and, in the process, impact younger generations. I've never enjoyed anything more in my professional life than creating something out of nothing every single day, or chasing a new thought or disruptive idea.

Now that period of my life has come to an end, and I'm starting a fresh chapter in life, exploring other entrepreneurial and social avenues with an evolved sense of purpose, bringing with me everything I've learnt, unlearnt and learnt again over the years.

As I've mentioned in the previous chapters, so much of business and life can't be planned with any certainty. If you had asked me eighteen months ago whether I'd be writing a book today about my entrepreneurial journey, I would have called you mad. Time and tide move in strange, shifting, wonderful ways to transform you and your thinking, your priorities and perspectives on life. Once you let your guard down and allow the thoughts to flow, you discover more about where you are, where you want to be and what really excites you.

In 2014, for the first time in recent memory, I had a chance to take stock and introspect, to review, to look at life away from the entrepreneurial treadmill that I had stepped on to over two-and-a-half decades ago. I didn't feel the need to go to the Himalayas for a month in a bid to find inspiration—though sometimes, I wish it were all that simple.

An acquaintance asked me early in the year, 'Now that you're at these crossroads, why don't you just relax and enjoy some time off?'

The question is deeper than it would appear to be, and it's one I hadn't asked myself for a long time. I mulled over it more in those few months in 2014 than in the previous twenty years combined. Ironic, now that I have some breathing room, I'm right back where I started from. The entrepreneur's circle of life.

Searching for an answer to that question, I asked myself: *Do I really want to go through that same drill all over again? The relentless quest for growth, team-building, innovation, crisis management and more?* My almost immediate reaction was, 'Of course. That's what I do. And I'll embrace the challenge again.'

I've got more irons in the fire today than ever before, working with smart and dynamic people who keep me fresh and engaged. The only change is that now I can do whatever I choose, so long as it has impact. That's a good feeling.

Creating impact is linked to passion, and my passion for what I do hasn't ebbed one bit since those first days in Grant Road, when the world held limitless possibility. In fact, if pressed, I would say that it has only ramped up. The whole myth of creating something, exiting and then going to the middle of nowhere to chill for the rest of your life is just that—a myth. True entrepreneurs, whether successful or struggling mightily, don't simply disappear. First of all, to have achieved something worthwhile, you need to be driven. It's in your DNA. So when one chapter ends, it's on to the next big (or small) thing, a chance to recapture that incomparable feeling of conquering the world one more time.

This chapter isn't so much about my future; rather, it holds broad thoughts for anyone ready for change or getting on with life's work. What you think might be a sea-change in lifestyle...isn't. Or at least it hasn't been for me. One of the greatest thrills I've got from a fresh start, though, is the opportunity to use the lessons learnt over the last two decades, many of which I've shared with you throughout this book, and to challenge myself in totally new sectors.

◆

My six-odd years of partnership with The Walt Disney Company,

followed by the two years of professional engagement with the company as the managing director of the combined Disney UTV India, was an incredible learning experience and a great source of inspiration for me. It only further strengthened my belief in scale and the importance of brand, innovation and staying the course. My relationship with Andy Bird, the chairman of Disney International, started with that eventful call—an offer to buy Hungama—and he has been an incredible colleague and mentor, both to me and UTV, for the years he sat on the company's board of directors. My transition to a professional inside Disney never felt odd, and I have Andy to thank for the smooth shift. When UTV became a part of Disney, I reported to him and admired and respected him in equal measure and do till date.

Around the middle of the second year, though, I questioned myself deeply about whether I was indeed the right candidate and professional to lead Disney's agenda in India for the next five years and more. When I couldn't answer the question in the affirmative, I began approaching that agonizing decision of letting go of the industry and moving on. This was one of the most difficult decisions of my career, coming quick on the heels of my exit just a year before from UTV—a business that I had built from the ground up for over two decades with an amazing team, many of whom, I'm pleased to say, are in great places in the industry. Sometimes, I wonder which was the tougher and more painful decision—selling my stake in UTV and taking on a role in a larger company, or the final call to move entirely out of the industry I had lived and breathed in for most of my adult life.

I don't have an answer. At least, not a simple one.

But Bob Iger, the chairman and CEO of Disney, made my decision easier to take with his farewell mail to me. Bob is a leader in every sense, with all the personal traits that define great leadership—a deep respect for people, and the capacity to empower them and give them independence; a collaborative and creative spirit; inspirational to the core; being proactive and leading from the front; and remaining a top-notch thinker and strategist. Bob said:

Ronnie,

I know corporations aren't always the easiest places to work, but we were lucky to have you, and I always enjoyed our interaction. Your spirit will remain alive at Disney, and I am certain India will be a place for us to thrive for years to come.

Best to you,
Bob

'You and I have some things in common,' Bob told me once on a plane ride. 'I started my career, too, for a short time at least, in front of the camera as a part of the weather team at ABC. I came to Disney when Disney bought ABC and ESPN.' An incredible start. And then to rise through the ranks to head one of the ten most admired brands and companies in the world, to kindle creativity and imagination in its movies, TV channels, theme parks, hotels, cruise ships and products, and to inspire a team of over a hundred thousand to work in synergy to create the magic that Disney stands for—all these successes place Bob Iger in a league of his own as a leader.

◆

Since I have the luxury of being choosy at this point in my life, I want to ensure that whatever I do in my second innings is disruptive in the extreme and has some life-changing impact. In the last year, I've been working on many initiatives outside of our deep commitment to our Swades Foundation—and one clear example of this is kabaddi.

Known to all South Asians, kabaddi is an ancient sport played in local clubs for the last century (most notably, perhaps, in a demonstration at the 1936 Olympics) without ever getting its moment in the sun. As it happens, the short, fast-paced game makes for great television viewing.

I was travelling overseas when Zarina, seated at a private dinner at the same table as the Mahindra Group's Anand Mahindra, learnt of his passion for kabaddi and his interest in establishing a league. 'I'm sure Ronnie will love the idea. He enjoys a good challenge and siding with the underdog,' she told Anand. 'Sounds like it's right up his alley.' When she told me about the conversation that night over the phone, I jumped

at the chance. Before I even got back, I was on the phone with Anand. One thing led to another. Since we were the first to say yes to a team and a league, we bagged Mumbai.

As the league took shape, we chose a name for our new sports division—U Sports (that was the easy part, in the same way I had chosen UTV and Unilazer before)—and our team—U Mumba, for Mumbai (the city was originally called Mumba). Within a week, we had a great logo, and we were ready to begin building a brand in the arena of sports.

So it came to be—a team was created and a sport put on the cultural map.

Kabaddi is an exciting and fun part of my new innings. Make no mistake, this serious business initiative is all about the game and the remarkable talent behind it. Eight team owners and teams, the league's promoters and Star TV focused the national spotlight on an age-old sport with the aim of getting a nation to play it along every street corner and for the next generation to adopt kabaddi as its own. In the short span of less than two months, kabaddi became a national sensation and the second most popular sport in India.

An idea staring us in our faces for decades, and it took a handful of mavericks to have the balls to back it and believe in it. When you can take something that is so much fun and make it a business, it completes the entrepreneurial picture.

◆

What do you want to be known for? How do you want to be remembered? What impactful enterprise do you want to champion?

Thought-provoking questions and hardly the kind you can answer on the spot. But ruminating on these questions helped me get clarity about myself and the companies I built.

These queries and the answers they generate will rub off on the brand of your enterprise, too, consciously or unconsciously. Give them some thought. But also know that the answers are not cast in stone; they can and will change as you evolve. But it's great to have a pin on them always, no matter what age and stage of life you're in.

◆

13
Dream Your Own Dream

I suppose human nature compels me to recall in photographic detail, and with nostalgia, my early days at Grant Road and my entrepreneurial journey since. The route from there to here has been circuitous, enjoyable and fun, occasionally disappointing, sometimes maddening and always challenging. I'd like to think that I've met those challenges with integrity and treated the people I worked with over the years fairly and with respect.

As I've mentioned in the previous chapters, you'll face setbacks along the way, more often than you can imagine. For all leaders, hard work and uncertainty are given. Success comes from harnessing ambition, hunger, passion and potential. The thrill comes from creating something from nothing, from confronting and surmounting the latest test every time you head into uncharted territory, from converting 'constraints' into triggers for innovation and disruption. Your future as a pioneer or even a late entrant is one of infinite possibility and opportunity—a broad, blank canvas awaiting transformation into a masterpiece through your vision and can-do attitude.

I chose to paint my own dream.

I've never regretted it.

◆

Throughout this book, I've discussed foolish mistakes, setbacks, missed opportunities and lessons learnt over the years to highlight the challenges any leader will face when jumping headlong into tomorrow's markets. I've examined scale, staying the course, spotting trucks and trends, failure and the role 'luck' plays (not much, if you recall). But to this I want to add three words that I know will guide me as I regroup and work for the next two decades or more.

Focus. Choices. Empathy.

Focus

First off, *focus* isn't an aspect of entrepreneurship or leadership that you embrace as you evolve, or that 'just happens' in the later years of your business or work life. In the early stages, it's great and proper to try many things. Until you've experimented and gathered evidence, you can't really know what works and what doesn't. But focus defines and gives shape to your efforts. Keep your focus strong, and you'll attract great ideas, sharp minds and reliable team members like iron filings to a magnet.

Focus occurs in the present. As far as I'm concerned, there is no such thing as hindsight. The moment passes. Who knows what the outcome might have been had you taken a different course. Worrying about the past only wastes time in the present. Time is your most precious commodity.

But if I *could* go back and change one thing *in hindsight*, it would be my focus.

If I knew then what I know now, right?

If I had understood the impact of focus those many years ago…

If I had had a mentor who had told me from experience that single-minded attention to an idea, regardless of the outcome, provided some of the most intense learnings…

If, if, if.

Things might have worked out quite differently.

I don't say any of this with even an ounce of regret, since I'll use my understanding of focus in every future endeavour. But to you, I'll say, give the idea more than a passing thought to save yourself future reflection. You'll find the time well spent.

Choices

Life is also about *choices*. As your gut instinct matures with every setback, challenge or mistake, you realize that building any strong enterprise requires making tough choices. As their leader or founder, your team looks to you for many things; primarily, though, they want you to make the right choices. Sometimes such decisions and their consequences (even when you're right) will leave you lonely. Such is the nature of business.

Day by day, we tend to forget to see life as a flow. But life is, in fact, a series of choices, each layering upon the next like the pages of a book. When we look back we recognize how each of them, large and small, has changed us. In the same way that a butterfly's wings can cause a storm on the other side of the earth, the choices we make, even those decisions taken without considerable thought, can have a positive ripple impact. On the other hand, they can take one down a dead-end path. Alas, life doesn't have a rewind button.

Take some time—not every few years, but as an ongoing activity—to stare out at the sea, the mountains, the stars, whatever works for you. Consider how your choices can define and change your life for the better. At the end of the day, successes and setbacks, credibility and reputation are built on the choices we make.

Empathy

Empathy—and to clarify, I'm not talking about sympathy, feelings of pity or sorrow for someone—is a proactive, deep understanding of how your team will handle a situation and the extent to which you are willing to help your team and your business succeed. Over the years, I've developed intense empathy for people and situations, the result of my having failed and rebounded more times than I can count. Stay in business long enough and little surprises you. You develop empathy by relating to the loneliness and desperation that are part and parcel of the entrepreneurial experience.

You've not experienced rock bottom until, well, you've really experienced it. You can receive the best (or best-intentioned) advice from family, colleagues, consultants and investors. At the end of the day,

though, they simply can't know the commitment or the sacrifice needed just to take an honest shot at success.

Developing empathy for team members, suppliers, customers and competitors gives you a more mature and humane view of business and life. Empathy will strip you of any self-importance or the know-it-all-attitude you (falsely) have, check any ego likely to get in the way when making decisions involving others, and eliminate the arrogance you can ill-afford to have if you want to grow and thrive. At the risk of sounding overly dramatic, while the final call is yours, and you're the one who knows what's best for your team, the business and the customer, it's only if you make your decisions with empathy that you're likely to succeed.

Empathy is a life-changer. As you become an industry creator (and, potentially, destroyer), you'll cease measuring success in terms of the number of competitors you've taken down along the way. Instead, you'll come to understand that coexistence works best since we are a part of an integrated ecosystem.

◆

In some of the early chapters, I have discussed how you can handle crises. For me, in such situations, the question that always comes to mind is: *What's my worst-case scenario?* Once I have an answer, solutions slowly emerge.

What I haven't discussed threadbare, though, is the fact that admitting to the worst-case scenario is not always simple (*easy* it will never be, but you can and should make it *simple*). Approach the situation by asking: *What choice do I have?* The other side of the coin is paralysis, a fall from the cliff.

In my experience, leaders and founders often fail to realize that the anticipation of failure is infinitely more stressful than its reality, and that even the worst-case scenario is never as bad as it seems.

Things can get tough, of course. Many have quit trying to salvage their businesses; several have surrendered to their fears and insecurities; some have dropped into an abyss and wallowed there. But find a slim glimmer of hope, and you'll hold on to it and make it grow and glow.

One day, at an internal training session for top executives, I randomly

ducked into a meeting an hour or so before my lecture. The session's moderator was giving a demonstration on confronting fear. To make his point, he stood in front of a bed of burning coal and asked all those present to take off their shoes and socks. Then, he asked his audience to volunteer to take turns at walking on the hot coal.

Every single person just stood there, arms crossed, looking at the moderator like he had two heads. 'What's wrong, guys?' I asked the group. 'The man's telling us to walk on hot coal, let's walk on hot coal!'

'But this isn't *Fear Factor*,' a guy at the back of the room said, clearly not amused. 'Why would we want to do this?'

I shrugged, got down to my bare feet and stepped onto the coals. The heat was intense but bearable, and the moderator encouraged me to establish a rhythm, just keep walking. In a few seconds, it was over.

The experiment wasn't dangerous, of course, but was meant to convey the idea of overcoming irrational fears; walking into a room with a live coal bed on the floor can cause some cognitive dissonance, especially if you're not expecting it. In addition to confronting fear, you also learn to put your trust in people and lead from the front.

It's an age-old dilemma that has existed over eons, to ensure that you have the best chance for survival. Your right brain wonders how you're going to get across that coal bed without burning your feet badly or embarrassing yourself (if polled on the issue, many would choose burning over embarrassment). At the same time, your left brain flashes everything in your life that will make getting to the other side worthwhile. That glimmer of hope from your left brain, along with the right brain's logic of following a plan step-by-step until you've accomplished your goal will be permanently etched in your memory once you've made it across safe and sound.

By the time you get to the other side, you've learnt more lessons than most—how to handle fear and uncertainty, compartmentalize decision-making and focus on the immediate present to leverage future advantage. In short, you've learnt lessons about life.

You now know what it takes to succeed.

Until the next fire pit appears. And trust me, there will be many.

◆

I'm not a great believer in Plan B when it comes to tough decisions, crisis management, or worst-case scenarios. This may sound like a contradiction to my earlier statement—that working on worst-case scenarios is a must. Don't get me wrong, I'm not saying it's not good discipline to work on Plan B, which allows you to consider 'what ifs' and helps in the planning stage, when you have the luxury of time and the option of keeping that Plan B tucked away.

But having a backup plan only takes away from the singular, unshakable faith you need to have in your Plan A, distracts you from the goal and gives you and your team the false impression of a safety net (which, by the way, is not there) should you fall. Plan A means setting your laser sight on your goal. Plan B implies keeping one eye on the exit. And that's exactly where you'll head when Plan A becomes too ambitious, too disruptive or just...too much. Remember Arjun, with bow and arrow in hand, when his teacher asks him what he sees as he takes aim at the bird in the far-off tree. 'Ankh,' he replies, focusing only on the eye of the bird.

Real conviction and focus, not Plan B, allow you to stay the course and navigate do-or-die scenarios. With every opening door, you feel the renewed vigour that comes from being on the right path. That path will never be straight or simple, but it's the one you've chosen to follow to its conclusion.

In crisis mode, ask the hard questions that define you as an entrepreneur and a leader. When the chips are really down, one thing you don't want is the distraction of a Plan B. A crisis demands uncompromising faith in yourself and a single-minded focus on executing decisions made under pressure—both of which require you to communicate in a direct, timely fashion, gain the confidence of team members and other stakeholders, and move your company from calamity to success.

At times like these, a Plan B—either conceived by you or by your colleagues or external consultants, who can never know every aspect of your organization nor be around to then react with you in the saga of future twists and turns—weakens your resolve. This is my personal view based on experience; you'll be amazed at what your mind, body and

resolve can do when you believe and act as though you have only one way out of the tunnel.

Let me emphasize this point with a hypothetical example, as I think it's an important one and it's critical that you're comfortable with the level of resolve required to succeed when the chips are down. Say your company has experienced a serious crisis and you've identified three options to resolve the situation:

1. get rid of the whole business in a fire sale or run the risk of watching it disappear;
2. without a buyer, shut the business down, salvage what you can, pay off some of your debt and call it a day, hoping to start afresh; or
3. fire many of your teammates, cut costs and sell the best-performing part of the business to give yourself more time.

Now figure out which is your Plan A.

At the time of a crisis, colleagues, investors and others will advise you to have a plan for each of the three options. 'Pursue all three and determine your best outcome,' they'll tell you, acting as if they know what they're talking about. But unless they've been in on all the meetings with you and made the tough decisions alongside, they don't have a clue. Even though their approach seems like a logical response to a difficult situation, reality as it appears from the outside rarely matches the leader's keen perception. Crisis management of this sort is a useful exercise to solve in business school or during a hypothetical boardroom discussion. At the end of the day, though, businesses aren't saved by academic decisions. They're saved by the people who know their organizations inside out and make decisions based on the best available information.

I would strongly suggest going with the option that makes the most sense to you, the one you feel you can pull off and whose outcome you can live with. *Keep in mind, of course, that sometimes the best option is not the one you can live with*—one of the many contradictions in business you need to come to terms with in your own mind.

Dig in. Dig deep. And if all else fails and you feel that shutting your

business and squaring things off is what you can live with, then make that your choice. But it's *your* choice to make, and yours alone. The harsh reality of entrepreneurship is that if you had designed a Plan B on the advice of consultants or stakeholders and if even that had failed despite your best planning, no one would be willing to share the blame with you. You're on your own, even after having abided by the advice of others. Just because it's Plan B doesn't mean it will work. In fact, without being battle-tested, few such plans will stand the test of time and history. And so, I dare say, overall, Plan B is best left to strategy consultants and business schools as great learning, as an exercise to give the left brain—even as you work through your decision-making curves.

I believe deeply in understanding history, which tells us that Patton, Montgomery, Napoleon and other great men of war routinely went into battle without a Plan B. The logic guiding that strategy is airtight. Imagine, if you can, landing on the beach at Normandy, facing relentless gunfire and horrific casualties, as those around you drop one after the other into the surf.

Is your first thought: *Tell me again, what's my Plan B?* Hardly.

Instead, you think, *I've got to keep a clear head, meet the challenge and get over the hurdles that arise before me. I'm here to do my part to win the war.*

That's real life in times of crisis.

◆

Be honest. With yourself. At all times.

At the risk of sounding like a broken record, that's not as easy as you might think. Chances are, you're fooling yourself the majority of the time.

When I evangelize about being honest with yourself at all times, I'm not talking about integrity—a given if you want to succeed—but about squaring your beliefs with your reality. As entrepreneurs and leaders, it's in our DNA to be positive (if not overly optimistic) even in the most dire circumstances. Our nature is to absorb good news and push the bad under the carpet. But a fine line separates the positive and the real. We cross that line when we ignore the facts set in front of us, convinced that focus, hard work and passion are enough to ensure any desired

outcome. They never are.

Worse still, we're all pretty adept at justifying our failures and latching on to any reason under the sun to rationalize why the business isn't doing as well as it could: the environment, monetary policy, monsoons, Iraq, a slowdown in consumption.

And, and, and. *None of it is my fault.*

Chances are, though, not one of these excuses really affects your business at scale. Smart leaders, brutally honest about the challenges they face, have already factored all of these contingencies into their plans and are stronger and better for their preparation and foresight. The rest shoulder the world's woes as if they're carrying them single-handedly up misery's Mount Everest. That's a major factor separating the successful from the also-rans.

As outsiders with little knowledge of the real facts, why do you think Warren Buffett has managed to stay so far ahead of the pack for such a long time? I'll hazard a guess that outside of the four virtues crucial to the successful entrepreneur—focus, a conservative growth mindset, a passion for deep learning and the highest level of curiosity—Buffett benefits from tight-knit teams that can be brutally honest with one another at all times. As he has said in public, 'You only have to do a very few things right in your life so long as you don't do too many things wrong.' There are many other examples, all over the world and in India, of such entrepreneurs who stand out as true wealth creators. They all benefit from one simple rule.

Be honest with yourself at all times.

◆

So let me step back and end with my vision for the future of India.

I'm deeply proud of our country and its true potential. I started this book by telling you how much I believe in the spirit and resilience of this great nation. More and more, though, I worry that we aren't stacking up on the global stage, at least not yet. Barring some rare exceptions, we have a long way to go before we realize our full greatness.

India faces exceptional challenges. More than half the population

lives in the rural hinterland, detached from the rest of the country. While change can be helmed by a few hundred or a few million—a young, urbane, talented generation that displays an open, honest anticipation for the future—the entire population needs to be swept by new ways of thinking and acting, by fresh goals for the future; this can only happen if the other half of India, in distant rural areas, is made to feel a part of the transformation.

No government can be responsible for such change. *People* bring about change. *You* bring about change and impact the lives of others. That's why I love our movie *Rang De Basanti*. Remember the scene at the end where, when the boys are trapped at the All India Radio station, and Karan speaks live on air to the entire nation: '*Koi bhi desh perfect nahi hota, usey perfect banana padta hai.*' ('No nation is perfect. We have to make it perfect.')?

Seven decades ago, within the lifetime of many of our parents and grandparents, around the time we gained our own independence, Germany and Japan lay in ruins, shamed and defeated for the world to see. Those countries overcame their setbacks not because of the words of a few leaders, but on account of the entire populace thinking and acting in unison, and pursuing a common goal. Each ordinary citizen kept his head down and did his part to make his nation great again.

This is the example we need to follow. No longer can we fool ourselves into thinking that opportunity, a solid home market and good governance will elevate us in the world pecking order. No longer can we afford to think: *I simply cannot make a difference, let's go with the flow and see what happens.* No longer can we sit on our arses, our only contribution being to complain and feel helpless. No longer can we wait for others to make the first move.

An unprecedented rising will require sacrifice, ambition and accountability. All of us, in our own professions, as entrepreneurs, doctors, agriculturists, traders, teachers, public servants, researchers, or scientists, need to commit to a better future—aware that if we miss our chance now, we miss it forever.

◆

As a country with a population of 1.3 billion, India barely has a presence on the world stage in any sport. When I mention that fact in conversation, a common response is a shrug and the comment: 'Why focus on sports? What about so many innovators and leaders of Indian origin who have made an impact globally in the sciences and technology and head the world's most respected companies?'

'Thank you for making my point for me,' I say. Sure, we've always had talent. But let's be honest, those who excel on the global stage and in Fortune 500 companies—and more power to them—have done so in their individual capacities, riding on their own merit. These successes may reflect well on India, but do little to help the vast numbers of Indians reach their potential and bring about the entrepreneurial revolution we've envisioned for decades.

I'm willing to wager one rupee (my maximum bet, and not because I think I will lose) that the day India wins big at the Olympics—and I mean twenty-plus golds—and becomes a global player in sports, we will already have become an economic superpower. Gauging a nation's impact on the world stage by its sporting successes might sound like an odd metric, but the connection is undeniable. After all, most success springs from feeling joyous and confident—dare I say *unstoppable*—and believing one *can* accomplish almost anything—and sporting victories contribute to such euphoria.

◆

Let's learn to create products and services that deliver for life—not repair for life.

For this, we need to unleash and reach our creative potential. While the world may be running out of natural resources, creativity remains a renewable commodity, available in abundance—no need to ration it. Nor is creativity attached, as some think, exclusively to the arts. Rather, creativity exists in every field, and leads to inventions, works of imagination, creations of limitless possibility. Creativity spans the realm of dreams and the reality of the marketplace. The day we reach our creative potential, we will be unstoppable. If we fail to reach our potential, though, no one need stop us—we aren't going anywhere.

As a nation, we need to figure this out over the next decade. Instead of aligning ourselves with short-term objectives, we need to reach for long-terms goals. Instead of merely talking the talk, each of us needs to contribute in full measure, walk the walk.

Don't wait a day more to begin. No one will sound the bugle for the charge up the hill. Bring your own bugle (or drum or sitar) and running shoes, set your sights on the peak and settle for nothing less. Bring your ideas and your passion and your vision, and prove to the world that you can make a difference.

We have one more chance. The odds are stacked against us. But we have what it takes to turn this fantastic nation around. And we'll do it with the youngest, most energetic, most passionate people in the world, with optimism and hope.

It's all possible.

Just dream your own dream—and when you do it, dream with your eyes open.

◆

Appendix
Some Frequently Asked Questions

While my book ends with the last chapter, 'Dream Your Own Dream', I realize that I may not have addressed some practical concerns you may still have, specific topics uppermost in your mind. I've covered a fair number of learnings, but I'd like to address some of the questions most often asked by colleagues, leaders and fellow entrepreneurs on culture, team-building and hiring, vision, mentors, fundraising, brand, and building and growing businesses, among others.

I've tried to answer these questions succinctly and from the heart, drawing from my experiences and sharing my perspective on issues we all face as we live out our dreams. While I don't for a minute think that any of these questions can be answered fully in a page or two, or that my answers are the only way forward, my hope is that these responses will encourage you to explore new and old territories further on your own. These are the very questions I wish someone had answered for me before I started on my own journey. Knowing then what I know now would have shaved years off my learning curve.

So on this one, let's dream it in fast-forward.

Question 1

How important is culture in an organization? At what stage in the company's life is it best to build it? How can I maintain a vibrant, healthy culture as the company grows? Can leaders institutionalize culture? What are the best indicators that it's working?

Answer 1

I've always obsessed about culture. Companies succeed or fail based on culture. Organizations are about people; people respond to culture. The two are inseparable. The sooner you begin to instil culture in your organization, the better. As the company grows to scale, I would also like to build the word 'values' into the company's culture.

Think about a company's culture as a reservoir. It has been built by everyone and has each team member's buy-in. Always, but especially during the down times, every member of the team can draw from that reservoir and refill it when the need arises. *It's everybody's reservoir.* That's how a great company's culture works.

Cultures differ from organization to organization, each natural and organic and suited to the team that has been built. Culture can't be superimposed, nor is it a function outsourced only to the HR division. It comes from the top, through leaders who have the company's best interests at heart and want to instil a strong sense of ownership in every team member. As a leader, *you* set the culture. Companies with a great and vibrant culture will perform a full 100 per cent better than those without.

Part of a great culture is a great office, though that hardly means a Google headquarters or free breakfast and video games, a plush suite or private showers. Rather, let's emphasize liveliness and energy. Sometimes the best offices are crowded affairs that leave little room for video games but encourage plenty of interaction among team members, so they can exchange ideas and work collaboratively on important projects. In my two decades, our offices were always compact. There was never a feeling of wide-open space, but I *always* felt the energy and had a sense of fun in those workplaces.

In such an open culture, bad news travels up very quickly. In formal

environments, bad news gets smothered. Formality implies protocol. Protocol means slowing down. In the twenty-first century, there's no room for formality.

Courage is also an important characteristic of a great professional culture. Be sure to create a work environment that encourages people to take decisions while knowing they'll be supported. Mistakes are a part of the process, provided they don't recur. Without allowing the team to display courage and assertiveness, you'll never build a flat and empowered structure. Instead, a 'cover your arse' or 'present upwards and await a go-ahead' culture will prevail.

Culture formation is ongoing and doesn't magically appear all at once with a spectacular Big Bang, but from innumerable single moments, modelled from the top by a consistent leader and followed by all. Even when mid-sized or large companies want to re-invent themselves, they first attack culture, the most powerful tool for any company.

Question 2

You focus a lot of attention on communication. How important is communication to building a strong culture (and more) in any business?

Answer 2

Establishing a culture of communication from day one in every endeavour has been critical for me—be it through the red-lined notepad (the perfect size for a one-liner or an action-necessary request) that I've used for the last fifteen years to get the team members' attention, or by answering phones and getting back to mails in a timely fashion, or by breaking news to the team, or leading the multiple faces and voices of the organization. Soup to nuts. No entrepreneur can succeed without communicating well.

One of my most disruptive acts of communication was my year-end mail, which went out for most of the last decade. On the first or the second of January, I'd send a long mail to the team, breaking down the previous year, good and bad, warts and all. In 2009, after the global meltdown, the mail was titled 'To hell and back, 2009, a year

to overcome, own and win with disruptive thinking'. By the following year, of course, nobody was out of the woods yet, so it was 'Wishing you a relentless 2010'. That sort of communication sets the tone for the organization.

It's a continuous process. After that second mail in January 2010, everybody started using the word 'relentless', and that attitude of *relentlessly* pursuing goals started to seep into our thinking. For instance, in a meeting a few weeks later, somebody said, 'Yes, we're having a problem with this issue, but let's just stay at it, don't worry about it...' Such audacity and a straightforward 'we can do this' approach, taken from those notes and growing organically over time, really set the culture for the coming year. Direct, honest and productive communication with the right blend of inspiration and humour and little room for surprise goes a long way.

In fact, humour is an underrated aspect of communication. I may have lost my patience many times over the years or shown my frustration to the team, but I never lost my sense of humour. Most team members saw my sense of humour in two forms: sarcastic comments that were never meant personally or harshly; and bizarre, zany comparisons of the present situation with a reference we all shared. I've never been one for long personal discussions and bonding over a drink after work, but a work-related sense of humour keeps team members focused on the task at hand and creates a strong professional bond.

Entrepreneurs must be multitaskers, but you can never compromise on communication or let your guard down when it comes to being direct and honest with your team. Be as respectful of your colleagues' time as you want them to be of yours. Courtesy and respect go hand in hand with effective communication. They kill the culture of silence and the dilatory tactics that gum up organizations where communication isn't valued.

Question 3

How do I attract, motivate and retain top talent? How do I measure and reward performance and strike a productive balance between short-term targets and long-term goals?

Answer 3

First, ask yourself three questions:

Do I have a clearly established broad vision that I can articulate to my team and my prospective hires?

Am I inspirational when I communicate my passion and plans for the company's future?

Have I defined the company's culture and earned some buy-in from my team when it comes to practising it?

Vision, ambition and culture attract top talent. The people you want on your team also want to be at ease while working with you, directly or indirectly. They need to feel as though they can learn something from you every day and look up to you as a leader. If they see a collaborative and open, yet hungry, culture of success, they'll know their views will be heard and that they'll have plenty of opportunity for personal growth.

To attract the right people, you need to hire the right people. It's a positive feedback loop. On the other hand, if you hire poorly, word will get around. One or two key team members who, when hired, quickly become the odd ones out in your company's culture or just don't perform to expectations can become distractions to the organization as a whole. Hiring properly at the top is as critical as it is difficult.

I prefer hiring team players with strong collaborative skills, high levels of accountability, and past experience in delivering results and targets. Capable and bright are useful traits, of course, but make sure your hires are good fits for the company. She may be a rock star, but if she's not a team player or doesn't buy into your culture and values, it's going to be a short-lived stint.

At the end of the day, you can only know so much after a handful of interviews and meets. For your interviews, besides the first office visit, meet applicants at different locations—maybe over a meal or even on a walk or a jog. As you interact in different environments, you start to get a sense of the person you're hiring, not just their résumé.

During such interviews you'll quickly discover whether a prospective team member would rather talk or listen, the level of self-confidence she brings to the team, and whether she has a high level of curiosity

and genuinely wants to learn more. An important and often overlooked aspect of hiring is having all your key team members and direct reports interview the candidate. Not always easy to schedule, but a great way to validate your own opinion of that person. Operate your company with that level of openness, and you'll gather some incisive views from trusted colleagues and send out a strong signal to all team members that you maintain a genuinely flat structure.

Question 4

As I grow the company, some of my current team members, who have been loyal from the beginning, aren't able to scale up and manage. How do I handle this situation? Is it likely to happen again later?

Answer 4

Growing your company beyond the talents of your team is a real problem, faced not just by startups, but also by small- and medium-sized companies. Don't underestimate what an asset your loyal team is. In many ways—not least in terms of institutional memory and experience—these colleagues are irreplaceable, having watched with great pride as the company has grown.

But things don't always work the way we imagine. Such is business and life. Meet that challenge head-on. People who haven't grown with the organization do you and themselves a disservice by staying on. The onus is not always on you to take the first step. Likely, your colleagues will spot the increasing gap between productivity and efficiency as quickly as you. In either case, frank counselling from you—that their growth is limited and it's time to move forward—is the order of the day.

After a period of discomfort over letting go a long-time team member, you'll find those who can adapt and grow with you. If you keep the old guard on, chances are they'll resent the 'new hire'—. or, if she comes from within the organization, they'll question your judgement. Nothing kills a vibrant culture quicker than resentment and animosity.

Hiring for the future and perhaps avoiding a repeat of having loyal team members who can't scale with the company presents you with a

different set of challenges. As a leader, you build the company always with one eye on frugality and cost. You want to hire at the level your company has risen to at a given point in time, not where you think the company might be in one or two years.

If you've grown your company till date with this overly frugal culture, and hired 'just in time' for today, chances are the attitude will settle into the organization's DNA and affect growth, ambition and eventually even success. Take, for example, the Arsenal Football Club. They have the best financial metrics for debt, credit rating and more, but they've not won the league in Europe in almost two decades. Much of that, I think, has to do with their frugal approach of not 'buying' or paying a premium for star players. Decide where *you* stand vis-à-vis talent and your growth ambitions. Those are critical decisions.

Question 5

What is easier: starting or building a business to scale?

Answer 5

The short answer: starting is easier. I've always maintained (and have even mentioned several times in this book) that your first funding is simpler than your follow-up rounds. Most think: 'Once I get a foot in the door, the momentum I've built will always make future funding easier.' Actually, it's quite the opposite. While starting up, you can wait for the right moment and cut your coat according to your cloth. But once you have a business, customers, commitments and a team, you can't afford to hit the pause button. When you're on the treadmill, you have to deliver.

Starting and scraping and coming to a level is one step. Building is about staying there. When you're starting up, you have the luxury of trying out different ideas and searching for creative solutions to execute them. Once you're in 'build stage', though, focus is key. Without focus, you won't build to scale, create real value, lead a great team, or head an exceptional business and organization.

In the starting-up phase, you can be many things to many people, a bit all over the place. In build mode, you need to be at the right place

(preferably at the right time), and that means creating and looking for opportunities and staying in a constant state of readiness at multiple levels.

When you're starting up, you may be the one to meet every customer or client and build relationships. As you build, you empower your team and pass those responsibilities to them, while using technology to stay in touch with customers and 'what's out there'.

Many entrepreneurs wonder if, in fact, they're the right people to build the company they started. While there's no easy answer, it really depends on how you've grown with the company and, more importantly, how you've hired, built and empowered an exceptional team. If you've done all those things well, you're ready to build, lead your company to scale and give success your best shot.

Question 6

Everyone tells me that mentors are important, not just while starting up but as the company grows. How do I find a mentor? How do I know I have the right one? Can multiple mentors work? Should I change mentors as the business scales or morphs?

Answer 6

A 'mentor' implies someone more experienced than you. But the question is, 'Experienced at what?'

Most mentors can't give you a 360-degree panorama view, but you should never give up looking for someone with that breadth of invaluable knowledge. Before targeting a specific mentor, know exactly what you're looking for. Can you talk to her about strategy, finance, decision-making, market, growth, disruption, innovation, people and hiring? In short, *everything*? Or has she built a large company or an organization from the ground up, and you seek her as a mentor for that reason?

Ample experience generally suggests a more mature mentor. Keep in mind that a significant age gap might get you grey hair and wisdom, but it may not find you a mentor. A mentor should be able to put herself in your shoes and extrapolate from experience, not assume that 'back

in the day' will work in today's far different business climate. If your mentor is caught in a time warp, you may be getting a lot of wisdom, but you're not getting proper mentorship. Don't confuse the two.

And never look for a mentor in your family, it's just a bad idea, plain and simple. Your family is there to share your challenges or support you, but family dynamics can be tricky. If an elder gives you advice, he expects you to follow it. Also, family members will offer advice based on how they know you and perceive your strengths and weaknesses. It's not always bad baggage, but it's baggage nonetheless.

My personal recommendation would be to stick with one mentor, invest time in each other, get into a rhythm and be honest to a fault. A lot of entrepreneurs get frustrated with their mentors because what they really want is an evangelist to turbo-charge them and boost their confidence, to light the candle for them every day. At the same time, the mentor is thinking, *Now wait a minute, if that's all you wanted, then why the hell did you come to me for advice? My advice is going to be blunt. My advice may be, 'You don't know what the hell you're talking about!'*

Question 7

The question of work-life balance inevitably comes up when I hire at senior levels. High pressure and stress lead to attrition. Even I feel as though I get too little time with family and friends. What's the right balance?

Answer 7

All said and done, work-life balance is *vital* to the success of any business.

But a common misconception is that work-life balance is more difficult in startups than in other workplaces. The bottom line: If your company's culture from the start is 'work hard, play hard' and 'we need more thinkers and planners versus doers', you'll create the perfect balance.

Look, at the very beginning, you and the first few team members and co-founders will live off the energy and excitement of those early days and be perfectly happy multitasking for a year or two. That's fine. But as soon as you start growing a company, you want to make sure that

a work-life balance becomes part of your professional culture.

Much of that balance comes from keeping an eye on your time-management skills. *If you, as the founder and leader, have poor time-management skills, the whole company is doomed.* Stress rolls downhill. Keep your pulse on the time-management skills of your key team members as well. Establish the workplace tempo and rhythm by having everyone in the core management team on the same page, however big or small the company. If you're a founder who just can't delegate—either because you (falsely) think you're the best person to do every job or you keep hiring weak teams—your culture and work-life balance will be continuous sources of stress for your organization.

Neither productivity nor efficiency can go up in an organization that works fifteen-hour days every day of the week. Let's face it, these days everyone is plugged in and ready to go at any time. Employees want to feel as though the company respects their time and leaves the balancing of work in their hands and to their discretion. Give team members such freedom and witness the magic of ownership!

Work-life balance isn't just about work, it's also about taking time off. Vacations are switch-off time, and are a must. When UTV matured as a company, we made a rule that vacation leave was not to be carried forward into another year nor was it encashable. The message was clear: *We want you to take time off, to recharge. We need to see your team working in your absence. That's the true test of your effectiveness. Come back fresh and ready to take on the world with your bright new ideas.*

Question 8

How do I retain and motivate my team and employees when business is on the decline? Life cycles in our business change constantly. How do I bring the team along without having them feel the stress of change?

Answer 8

In short, the two key words: *Communication* and *decisive action*.

Frank and transparent communication isn't a one-off occurrence. In many chapters of this book, I've discussed various crises we suffered and survived. In all these instances, we brought the team together and spoke

openly and honestly. Everyone rallied with our assurance (conveyed with a sense of humour) that there was light at the end of the tunnel. People need to see body language and read facial expressions, hear proper communication and trust the leader's tonality and confidence. These things make all the difference, not rhetoric. *It's not always what you say, but how you say it.*

For organizations, often the best time to reflect on and discuss cost and strategy from all perspectives is during a period of decline or when there is a change in direction of the company's future. Institute focused communication in the smaller groups. The biggest problem during a time of crisis or change, large or small, is rumour-mongering from within. Do everything in your power to kill these Chinese whispers. Do your homework and know what your team needs to hear, so you don't give bad news in drips and drops. The worst thing a leader can do in crisis situations is call the team together three weeks after what the entire company thought *was* a complete briefing and tell them, 'By the way, there's *more* bad news.'

During a real crisis, 20 per cent of your team will move on. Your initial reaction as a leader might be, *At a time like this, the last thing I want is high attrition.* But this isn't the time to salvage past relationships. As a part of your culture-setting in the organization, you need to let go of those who lose faith in the company. Instead, focus on the team members who will be around through thick and thin. Those who run at the first whiff of a crisis will never be your long-term players. Bite the bullet and move on.

Question 9

How important is a co-founder? Can I have more than one? Do I need pro rata investment from each? Can friends make good co-founders? Can team members later become co-founders and will that help the company moving forward?

Answer 9

Starting, running and growing an organization is a lonely job. Even though you have colleagues you trust and whose views you value, at

crunch time, you're alone. While it would be good to have someone to share the burden with, choosing a co-founder is a serious long-term decision. If you wish to pursue a co-founder, you should have a history with that person. Both of you should know each other's strengths, weaknesses and idiosyncrasies. If not, spend a good six months getting to know intimately how the other person thinks, reacts and plans for the future.

By definition, founders or the founding team are with the business from the outset, taking personal risks in the form of investment or personal sacrifice and perhaps, leaving another job or taking less pay to become a part of the organization. When I started out with the business of toothbrushes, I had a co-founder, Manoj Mehra. Manoj didn't contribute in terms of equity, but he was the active manager. At UTV, Zarina (whom I was not married to at the time) and Deven Khote were the company's first two employees. A couple of years down the road, I invited them to become co-founders and that's what they remained right to the end. Team members who have been on board from the start can be made co-founders over time, thus increasing their sense of belonging. In such situations, make sure that their elevation to the status of co-founders is based entirely on merit, and is not a retention strategy.

Not all founders contribute with money and that's fine. If they do, their shareholding becomes proportionate to their investment. In the absence of equity participation, the founder funding the business should decide the allocation of percentage holdings.

On the issue of friends as co-founders: If you're embarking on this long journey solely because your co-founder is a friend, my response is a resounding *No!* In fact, any business decision involving friends or family requires you to think ten times and then think some more. Relationships change, evolve and mature. Nothing stands still. If you have a friend or family member outside work who could be a co-founder, you'll face a conflict of interest, always and without exception, regardless of how objective you *think* you are. In the long run, chances are you'll lose both your objectivity and a friend.

Question 10

How important is articulating a vision for the company and at what stage should I create one? Will my struggling to come up with a vision statement affect the company's ability to think big and build scale and excellence?

Answer 10

The vision statement refers to three or four lines that define your company's identity and your reason for being to team members, customers and all stakeholders. It is conveyed through the eyes of the founder and a core team early in the life of a business. For the record, I'm not an advocate of large group sessions or joint-vision statements.

Chart your company's vision by addressing a few broad questions:

Why did I start this business?

What does it stand for?

What need will it serve and what impact will it have?

What breakthrough or life-changing product will it create and offer?

What scale do I see for the business three to five years down the road?

You could also add a line on culture and values, if you think that will propel the vision into the future.

You're not in competition to make the most fantastic vision statement, nor will such a statement garner you any ranking in the real world. Rather, state with clarity and honesty what is right and appropriate from the company's point-of-view. We tend to place vision statements on lofty pedestals. For this reason, vision statements in many organizations spin out of control quickly, and lose the sharp focus of the best. If the vision statement mentions more than two or three aspirations for the company, chances are it will get entangled in windy rhetoric and find itself on a glass plate at the reception area without converting too many sceptics along the way.

Keep in mind that a vision statement doesn't guarantee success, but not having one can become an obstacle and a challenge. Make sure it's simple, clear and easily understood. Above all, the vision statement should inspire and set the benchmark for the company's ambitions.

Begin here, evolve your vision and dream big.

Question 11

A common buzz phrase today is 'value creation'. If I build a profitable company and grow revenues then I'm creating value, right? But what is real value creation?

Answer 11

Most people feel that if a company has good market share, growth and profitability, then it's creating value. What better way to create value than by sustaining hardcore delivery, year on year, of what you do best? That's a fair statement. I see the fundamentals of value creation in any company as scale, market share, growth, profitability, consistency and predictability of revenue. Without these, you're not creating much value in the first place.

But these elements might make up only 50 per cent of your value. What are the factors that contribute to the other 50 per cent, the differentiators that bring attention to your company? The list below isn't meant to be exhaustive, but I hope it triggers some introspection.

- Brand: This can give you a phenomenal premium. What about your brand gives you a loyal customer base and the ability to charge a premium for your product or service? What differentiates the top two or three companies that have breakout brands in every sector?
- Innovation, technology, research and development, intellectual property and patents: None of these will ever show up on your balance sheet, but they can give you an intangible advantage when creating value.
- Customers: Do you have a unique way of handling customers or building a customer base? Conventional wisdom may talk about television advertising and capturing regular customers, the people already coming to you. Look at your customer base and understand *how you do what you do* can create massive value.
- The 'X factor': If you have it, people will spot it. If you have to ask what it is, you don't have it. Understand and evangelize your X factor. Some companies command a huge premium just

because they're aggressive, disruptive in their space, or spot trends better than others. Apple and Google are great examples, where 30 to 50 per cent of their value is based on some X factor. For instance, let's take Apple's track record of instant success with every product they put on the market. Reality might be slightly different (even Apple misses the mark every once in a while), but perception is everything.

Value creation isn't something you consider only when you're looking for the exit. Value is what you create for yourself and your shareholders when you build for the long haul.

Question 12

The 'B-School Question': How important is it for me to have pursued management studies or postgraduate work before running my own business? Are my chances of attracting the bigger investors higher with a B-School degree? Do you personally miss not having pursued an MBA or a CA degree?

Answer 12

Let's be clear. All higher education is a personal choice and it should be so. No matter what you do, always have a firm idea about *why* you're doing it. If you can give an honest answer to the question: *Why do you want to go to B-School?*—not because of peer or parental pressure, not because it's Plan B or a safety valve, not because 'it's the right thing to do'—you'll take the right call. But understand explicitly why you're investing the next several years of your life in education and exactly what you plan to gain from it. Now write down a half-pager describing what you see for yourself after graduation. Be brutally honest. *It's your call alone.*

One concern I have with B-School graduates is that they tend to take all their learnings from those years as gospel for life. On confronting hard logic and practical problems, their first instinct may be to go back to the sandbox of bookish wisdom without taking time to understand (the often harsh) reality. B-School is useful if they can translate their learnings into real world currency and accept that they'll have to *unlearn*

a few things as well. Once out of school, they'll be tested in ways for which school hasn't prepared them.

I personally haven't seen a connection between investor interest and academic qualifications. Investors assess you, your team and co-founders, your space and its headroom, and your execution plan based on their entrepreneurial merit. Full stop.

Do I regret not having pursued higher studies after a BCom? Back in college, I was clear I didn't want to pursue further studies. I didn't pen a half-pager, though I did forward gaze and imagine life after an MBA or a CA; I quickly decided it wasn't for me. I had a lot of peer and parental pressure. My brother is one of the most qualified people I know. But as I've also said throughout the book, I don't much believe in hindsight. If I'd done my MBA, maybe those two years (or five for a CA) would have structured my mindset and my ambitions differently. Maybe the logic and balanced thinking and planning fostered by either degree would have steered me away from entrepreneurship.

Maybe, maybe. Who knows?

What I do miss is going to a great university for a year or two. The interactive learning and teaching and those competitive peer groups would have been a great experience. I loved the 1973 movie *The Paper Chase* (recommended—an oldie but a goodie) set in Harvard Law School. I don't want to become a lawyer but have always envied that environment, the unfettered learning that prepares you for life in so many ways as long as you're agile and adapt to your environment once you leave.

Question 13

People and talent are critical to the success of any business. Having started a business in my small town, I'm now having trouble assembling a great team. I know that thousands of entrepreneurs face the same challenge. Any advice? Should I relocate?

Answer 13

Start by turning that perceived disadvantage to your favour.

One of the biggest challenges many businesses face is their inability

to scale because they lack a thorough understanding of the consumer and struggle to operate outside a few big cities. India's real growth in the future will come from small- and mid-sized cities, the very place you're sitting in right now!

Mr Tata didn't hesitate to build the largest steel plant in the world in Jamshedpur, at that time a small city. Nor did Mr Ambani dither, when he built one of the largest refineries in the world in Jamnagar. Walt Disney brought his Disneyland dream to fruition in a valley miles from any real city. The list goes on.

Your colleagues and you grew up where you've started your business, that market is inscribed in your DNA and so, there's a clear *advantage* for you. Your overall cost and salary structure is going to be much more competitive in a smaller market than in one of the top four cities (where you'll be overpaying with the big boys). And if your business has a manufacturing, assembly or distribution element, chances are you can stay closer to your operation by being where you are right now.

Let's zero in on why you've had difficulty attracting top talent. Maybe you're looking for a research and development head, maybe a great design or marketing person. So pick the top two hires where you need the best talent, increase your budget, overpay for talent and create an attractive environment for those individuals to move to your city. Offer them better living accommodation than they would get where they currently live, clubs, some great schooling, travel and, if you think necessary, stock options, wealth-creation opportunities, or maybe even co-founder status.

What are your choices if you want to build a great business where you are?

- Look at a branch office outpost in another city where the talent you want can stay—understanding that such a move splits the company at a stage where you need everyone together so as to build the right professional culture.
- Scale down your ambitions and cut your coat according to your cloth, which is pretty much what you were thinking when you asked this question.

- Pay extra for those top hires, and get on with it.

They're all workable solutions—just take a call! It boils down to your own mindset and vision and your willingness to turn that challenge into an opportunity.

Question 14

The noise levels in the media and the interest displayed by venture capitalists and investors are so high for all things e-commerce, digital, or Internet-driven, that these seem like the only strong markets for growth. Is anybody these days taking a serious look at large, untapped markets within small towns and rural India, and the other sectors which can spur the country's growth?

Answer 14

All entrepreneurship begins with the process of choosing your space, articulating your vision and crafting your plan and your differentiators. Investors will judge you and your team based on merit and your potential within that sector. Turn off the media hype and choose a market where you can excel, innovate and disrupt.

Despite the noise, the fact is that more money in India goes into serious sectors with markedly more headroom than into e-commerce, digital or Internet-based organizations. Besides, people tend to hear about the *few* successes in the tech space, not the large percentage that can't scale or just don't make it.

The herd typically follows the noise and what appears to be the path of least resistance. Of course, e-commerce, tech and the Internet are interesting and useful businesses, but your probability of success in them is so much lower because of such herd mentality. If you can turn your back on that seductive siren call of e-commerce and build a solid business, guided by your passion and dedication to a vision, that's your best bet. Especially in emerging markets, coupling long-lasting impact with sustained value creation will get you noticed and respected by everybody.

Many of the most innovative businesses today have nothing to do with inventing a new microprocessor or a faster cell phone. There are

massive scalable opportunities in clean water, agriculture and energy, affordable housing, personalized education, healthcare, life sciences and nutrition, pollution-control and air quality, food and the packaged ready-to-eat sector—basic businesses with nearly limitless potential and headroom for the foreseeable future that provide important, impactful products and services. Despite what the media may tell us, these sectors receive top funding and massive attention from savvy investors.

Stay with your convictions and separate yourself from the herd.

Question 15

Bringing in investors and venture capital is a part of the growth story of most companies. Venture capitalists (VCs) are great for board-level contribution, opening doors and bringing in governance and discipline. But they don't really get it, do they? Most have never started a company and have little idea of how to run or grow a business. The gap is wide between investors and entrepreneurs when it comes down to the brass tacks. What's the right balance in this relationship? How does one set expectations on both sides?

Answer 15

As long as businesses have existed, there has been friction between founders and investors. Everyone who starts a business thinks, *I know how to run my business. I need the money, but once they invest, why can't they just back off and understand I'm the best guy to run things?*

Many entrepreneurs don't acknowledge the value of strong, long-term risk capital, without which the company would suffer, or worse. Investors come to you with wide and varied experiences. Contrary to popular belief, they're not risk averse. That's capital crap. VCs know that of ten investments, two will turn out to be stars, five will hover around average and three will crash and burn. A VC's risk is even higher than the one you took to start your business! So imagining conservative, suited guys who will only make life difficult for you is flawed and short-sighted. In the end, that attitude could cost you the investment you need to grow your business.

Don't forget: You need the money, *their* money. And money gets a seat at the table. In that sense, who are you to decide what happens?

VCs also bring their broad knowledge of many sectors to bear on their investments. A savvy VC will have looked at more than 1,000 companies, eliminated 950, narrowed that list to ten and finally decided to invest in five. In that case, you're in the 0.5 per cent of the companies that the VC has examined. Very few entrepreneurs I know have that depth of experience or the ability to look at sectors and spaces, introspect and give a thumbs up or down on whether to invest. Admit it, if you did the same thing, your company would be history! VCs have also met more team members and potential entrepreneurs than you've ever met.

Sure, you'll always be the best person to spot your own trucks and trends. But investors and VCs have seen their fair share as well, across multiple sectors and levels. Look at your investor as someone to brainstorm with or perhaps, even as a mentor, in which case the value added could be astronomical. Also be aware that such proximity can present its own problems. Friction in the investor-entrepreneur relationship often occurs when an investor wants to keep a finger on the pulse of day-to-day operations. The truth is, an investor can *never* tell an entrepreneur exactly what to do. What he can do, though, is give a business a solid foundation and impart his experiences—so long as the entrepreneur is willing to listen.

Like everything else in business and in life, everything boils down to balance and making relationships work through open and honest communication and a mutual interest in what's best for the company.

Question 16

What are some of the toughest decisions I will have to make and the crossroads I will come to in the early years of building a business?

Answer 16

This list isn't exhaustive, of course, but write these down, and anything else you come across, in your black book. Add to the list early and often with comments, tracking how you evolve year on year and anticipating those trucks and trends as you reach your benchmarks and milestones.

- Startup mindset: Be prepared to hit the ground running. Starting a company and growing a company are two different things and require different DNA structures. How will you grow into those roles?
- Fundraising: Your second and each subsequent round of funding will be more difficult than your first.
- Speed versus strategy: Speed, for too many people, suggests moving fast, impulsively and with little thought for the consequences. Not true. The flipside is overthinking every option and letting the moment and the opportunity pass you by. Strike a balance between the two.
- Hard work versus shortcuts: Although *jugaad* in its purest sense stands for frugal innovation, many people assume it means a 'shortcut' or a get-it-done-whatever-it-takes attitude. You'll never build a strong organization or a quality team with such an approach.
- Day-to-day concerns: How do you continue to price your product or service in an environment where your competitor practically gives it away for free? How do you continuously realign your business model and team such that they stay relevant, yet consistent, at all times?
- Team-building: Assemble a team for scale, not one you outgrow every eighteen months.
- Value and exits: While you focus on building your business for the long term, your investors are more concerned about the next round of valuation and, at some stage, on liquidity or an exit. Balance both imperatives, but don't pass up an opportunity to build the company.
- Growth versus profitability: Ideally, both should work in tandem. When they don't, though, you need to be very clear about your direction and be in complete sync with your stakeholders, including your investors and team. Without any eye on profitability, however, you're fooling yourself.

Question 17

So much importance is placed on building a brand. How do I build brand from the outset? When and how much do I spend on branding? How do I know my brand is working? As a founder or the CEO, what sort of priority should I give this?

Answer 17

Brand-building begins from day one, and as a part of your vision statement. Despite how sexy the idea of a brand has become, not everyone needs to enter the whole 'brand race'.

First, determine how or whether having a brand will move the needle for your company. Maybe you provide a great service. You stand for something. But is your business relevant for brand-building in your sector? Do you have a differentiator? The common expectation regarding brand-building is having a *Eureka!* moment. But brand-building is a slow, steady process.

Most people believe brand-building and marketing are one and the same. They're not. Sure, advertising increases awareness and sales. But even if everyone on the planet has heard of you, that doesn't necessarily make you a *brand*. So what does? Credibility, sustained excellence while providing a service and/or a product, the ability to constantly surprise the customer, strong values, loyalty, and other people's willingness to pay a premium for your goods and services—these are all characteristics of a brand.

In the olden days, a brand was a mark of ownership on sheep or cattle. Today, it's suggestive of a product or service that leaves a unique mark and originates from the founding team. A brand can be created by compelling people to form an opinion about you and your company. It can also be a great attractor of talent, allowing you to hire the most innovative and cutting-edge people to work with.

Your brand emerges from everything you stand for—the quality of your product, your service, your innovation, your PR and how you communicate your vision and your goals. Even word-of-mouth and the way you, as the founder, are viewed by the general public are vital to the creation of your brand. Brands evolve, carry emotional weight, give

value for money and possess a 'wow!' factor for the consumer, who can't get the product or service you offer in quite the same way anywhere else in the sector.

You need to get two things right from the start to build a brand.

First, your company name and logo. A simple thing, but a necessity if you're serious about building a brand for the long term. UTV stands for 'United Television', and it doesn't get more boring than that. But from the start, we wanted the UTV brand to stand for innovation, disruption and creativity. Part of the brand, of course, was the UTV logo—red, green and blue. Over a decade of brand focus, we wanted the logo to become even more colourful, high-energy and creative—so it evolved, with the same three colours swiped as tika lines across the screen by a hand. Even later, the twenty-first century iteration reflected our cutting-edge content, pioneering innovation, and passion for disruption, with the logo and the three core colours coming alive in a burst of energy.

Second, define what your brand stands for. In other words, effectively and thoroughly communicate what vision, culture and values you're building for the company and its stakeholders. Your brand has arrived when it's of commercial advantage to your company and business, when people want to work for you and stay with you because of what you stand for, when customers trust you and expect a consistent product or service from you, and when you can leverage collaborations with people who clamour to partner with you.

If you're consistent even while constantly surprising people, you're building a brand. Take Disney as an example. It starts with its values— the all-seeing eye for detail and the jaw-dropping, fantastic world that invites people in. It's the magic you feel when, headed to the car at the end of a long, satisfying day, you hear a rumble in the distance, and a couple of minutes later, a parade appears out of nowhere. Once the parade has passed, fireworks blossom in the sky above your head. Just when you think the day is over, you get a tonne of additional special memories to take with you.

That's brand.